NEXUS NETWORK JOURNAL Architecture and Mathematics

Aims and Scope

Founded in 1999, the *Nexus Network Journal* (NNJ) is a peer-reviewed journal for researchers, professionals and students engaged in the study of the application of mathematical principles to architectural design. Its goal is to present the broadest possible consideration of all aspects of the relationships between architecture and mathematics, including landscape architecture and urban design.

Editorial Office

Editor-in-Chief
Kim Williams
Corso Regina Margherita, 72
10153 Turin (Torino), Italy
E-mail: kwb@kimwilliamsbooks.com

Contributing Editors
The Geometer's Angle
Rachel Fletcher
113 Division St.
Great Barrington
MA 01230, USA
E-mail: rfletch@bcn.net

Book Reviews
Sylvie Duvernoy
Via Benozzo Gozzoli, 26
50124 Firenze, Italy
E-mail: syld@kimwilliamsbooks.com

Corresponding Editors
Alessandra Capanna
Via della Bufalotta 67
00139 Roma, Italy
E-mail: alessandra.capanna@uniroma1.it

Ahmed Ali Elkhateeb
King Abdulaziz University
Department of Architecture
Faculty of Environmental Design
21589 Jeddah, Saudi Arabia
E-mail: aelkhateeb@kau.edu.sa

Tomás García Salgado
Palacio de Versalles # 200
Col. Lomas Reforma, c.p. 11930
México D.F., Mexico
E-mail: tgsalgado@perspectivegeometry.com

Ivan Tafteberg Jakobsen
St. Blichers Vej 20
DK-8230, Aabyhoj
Denmark
E-mail: Ivan.Tafteberg@skolekom.dk

Robert Kirkbride
studio 'patafisico
12 West 29 #2
New York
NY 10001, USA
E-mail: kirkbrir@newschool.edu

Andrew I-Kang Li
Initia Senju Akebonocho 1313
Senju Akebonocho 40-1
Adachi-ku
Tokyo 120-0023, Japan
E-mail: i@andrew.li

Cover
"Structural Oscillation", 2008. Photo © Alessandra Bello

Jesper Matthiasen
Silkeborg Vej 130, 1.tv
DK-8000, Aarhus C, Denmark
E-mail: Jesper.Matthiasen@skolekom.dk

Michael J. Ostwald
School of Architecture and Built Environment
Faculty of Engineering and Built Environment
University of Newcastle
New South Wales, Australia 2308
E-mail: michael.ostwald@newcastle.edu.au

Vera Spinadel
The Mathematics & Design Association
José M. Paz 1131 - Florida (1602), Buenos Aires, Argentina
E-mail: vspinade@fibertel.com.ar

Stephen R. Wassell
Department of Mathematical Sciences
Sweet Briar College, Sweet Briar, Virginia 24595, USA
E-mail: wassell@sbc.edu

João Pedro Xavier
Faculdade de Arquitectura da Universidade do Porto
Rua do Gólgota 215, 4150-755 Porto, Portugal
E-mail: jpx@arq.up.pt

Instructions for Authors

Authorship
Submission of a manuscript implies:
* that the work described has not been published before;
* that it is not under consideration for publication elsewhere;
* that its publication has been approved by all coauthors, if any, as well as by the responsible authorities at the institute where the work has been carried out;
* that, if and when the manuscript is accepted for publication, the authors agree to automatically transfer the copyright to the publisher; and
* that the manuscript will not be published elsewhere in any language without the consent of the copyright holder.

Exceptions to the above have to be discussed before the manuscript is processed. The manuscript should be written in English.

Submission of the Manuscript

Material should be sent to Kim Williams
via e-mail to: kwb@kimwilliamsbooks.com
or via regular mail to: Kim Williams Books,
Corso Regina Margherita, 72, 10153 Turin (Torino), Italy

Please include a cover sheet with name of author(s), title or profession (if applicable), physical address, e-mail address, abstract, and key word list.

Contributions will be accepted for consideration to the following sections in the journal: research articles, didactics, viewpoints, book reviews, conference and exhibits reports.

Final PDF files
Authors receive a pdf file of their contribution in its final form. Orders for additional printed reprints must be placed with the Publisher when returning the corrected proofs. Delayed reprint orders are treated as special orders, for which charges are appreciably higher. Reprints are not to be sold.

Articles will be freely accessible on our online platform SpringerLink two years after the year of publication.

Nexus Network Journal

DIGITAL FABRICATION

VOLUME 14, NUMBER 3
Winter 2012

KIM WILLIAMS BOOKS

Nexus Network Journal
Vol. 14
No. 3
Pp. 407-582
ISSN 1590-5896

CONTENTS

Kim Williams

Kim Williams Books
Corso Regina Margherita, 72
10153 Turin (Torino) ITALY
kwb@kimwilliamsbooks.com

Letter from the Editor

Digital Fabrication

Abstract. *NNJ* editor-in-chief Kim Williams introduces the papers in *NNJ* vol. 14, no. 3 (Winter 2012).

It is a pleasure to present vol. 14 no. 3 of the *Nexus Network Journal* dedicated to Digital Fabrication. It was exactly ten years ago that the first *NNJ* paper regarding this field – George Hart's "In the Palm of Leonardo's Hand" (vol. 4, no. 2, pp. 103-112) – was published. In the space of that decade, rapid prototyping and digital fabrication in architecture have gone from fantasy to reality. As the papers published here show, digital fabrication is changing architecture in fundamental ways in every phase, from concept to artifact. One manifestation of these changes is apparent in the way the authors refer to "making" architecture and to the architect as "maker". To me this has the positive effect of restoring to the architect some of his original function, that is, involvement in the actual fabrication of the built object. The architect who exploits techniques of digital fabrication need no longer remain a mere overseer some steps removed from the process of execution, but can actually intervene and modify his design as it is being carried out.

On 9-10 September 2011 the ISCTE–Instituto Universitário de Lisboa hosted a symposium entitled "Digital Fabrication – A State of The Art" to discuss the current status of the field as well as its integration into programs for architectural training. The symposium organizers – Alexandra Paio, Sara Eloy, Vasco Rato, Ricardo Resende and Maria João de Oliveira – have contributed a paper to this issue entitled "Prototyping Vitruvius, New Challenges: Digital Education, Research and Practice" which serves as an overview of the field and an introduction to the other papers included here by symposium speakers, each of whom discuss a particular aspect of digital fabrication in architecture based on first-hand experience. Kevin Klinger contributes a paper on "Design-Through-Production Formulations" as implemented at the Institute for Digital Fabrication at Ball Sate University. Bob Sheil's "Manufacturing Bespoke Architecture" addresses the changing roles of designers and makers in architecture as the constraints of industrial standardization are relaxed. Sheil is Director of Technology and Computing at the Bartlett School of Architecture, University College London. Tomas Diez leads the project Fab Lab at the Institute for Advanced Architecture of Catalonia (IAAC) and coordinates the Fab Academy program offered by the worldwide network of Fab Labs. His paper, "Personal Fabrication: Fab Labs as Platforms for Citizen-Based Innovation, from Microcontrollers to Cities" discusses how the generation of knowledge and the sharing of know-how will create a collective mind capable of defining the future of production in the life of mankind and its relation with the environment. In "Digital Fabrication Laboratories: Pedagogy and Impacts on Architectural Education", Gabriela Celani, founder and director of the Laboratory for Automation and Prototyping in Architecture and Construction at the University of Campinas, examines the implications of digital fabrication for architectural education. Tobias Bonwetsch of ETH's Laboratory for Architecture and Digital Fabrication presents "Robotic Assembly Processes as a Driver in Architectural Design". The Lisbon symposium was completed by a workshop led by José Pedro Sousa of the Faculty of Architecture at the University of Porto (which, by the way, hosted the 2010 Nexus conference). His report of the workshop is presented

DOI 10.1007/s00004-012-0130-8; *published online* 5 October 2012

in the paper entitled "Material Customization: Digital Fabrication Workshop at ISCTE/IUL".

Digital fabrication truly represents a leading edge of research in architecture, and I am very pleased that the *NNJ* was chosen as the venue for publication of these important papers.

This issue contains other research papers as well. In "Design and Tracing of Post-Byzantine Churches in the Florina Area, Northwestern Greece", Aineias Oikonomou investigates the application of specific design and constructional tracing in post-Byzantine churches situated in northwestern Greece during the period from the fifteenth to the nineteenth century. This complements Oikonomou's earlier paper on Greek houses ("The Use of the Module, Metric Models and Triangular Tracing in the Traditional Architecture of Northern Greece", *NNJ*, vol. 13, no. 3, pp. 763-792). Farah Habib, Iraj Etesam, S. Hadi Ghoddusifar and Nahid Mohajeri, a group of authors affiliated with Islamic Azad University, Science and Research Branch of Tehran, have contributed a fine, original research paper entitled "Correspondence Analysis: A New Method for Analyzing Qualitative Data in Architecture". Correspondence Analysis is a method primarily used in genealogy but here, for the first time, it is applied to architectural studies. The test case examines the influence of five distinct garden styles on the design of a formal garden – unfortunately no longer existing – in Tehran's city center. The research paper by Francisco Roldán, "Method of Modulation and Sizing of Historic Architecture" presents a proportional system consisting of combined numeric and geometrical elements that he uses to analyze architecture of the past. In "Descriptive Geometry: From its Past to its Future", Riccardo Migliari of Rome's "Sapienza" University attempts to reconcile traditional and contemporary methods of graphic investigation, namely, descriptive geometry and CAD, to show how it is possible to give new life to the ancient science of representation and, at the same time, endow CAD with the dignity of the history that precedes it.

This issue concludes with my own review of Mark Peterson's book, *Galileo's Muse: Renaissance Mathematics and the Arts* (Harvard University Press, 2011). Who wouldn't want to have the muse who guided Galileo looking over his or her own shoulder?

From ancient to futuristic: there is something for everyone in the Nexus Network Journal!

Kim Williams

About the author

Kim Williams is the director of the conference series "Nexus: Relationships Between Architecture and Mathematics" and the founder of the *Nexus Network Journal*.

DOI 10.1007/s00004-012-0124-6; published online 21 September 2012

Research

Prototyping Vitruvius, New Challenges: Digital Education, Research and Practice

Alexandra Paio [1,2,4]
ISCTE – Instituto Universitário de Lisboa
Avenida das Forças Armadas
1649-026 Lisbon, PORTUGAL
alexandra.paio@iscte.pt

Sara Eloy [1,2]
ISCTE – Instituto Universitário de Lisboa
Avenida das Forças Armadas
1649-026 Lisbon, PORTUGAL
sara.eloy@iscte.pt

Vasco Moreira Rato [1,3,4]
ISCTE – Instituto Universitário de Lisboa
Avenida das Forças Armadas
1649-026 Lisbon, PORTUGAL
vasco.rato@iscte.pt

Ricardo Resende *[1]
*Corresponding author
ISCTE – Instituto Universitário de Lisboa
Avenida das Forças Armadas
1649-026 Lisbon, PORTUGAL
jose.resende@iscte.pt

Maria João de Oliveira [4]
ISCTE – Instituto Universitário de Lisboa
Avenida das Forças Armadas
1649-026 Lisbon, PORTUGAL
mjoaomoliveira@gmail.com

[1]ISCTE – IUL, Lisbon
[2]ADETTI – IUL
[3]Dinâmia'CET – IUL
[4]Vitruvius FabLab – IUL

Abstract. This paper discusses a key subject of research at ISCTE-IUL, Digital fabrication in architecture offers new perspectives and design innovation in three main areas: academia, research and professional practice. In order to investigate these new challenges and its contributions to architecture in Portugal, a group of multi-disciplinary researchers organized a symposium that presented a state of the art in digital fabrication. The main points were the creation of the Virtuvius FabLab–IUL laboratory and the definition of appropriate new lines of research in digital fabrication.

Keywords: digital fabrication, digital architecture, fablab laboratories, digital tools

Introduction

Over the past decades, the development of new technologies and the emergence of sustainable/integrated digital tools for visualization, representation and fabrication have played crucial roles in architectural design, as a new paradigm at various levels: education, research and architectural practice. The digital revolution has transformed not only the process of architectural thinking but also the making. Architecture schools around the world are creating digital fabrication laboratories to provide their students with the skills to support new learning processes, scientific innovation and development linked to architectural practice and the building industry. Digital technologies have released a multiplicity of new career opportunities for graduates and advanced architectural education. Digital methods enable architects to create complex parametric modeling geometries; generate construction information directly from design; test its performance virtually and physically; and produce full-scale models of their designs. Thus, it has been necessary to introduce new architectural curricula in academia and new strategies to approach technology, implement digital thinking, and foster collaborative environments and digital methods. The main goal has been to explore the new digital technologies and their contribution to solving some of the challenges presented to society and architecture. Social responsibility requires greater sensitivity to innovation. Digital design sensibility must encompass the school culture [Cheng 2003]. The progress of architectural practice

is characterized by two forces, one driven by the spirit of time and the other by innovation. Nevertheless, there is still a long way to go. In other words, the connection between a physical visual order and digital order is not fully understood, but at the same time the situation indicates many things can no longer be coded in the same manner as earlier. Architecture is evolving into far more of an infrastructure capable of taking on a variety of spatial and functional programs, than the actual physical edifice. In this light, critical thinking becomes an essential instrument in a research based architectural education [Fjeld 2008:7].

The variables are unlimited and involve the consorted efforts of all, especially academia and industry. Other important issues are the technological limitations and future directions.

In order to investigate these processes and their contributions to architecture in Portugal, ISCTE-IUL, organized a symposium that would allow a state of the art in digital fabrication. The main topics were the creation of the Vitruvius FabLab–IUL laboratory, and the identification and definition of new advanced architectural education according to new lines of research appropriate to digital fabrication. The event was organized in cooperation with the industrial companies and had the participation of internationally renowned researchers in the field of manufacturing and digital architecture. The aim was to bring together professionals and non-professionals to reflect and discuss the work that has been developed in the area of new technologies, interactive architecture and digital fabrication.

This paper has four sections: the first section introduces the digital fabrication challenge. The second section describes the state of the art of digital fabrication and the symposium contributions, which are presented as papers in the present issue of the *Nexus Network Journal* (vol. 14, no. 3, Winter 2012). The next section, describes the area of expertise in digital fabrication at ISCTE-IUL and the first steps of research at Vitruvius digital fabrication laboratory. The final section discusses the results and future work.

A digital fabrication challenge: teaching/learning, research and practice

The architect should be equipped with knowledge of many branches of study and varied kinds of learning, for it is by his judgment that all work done by the other arts is put to test. This knowledge is the child of practice and theory. ... There are three departments of architecture: the art of building, the making of time-pieces, and the construction of machinery. ... All these must be built with due reference to durability, convenience, and beauty [Vitruvius 1960: 5, 16, 17].

As Vitruvius reminded us, the relationship between conception and production is very important. This relationship has played a vital role in the development of both areas throughout history. But in the beginning of the twenty-first century, these matters assume new contours. The digital revolution has completely reconfigured this relationship, creating a direct link between the two based on the processes of computer numerically controlled (CNC) prototyping [Kolarevic 2003].

Tools once limited to non-creative areas are now part of everyday life for architect students, researchers and professionals. CNC combined with digital design tools make it possible for the designer to directly transfer design information to fabrication machines (milling, laser cutting, robots and 3D printers). Nowadays, the design process (academic, research, practice) is no longer conceivable without the aid of information technology.

This is due to the increasing need to quickly and flexibly fabricate tailored architectural solutions, as well as the complexity of the physical structures and the processes of assembling them. The modern paradigms of repetition, standardization and customization pose new questions regarding both the emerging aesthetics and the future production means for a new practice [Vicent and Nardelli 2010]. As Michael Meredith puts it,

in this new production context, increasing importance has been given to the role of parametric design, a process based not on fixed metric quantities but on consistent relationships between objects, allowing changes in a single element to propagate corresponding changes throughout the system. In parallel, developments in scripting have opened the way to algorithm design processes that allow complex forms to be grown from simple iterative methods [2008:8].

Recently, relevant research in the field of natural structures has focused on generating complex geometries and the emergence of prototyping, providing additive technologies for these purposes. Fab(a) thing is a project that opens up new paths for the design process [Malé-Alemany et al. 2011]. This has become a means for delivering geometrically precise and useful prototypes within short periods of time [Oxman 2011].

The digital fabrication technologies are pointing to new ways to foster the communities of researches and individuals to develop sustainable tools based on open source hardware and software and self-learning processes. According to Mark Burry,

Digital design is now fully assimilated into design practice, and we are moving rapidly from an area of being aspiring expert users to one of being adept digital toolmakers". The final intention is that any person, anywhere, could produce its own devices [2011:8].

However, knowledge related to digital issues is not taught at an equivalent level in architecture schools and the challenges are large. Preparing students and professionals of architecture to meet these challenges requires appropriate responses, based on the desire to reconcile historical and cultural identity within a global community.

State of the art of digital fabrication

CAD/CAM technologies are being used in architecture and building technologies to foster innovation and introduce original approaches to the design and building processes. Digital fabrication brings new possibilities to the design-through-fabrication processes, alleviates geometry constraints on mass production strategies and enables the production of custom components without increasing labor [Shelden 2002: 46].

As stated by Malcolm Mitchell and William McCullough, new tools often "seem strange and are understood in contrast to their predecessors" [1994: 464]. In fact, digital fabrication tools are still being affected by this appearance of novelty in architecture. However, over time their use has become commonplace both in education and practice in architecture. Today the benefits of digital fabrication in architectural research are becoming well understood and the contributions of the experiments undertaken are accepted to the extent that technologies are becoming more approachable and transparent. The use of digital fabrication in combination with other digital methods such as generative design systems, parametric design and shape grammars in the design practice allow the development of new and diversified solutions. Thus the possibilities brought about by the new technology-based methods of design and fabrication enable the

emergence of solutions that were frequently impossible to achieve via other, non-computer-aided methods.

The emergence of CAD technologies in the 1980s changed some aspects of the design process but focused essentially on the representation of architecture with the systematic use of 3D models and realistic renderings. At the time, representation of the building was done by traditional 2D drawings. This kind of representation was seen as a necessity to inform the final construction, but was often untested as a valid construction method. Physical models were almost replaced by virtual models during the "digital fantasy era" and there was almost no relation between virtual models and real construction [Celani 2010]. During the 1990s Mitchell and McCullough [1994] witnessed the initial uses of digital fabrication and 3D scanner in architecture, previously used by the naval and aerospace industries, with experiments by Gehry [Shelden 2002].

Although Gehry introduced innovations in the materiality of architecture, the architecture and manufacturing processes which involve working with prototypes is not a new subject. In fact Gaudí, Buckminster Fuller, Mies and other architects used models to test their ideas [Kolarevic and Klinger 2008].

Since Gehry's first experiments, several digital fabrication laboratories, or workshops, were created in universities, industries and offices. These laboratories are fully equipped with computer-operated machines able to manufacture almost everything from integrated circuits to entire houses [Diez 2012]. According to Celani [2012] initially these labs mainly produced scale models using 3D printers, but researchers soon found new hypotheses for production of full-scale prototypes and started to orient their research to post-industrial methods.

Nowadays the connection between the concept and the fabrication phases is increasing and both are cross-referenced to exchange information and enhance the object's performance. Visualization, geometrical manipulation and simulation make it possible to anticipate incompatibilities and design errors that can be corrected on time. Being able to simulate the building's performance during the design process as well as work with real environment parameters creates buildings which are more connected to the environment and have better performance. The simulations and analyses of building performance informs its final form, which means that, all the other aspects aside, form is being informed mainly by performance [Klinger 2012].

The fabrication of models, prototypes or building components through digital fabrication uses subtractive, additive and formative technologies by modelling, dividing, machining and assembling surfaces.

CNC cutting, both 2D and 3D, is a subtractive technique that may use laser-beams, plasma-arcs or water-jets. It consists in cutting complex geometries in a very rigorous way. Multi-axis milling machines are also subtractive technologies since they remove parts of a solid material and may create textured surfaces.

Additive technologies, often referred as rapid prototyping, make it possible to create a 3D model by overlapping layers of material (polymer, metal and clay, among others). Due to the small size of 3D printing machines this technology has a limited application in the architectural design processes, being limited to small components. However the use of robots to assemble components or to print construction material is also an additive technology and its use is being widely investigated nowadays [Bonwetsch 2012; Malé-Alemany et al 2011; Webb and Pinner 2011; Kestelier 2011]. Instead of using

Printed in the United States
By Bookmasters

Index

Robins RG (1985) The solubility of barium arsenates: Sherritt´s barium arsenate process.-
 Metall.Trans.B 16 B: pp 404-406

Rösler HJ, Lange H (1972) Geochemische Tabellen.- VEB Deutscher Verlag f.
 Grundstoffindustrie: 674 [Neuauflagen 1975, 1981]

Sauty JP (1980) An analysis of hydrodispersive transfer in aquifers. Water Resources. Res.
 16, 1: pp 145-158

Scheffer F, Schachtschabel P (1982) Lehrbuch der Bodenkunde, 11.Aufl.-Enke Verlag;
 Stuttgart

Schnitzer M (1986) Binding of humic substances by soil mineral colloids. In: Interactions
 of soil Minerals With Natural Organics and Microbes. In: HUANG P M, SCHNITZER
 M (Eds).-Soil. Sci. Soc. Am. Publ. No. 17, Madison, WI

Sigg L, Stumm W (1994) Aquatische Chemie.-B G Teubner Verlag; Stuttgart

Silvester KS, Pitzer KS (1978) Thermodynamics of electrolytes. X. Enthalpy and the effect
 of temperature on the activity coefficients.-Jour. of Solution Chemistry, 7: pp 327-337

Sparks DL (1986) Soil Physical Chemistry.- CRC Press Inc., Boca Raton; FL

Stumm W, Morgan JJ (1996) Aquatic Chemistry, 3rd edition.-John Wiley & Sons; New
 York

Thorstenson DC, Parkhurst DL (2002) Calculation of individual isotope equilibrium
 constants for implementation in geochemical models.- US Geol. Survey Water-
 Resources Investigations Report 02-4172

Truesdell AH, Jones BF (1974) WATEQ, a computer program for calculating chemical
 equilibria of natural waters.-US Geol. Survey J Research 2: pp 233-48

Turner BF, Fein JB (2006) Protofit: A program for determining surface protonation
 constants from titration data. Computers & Geosciences 32: pp 1344–1356

Umweltbundesamt (1988/89) Daten zur Umwelt.-Erich Schmidt Verlag; Berlin

Van Cappellen P, Wang Y (1996) Cycling of iron and manganese in surface sediments:
 American Journal of Science 296: pp 197-243

Van Gaans PFM (1989) A reconstructured, generalized and extended FORTRAN 77
 Computer code and database format for the WATEQ aqueous chemical model for
 element speciation and mineral saturation, for the use on personal computers or
 mainframes.-Computers & Geosciences, 15, No.6.

Van Genuchten MTh (1985) A general approach for modeling solute transport in structured
 soils: IAH Memoirs.- 17: pp 513-526

Vanselow AP (1932) Equilibria of the base-exchange reactions of bentonies, permutites,
 soil colloids and zeolites.- Soil Sci. 33

Wedepohl KH (Hrsg.) (1978) Handbook of Geochemistry.- Vol.II/2; Springer, Berlin-
 Heidelberg-New York

Whitfield M (1975) An improved specific interaction model for seawater at 25°C and 1
 atmosphere pressure.-Mar. Chemical, 3: pp 197-205

Whitfield M (1979) The Extension of Chemical Models for Seawater to include Trace
 Components at 24 Degrees C and 1 atm Pressure.-Geochmimica et Cosmochimica
 Acta, 39: pp 1545-1557

Wolery TJ (1992a) EQ 3/6, A software package for geochemical modeling of aqueous
 systems: Package overview and installation guide (Ver.7.0).-UCRL - MA - 110662 Pt I
 Lawrence; Livermore Natl. Lab

Wolery TJ (1992b) EQBNR, A computer program for geochemical aqueous speciation-
 solubility calculations: Theoretical manual, user´s guide, and related documentation
 (Ver.7.0).-UCRL - MA - 110662 Pt I Lawrence; Livermore Natl. Lab

Modeling of Aqueous Systems: A Comparison of Computerized Chemical Models for Equilibrium Calculations in Aqueous Systems. Am. Chem. Soc.: pp 857-892.

Nordstrom DK, Plummer LN, Langmuir D, Busenberg E, May HM, Jones BF, Parkhurst DL (1990) Revised chemical equilibrium data for major water-mineral reactions and their limitations.- In: Melchior DC, Bassett RL (eds) Chemical modeling of aqueous systems II. Columbus, OH, Am Chem Soc: pp 398-413.

Nordstrom DK, Munoz JL (1994) Geochemical Thermodynamics.- 2nd edition, Blackwell Scientific Publications

Nordstrom DK (1996) Trace metal speciation in natural waters: computational vs. analytical. Water, Air, Soil Poll 90: pp 257-267.

Nordstrom (2004) Modeling Low-temperature Geochemical Processes. Treatise on Geochemistry; Vol 5; pp 37-72, Elsevier.

Odegaard-Jensen A, Ekberg C, Meinrath G (2004) LJUNGSKILE: a program for assessing uncertainties in speciation calculations. Talanta 63 (4): pp 907-916

Parkhurst DL, Kipp KL, Engesgaard P, Charlton SR (2004) PHAST-A program for simulating ground-water flow, solute transport, and multicomponent geochemical reactions.- U S Geol. Survey Techniques and Methods 6-A8: pp 154

Parkhurst DL, Appelo CAJ (1999) User's guide to PHREEQC (Version 2) -- a computer program for speciation, batch-reaction, one-dimensional transport, and inverse geochemical calculations.- U S Geological Survey Water-Resources Investigations Report 99-4259: pp 312

Parkhurst DL (1995) User's guide to PHREEQC - A computer program for speciation, reaction-path, advective-transport, and inverse geochemical calculations.- U S Geol.Survey Water Resources Inv. Rept. 95 - 4227

Parkhurst DL, Plummer LN, Thorstenson DC (1980) PHREEQE - A computer program for geochemical calculations.-Rev.U S Geol.Survey Water Resources Inv. Rept. 80 - 96

Pinder GF, Gray WG (1977) Finite element simulation in surface and subsurface hydrology.-Academic Press; New York

Pitzer KS (1973) Thermodynamics of electrolytes. I Theoretical basis and general equations.-Jour.of Physical Chemistry, 77: pp 268-277

Pitzer KS (1981) Chemistry and Geochemistry of Solutions at high T and P -In: RICKARD & WICKMANN, 295, V 13-14

Pitzer KS (ed) (1991) Activity coefficients in electrolyte solutions. 2nd edition, CRC Press, Boca Raton, pp 542.

Planer-Friedrich B, Armienta MA, Merkel BJ (2001) Origin of arsenic in the groundwater of the Rioverde basin, Mexico; Env Geol, 40, 10: pp 1290-1298

Plummer LN, Busenberg E (1982) The solubility of Calcite, Aragonite and Vaterite in CO_2-H_2O solutions between 0 and 90°C and an evaluation of the aqueous model for the system $CaCO_3$-CO_2-H_2O. Geochimica Cosmochimica Acta 46: pp 1011-1040

Plummer LN, Wigley TML & Parkhurst DL (1978) The kinetics of calcite dissolution in CO_2 -water systems at 5 to 60 C and 0.0 to 1.0 atm CO_2: American Journal of Science 278: pp 179-216

Plummer LN, Parkhurst DL, Fleming GW, Dunkle SA (1988) A computer program incorporating Pitzer's equation for calculation of geochemical reactions in brines. U S Geol.Surv.Water Resour.Inv.Rep.88-4153

Pricket TA, Naymik TG, Lonnquist CG (1981) A „random walk" solute transport model for selected groundwater quality evaluations. Illinois State Water Survey Bulletin 65

Herbelin A, Westall JC (1999) FITEQL: A computer program for determination of chemical equilibrium constants from experimental data [computer program], v. 4.0. Dep. of Chemistry, Oregon State University, Corvallis, OR.

Hiemstra T, Van Riemsdijk WH (1996) A surface structural approach to ion adsorption: The Charge Distribution (CD) Model.- Journal of Colloid and Interface Science, 179: pp 488-508.

Hiemstra T, Van Riemsdijk WH (1999) Surface structural ion adsorption modeling of competitive binding of oxyanions by metal (hydr)oxides.- Journal of Colloid and Interface Science, 210: pp 182-193.

Hölting B (1996) Hydrogeologie.-5.Aufl., Enke

Hückel E (1925) Zur Theorie konzentrierterer wässeriger Lösungen starker Elektrolyte.-Physikalische Zeitschrift 26: pp 93-149

Johnson JW , Oelkers EH & Helgeson HC (1992) SUPCRT92: A software package for calculating the standard molal thermodynamic properties of minerals, gases, aqueous species, and reactions from 1 to 5000 bar and 0 to 1000 C - Computers and Geosciences 18: pp 899-947

Käss W (1984) Redoxmessungen im Grundwasser (II).-Dt. gewässerkdl. Mitt. 28: pp 25-27

Kharaka YK, Gunter WD, Aggarwal PK, Perkins EH, Debraal JD (1988) SOLMINEQ.88 - A Computer Program for Geochemical Modeling of Water-Rock Interactions.-Water-Resources Investigation Reports 88-4227, 420 S.

Kinzelbach W (1983) Analytische Lösungen der Schadstofftransportgleichung und ihre Anwendung auf Schadensfälle mit flüchtigen Chlorkohlenwasserstoffen.-Mitt. Inst. f. Wasserbau, Uni Stuttgart 54: pp 115-200

Kinzelbach W (1987) Numerische Methoden zur Modellierung des Transportes von Schadstoffen im Grundwasser.-Oldenbourg Verlag; München-Wien

Kipp KL (1997) Guide to the Revised Heat and Solute Transport Simulator: HST3D, version 2.- U S Geol. Survey, Water-Resources Investigations Report 97-4157: pp 149

Konikow LF, Bredehoeft JD (1978) Computer model of two-dimensional solute transport and dispersion in groundwater.-Techniques of Water-Resource Investigations, TWI 7-C2, U S Geol. Survey; Washington D C

Kovarik K (2000) Numerical models in groundwater pollution.-Springer; Berlin Heidelberg

Lau LK, Kaufman WJ, Todd DK (1959) Dispersion of a water tracer in radial laminar flow through homogenous porous media.-Hydraulic lab., University of California; Berkeley

Langmuir D (1997) Aqueous environmental geochemistry.-Prentice Hall; New Jersey

Meinrath G (1997) Neuere Erkenntnisse über geochemisch relevante Reaktionen des Urans. Wissenschaftliche Mitteilungen des Institutes für Geologie der TU Bergakademie Freiberg Bd.4:, pp 150

Merkel B (1992) Modellierung der Verwitterung carbonatischer Gesteine.-Berichte-Reports Geol.-Paläont. Inst. Univ. Kiel, Nr. 55

Merkel B, Sperling B (1996) Hydrogeochemische Stoffsysteme, Teil I - DVWK-Schriften, Bd. 110.; Komissionsvertrieb Wirtschafts- und Verlagsgesellschaft Gas und Wasser mbH, Bonn

Merkel B, Sperling B (1998) Hydrogeochemische Stoffsysteme, Teil II - DVWK-Schriften, Bd. 117.; Komissionsvertrieb Wirtschafts- und Verlagsgesellschaft Gas und Wasser mbH, Bonn

Nordstrom DK, Plummer LN, Wigley TML, Wolery TJ, Ball JW, Jenne EA, Bassett RL, Crerar DA, Florence TM, Fritz B, Hoffman M, Jr G R Holdren, Lafon GM, Mattigod SV, McDuff RE, Morel F, Reddy MM, Sposito G, Thrailkill J. (1979) Chemical

Davies CW (1938) The extent of dissociation of salts in water. VIII. An equation for the mean ionic activity coefficient of an electrolyte in water, and a revision of the dissociation constant of some sulfates.- Jour.Chem.Soc.: pp 2093-2098

Davies CW (1962) Ion Association.- Butterwoths, London: pp 190

Davis JA, Fuller CC, Cook AD (1987) A model for trace metal sorption processes at the calcite surface: adsorption of Cd^{2+} and subsequent solid solution formation.- Geochimica et Cosmochimica Acta, 51 (6): pp 1477-1490

Davis J, Kent DB (1990) Surface complexation modeling in aqueous geochemistry. In: Hochella M F, White A F (eds) Mineral-Water Interface Geochemistry.-Mineralogical Society of America, Reviews in Mineralogy 23, 5.; Washington D C

Debye P, Hückel E (1923) Zur Theorie der Elektrolyte.- Phys.Z.; 24: pp 185-206

Drever JI (1997) The Geochemistry of natural waters. Surface and groundwater environments, 3rd edition.-Prentice Hall; New Jersey

DVWK (1990) Methodensammlung zur Auswertung und Darstellung von Grundwasserbeschaffenheitsdaten.- Verlag Paul Parey; 89

Dzombak DA, Morel FMM (1990) Surface complexation modeling - Hydrous ferric oxide.- John Wiley & Sons; New York

Emsley J (1992) The Elements, 2nd edition.-Oxford University Press; New York

Faure G (1991) Inorganic chemistry - a comprehensive textbook for geology students.- Macmillan Publishing Company New York . Collier Macmillan Canada Toronto - Maxwell Macmillan International New York - Oxford - Singapore - Sydney

Fehlberg E (1969) Klassische Runge-Kutta-Formeln fünfter und siebenter Ordnung mit Schrittweiten-Kontrolle: Computing 4: pp 93-106

Fuger J, Khodakhovskyi II, Sergeyeva EJ, Medvedey VA, Navratil JD (1992) The Chemical Thermodynamics of Actinide Ions and Compounds.-Part 12, IAEA; Vienna

Gaines GL, Thomas HC (1953) Adsorption studies on clay minerals. II A formulation of the thermodynamics of exchange adsorption: Journal of Chemical Physics, 21, pp 714-718

Gapon EN (1933) Theory of exchange adsorption [russisch].-J.Gen.Chem. (USSR), 3: pp 667-669

Garrels RM, Christ CL (1965) Solutions, Minerals and Equilibria.-Jones and Barlett Publishers; Boston [Neuauflage: 1990]

Gildseth W, Habenschuss A, Spedding FH (1972) Precision measurements of densities and thermal dilation of water between 5.deg. and 80.deg. J. Chem. Eng. Data, 17 (4): pp 402-409

Grenthe I, Fuger J, Konings RJM, Lemire RI, Muller AB, Nguyen-Trung C, Wanner H (1992) The Chemical Thermodynamics of Uranium.-NEA/OECD; Paris

Gueddari M, Mannin C, Perret D, Fritz B, Tardy Y (1983) Geochemistry of brines of the Chottel Jerid in southern Tunesia. Application of Pitzer´s equations.- Chemical Geology, 39: pp 165-178

Güntelberg E (1926) Untersuchungen über Ioneninteraktion.-Z. Phys. Chem. 123: pp 199-247

Harvie CE, Weare JH (1980) The prediction of mineral solubilities in natural waters. The $Na-K-Mg-Ca-Cl-SO_4-H_2O$ system from zero to high concentrations at 25°C - Geochimica et Cosmochimica Acta, 44: pp 981-997

Hem JD (1985) Study and interpretation of the chemical characteristics of natural waters.- U S Geol. Surv. Water-Supply Paper 2254, 3rd ed.

References

Abbott MB (1966) An introduction to the method of characteristics.-American Elsevier; New York

Allison JD, Brown DS, Novo-Gradac KJ (1991) MINTEQA2, A geochemical assessment database and test cases for environmental systems: Vers.3.0 user's manual.-Report EPA/600/3-91/-21. Athens, GA: U S EPA

Alloway, Ayres (1996) Schadstoffe in der Umwelt.-Spektrum Akademischer Verlag; Heidelberg

Appelo CAJ, Postma D (1994) Geochemistry, groundwater and pollution.- Balkema; Rotterdam

Appelo CAJ, Postma D (2005) Geochemistry, groundwater and pollution, 2nd edition.- Balkema; Rotterdam

Appelo CAJ, Beekman HE and Oosterbaan AWA (1984) Hydrochemistry of springs from dolomite reefs in the southern Alps of Northern Italy: International Association of Hydrology.- Scientific Publication 150: pp 125-138

Ball JW, Nordstrom DK (1991) User's Manual for WATEQ4F -US Geological Survey Open-File Report pp 91-183

Bernhardt H, Berth P, Blomeyer KF, Eberle SH, Ernst W, Förstner U, Hamm A, Janicke W, Kandler J, Kanowski S, Kleiser HH, Koppe P, Pogenorth HJ, Reichert JK, Stehfest H (1984) NTA - Studie über die aquatische Verträglichkeit von Nitrilotriacetat (NTA).- Verlag Hans Richarz, Sankt Augustin

Besmann TM (1977) SOLGASMIX-PV, A computer program to calculate equilibrium relationships in complex chemical systems. ORNL/TM-5775

Bohn HL, McNeak BL, O'Connor GA (1979) Soil Chemistry.-Wiley-Interscience; New York

Bunzl K, Schmidt W, Sansoni B (1976) Kinetics of ion exchange in soil organic matter. IV Adsorption and desorption of Pb^{2+}, Cu^{2+}, Cd^{2+}, Zn^{2+} and Ca^{2+} by peat.-J Soil Sci., 17: 32-41; Oxford

Cash JR, Karp AH (1990) A Variable Order Runge-Kutta Method for Initial Value Problems with Rapidly Varying Right-Hand Sides: Transactions on Mathematical Software 16, 3: pp 201-222

Chang TL, Li W (1990) A calibrated measurement of the atomic weight of carbon.- Chin. Sci. Bull. 35, 290-296.

Chukhlantsev VG (1956) Solubility-products of arsenates.- Journal of Inorganic Chemistry (USSR) 1: pp 1975-1982

Clark ID, Fritz P (1997) Environmental isotopes in hydrogeology.- New York, Lewis Publishers

Cook PG, Herczeg AL (eds.) (2000) Environmental Tracers in Subsurface Hydrology.- KluwerAcademic Press, Boston

To solve the third task, just add the following block in the PHREEQC control file within the first section (before the first END statement):

SURFACE_SPECIES
UO2(CO3)-2

 Hfo_wOH + UO2(CO3)2-2 + H+ = Hfo_wUO2(CO3)2- + H2O
 log_k 12.0

 Hfo_wOH + UO2(CO3)2-2 = Hfo_wOHUO2(CO3)2-2
 log_k 5.0

No changes have to be made to the WPHAST-input file. Rerun the PHAST model and you will see that much more uranium is sorbed than in the introductory example (log_k for $UO_2(CO_3)^{2-}$ are preliminary data only) and the arsenic sorption is less due to competitive surface reactions. The input files and the results can be seen in the folder 3_Reactive-transport/6c_3D-transport.

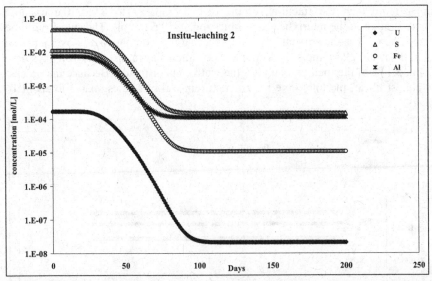

Fig. 93 Simulated concentration at the pumping well over a period of 200 days (fracture volume 0.05, pore volume 0.05, 1 cm of pore matrix connected to the fracture)

4.3.6 3D Transport – Uranium and arsenic contamination plume

The first task is very simple: just open in the WPHAST GUI the *INITIAL_CONDITONS* and *CHEMISTRY_IC*, then double-click *Default* and delete the 1 under *surface*. You may as well remove the surface statement from the file *.chem.dat, but even without removing this statement in the PHREEQC-Files the model does not take into account any surface complexation after the one single change in the phast-input file. Input files and the results can be seen on the enclosed CD in the folder 3_Reactive-transport/6a_3D-transport.

The solution of the second task is as follows: In addition to generating a new property (zone 5 with EQUILIBRIUM_PHASES 2) within WPAST the relating change has to be made in the *.chem.dat file:

USE Solution 1
Phases; Iron; Fe +2.0000 H+ +0.5000 O2 = + 1.0000 Fe+2 + 1.0000 H2O
log_k 59.0325; -delta_H -372.029 kJ/mol

EQUILIBRIUM_PHASES 2; Iron ; Uraninite(c) 0 0; Calcite 0 0; pyrite 0 0
END

The input files and the results can be seen in the folder 3_Reactive-transport/6b_3D-transport.

times more than the fracture volume (0.15 compared to 0.05), the uranium concentration in the matrix is also 3 times higher (9.6 mmol). The sum from time steps 21 to 201 is the amount of uranium discharged from the matrix over a period of 180 days (0.298 mmol). This simple calculation shows that after 180 days only about 3.1 % of the total uranium left the matrix via diffusion. Because the process is almost linear, the total time for uranium removal can be estimated to about 16 years.

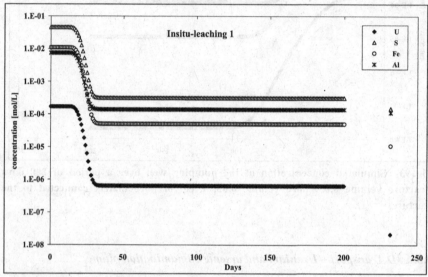

Fig. 92 Simulated concentration at the pumping well over a period of 200 days (fracture volume 0.05, pore volume 0.15, 10 cm of pore matrix connected to the fracture), points on the right side mark the target concentrations.

Changing the parameters as required by the exercise, the following value for the exchange parameter results:

$$\alpha = \frac{D_e \theta_{im}}{\left(af_{s \to 1}\right)^2} = \frac{2 \cdot 10^{-10} \cdot 0.05}{\left(0.01 \cdot 0.533\right)^2} = 3.52 \cdot 10^{-7}$$

If this value is used for modeling together with the smaller value for the size of the connected matrix with 0.01 m, the discharge behavior looks completely different (Fig. 93) For instance the uranium concentration has dropped to the groundwater values already after 100 days, all uranium is removed.

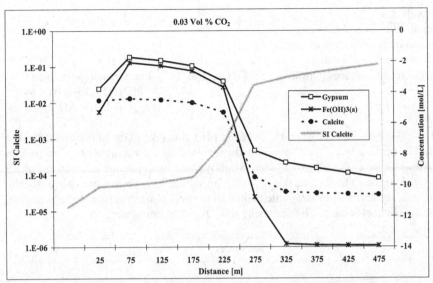

Fig. 91 **Dissolution of calcite, precipitation of gypsum and iron hydroxides, and the development of the calcite saturation index for the AMD water shown in Fig. 90**

4.3.5 In-situ leaching

The fracture system is modeled as a 1D aquifer with high permeability (20 mobile cells with the numbers 1-20), each one connected to immobile cells (number 22-41, number 21 is) reserved for the column's discharge). The content of the immobile cells can only be transferred to the mobile cells by diffusion. The value for α is calculated from Eq. 102 assuming $D_e = 2 \cdot 10^{-10}$ m²/s (range from $3 \cdot 10^{-10}$ to $2 \cdot 10^{-9}$ for ions in water, approximately one order of magnitude less for water in clays), $\theta_{im} = 0.15$, a = 0.1 m (thickness of the stagnant zone accompanying the fracture), and $f_{s \to 1} = 0.533$ (Table 16)

$$\alpha = \frac{D_e \theta_{im}}{\left(a f_{s \to 1}\right)^2} = \frac{2 \cdot 10^{-10} \cdot 0.15}{\left(0.1 \cdot 0.533\right)^2} = 1.056 \cdot 10^{-8}$$

The fracture volume θ_m was set to 0.05, the pore volume θ_{im} to 0.15.

Already after 30 days the concentrations for the depicted elements U, S, Fe, and Al drop. Further in the simulation the decrease is much smaller (Fig. 92). At the end of the data record, at a fictitious time of 230 days, the concentration of the groundwater is shown as a target value. However, to get down to this concentration, the simulation would have to be continued for many more years because of the slow diffusive transfer of contaminants from the immobile to the mobile cells.

Summing up the uranium concentrations for the time steps 1 to 20 gives the amount of uranium in the fractures (3.2 mmol). Because the pore volume is 3

-totals Ca C Fe
-molalities SO4-2 CaSO4
-saturation_indices gypsum calcite
-kinetic_reactants calcite # how much calcite is dissolved by KINETICS?
-equilibrium_phases gypsum Fe(OH)3(a) # how much gypsum and
 # Fe(OH)3 is dissolved by
 # EQUILIBRIUM?

Fig. 90 shows that the largest changes in pH value take place in the middle of the carbonate channel. There, also the decrease of iron concentrations due to iron hydroxide precipitation takes place. Slightly more moderate are the increase of Ca by calcite dissolution and the decrease of sulfate by gypsum precipitation. The significant decrease of inorganic carbon in the acid mine drainage at the beginning of the channel is caused by degassing of CO_2 to the atmosphere.

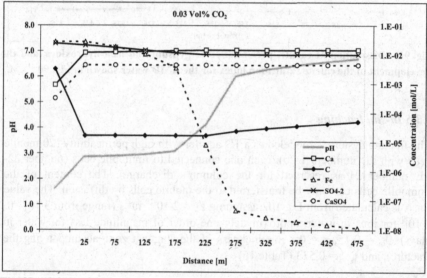

Fig. 90 Concentration changes in an acid mine water while flowing through a 500 m long carbonate channel

Fig. 91 shows the saturation index for calcite, which increases from almost -12 to about -2.27 in acid mine water, but does not reach saturation. Furthermore, the figure depicts the amounts of dissolved calcite in mol as well as the amounts of precipitated gypsum and iron hydroxide over the simulation time. It can be seen that a channel of 300 m would have a very similar treatment effect as the one modeled of 500 m length. Yet, modeling of gypsum and iron hydroxide precipitation was done without considering kinetics, but assuming a spontaneous precipitation. The modeling with a partial pressure of 1 vol% CO_2 shows the same behavior at lower pH values (approx. 0.5 pH units) and higher carbon contents.

even in the last cell the equilibrium is not reached yet, and thus, carbonate is still dissolved in small quantities (corrosion).

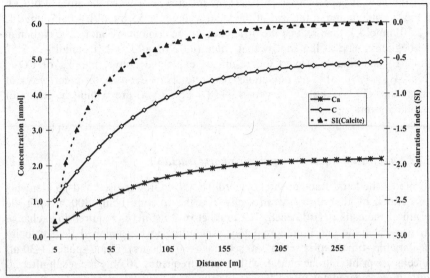

Fig. 89 Corrosion in a fracture showing convergence to the calcite equilibrium with increasing distance

4.3.4 The pH increase of an acid mine water

The acid mine water is defined as SOLUTION 0 and the water in the carbonate channel as SOLUTION 1. Within the keyword KINETICS 1-10 the calculation tolerance as well as the initial and the total mole mass of calcite can be defined. Obligatory are only the parameters 50 and 0.6. These are needed by the BASIC program, which must be implemented within the keyword RATES. Here, we use the BASIC program listed at the end of the database PHREEQC.dat. If the database PHREEQC.dat is used (which is not free of troubles, since there are, e.g., no data for uranium) or if the paragraph is copied into another database, it is not necessary to define a RATES block in the input file. PHREEQC uses automatically the RATES block from the database. Yet, if any other kinetic rates are to be used, the BASIC program must be copied into the input file under RATES. In any case, the KINETICS block is required.

Using the keyword TRANSPORT the model is built from 10 cells and 15 shifts. Flow velocity is defined to 1 m/s by setting -length and -time_step to 50. By that, the total length of the channel is 500 m and the total exposure time 500 s. To get the required information in a selected output file, the input definition must look as follows:

```
SELECTED_OUTPUT
-file    amd_kin.csv
```

the end of the channel but was not precipitated, must be the quantity released: 873.72 kg C/a - 402.58 kg C/a = 471.14 kg C/a or 1727.5 kg of CO_2/a. Alternatively, it is possible to calculate the difference between the amount of CO_2 at the beginning and at the end of the karst channel (2.55 mmol/L - 0.45 mmol/L = 2.10 mmol/L), then reduce the difference of the contents of inorganic carbon at the beginning and at the end by that value (4.62 mmol/L - 2.10 mmol/L = 2.52 mmol/L) and finally convert the result, as explained above, into kg of CO_2/a (1748.4 kg CO_2 /a). The deviations resulting from the two different ways of calculation (1727.5 kg CO_2/a versus 1748.4 kg CO_2/a) are within the limits of rounding errors.

4.3.3 Karstification (corrosion along a karst fracture)

To model the karst fracture the keyword TRANSPORT is used and 30 elements are defined by the sub keyword -cells. For the fracture being 300 m long the length of the cells is 10 m each. The number of 30 shifts is required to exchange the water volume one time completely. According to the assumed flow velocity the variable -time step is set to 360 seconds (= 0.1 hours). Using -punch 1-30 all 30 cells are printed in the output, with -punch frequency 30 only the result after 30 shifts is considered for all of those 30 cells. The adjustment of the equilibrium during transport can be done using EQUILIBRIUM_PHASES. It is important to add 1-30 behind the keywords SOLUTION, EQUILIBRIUM_PHASES, and KINETICS in order to consider all 30 cells.

By using the keyword USER_GRAPH, data are directly written to the spreadsheet GRID within PHREEQC and the graph is created automatically in the folder CHART. The script is as follows:

```
USER_GRAPH
-headings x Ca C SI(calcite)
-chart_title Karstification
-axis_titles "distance [m]" "concentration [mol] and SI-calcite"
-axis_scale y_axis 0 0.005
-axis_scale secondary_y_axis -3   0.0  1.0
-initial_solutions false
-plot_concentration_vs x
10 GRAPH_X DIST
20 GRAPH_Y tot("Ca"), tot("C")
30 GRAPH_SY SI("Calcite")
```

To display the secondary Y-axis for the calcite saturation index besides the primary Y-axis with the concentrations for Ca and C, "Chart options"/"Show secondary y-axis" must be chosen by click on the right mouse button in the graph. The result of the modeling can be seen in Fig. 89. The figure depicts a convergence to the calcite equilibrium. However, the saturation index shows that

to simply use the analysis of the water flowing in the karst channel. The same analysis is used as SOLUTION 0 (input solution). The only difference is that for the kinetic transport modeling the partial pressures for CO_2 and O_2 are adjusted to atmospheric conditions by means of EQUILIBRIUM_PHASES 1-40. It is important that also within the keywords KINETICS, RATES, and TRANSPORT all 40 cells are considered. A number of 50 shifts is sufficient for the complete exchange of the water, after which a steady state is attained. The results of PHREEQC always refer to one liter of water. Thus, the respective conversions must be done; from the stated value in mol calcite/L · 0.5 L/s (discharge) · 86400 · 365 s/a to mol calcite/a, and then from mol calcite/a · 100 g/mol to g calcite/a.

The result of the modeling is depicted in Fig. 88 as the precipitated amount of calcite per year in kg/a for the modeled 400 m in the karst channel after the discharge. The calcite supersaturation decreases within 400 m respectively 27 minutes from 1.58 to 0.16. Despite of the small discharge of 0.5 L/s, the amount of precipitation is 3354.85 kg of calcite per year within the first 400 m with an associated release of 1727.5 kg of CO_2 into the atmosphere.

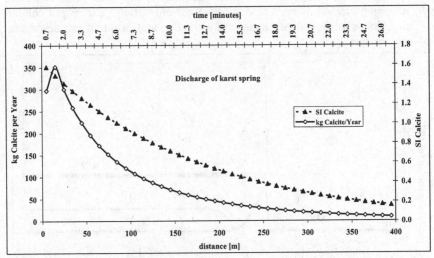

Fig. 88 **Calcite saturation index and amount of calcite precipitated per year for a discharge of 0.5 L/s in a 400 m long karst channel with a flow velocity of 0.25 m/s assuming turbulent mixing ($P(CO_2) = 0.03$ Vol%).**

The amount of CO_2 can be calculated from the difference of the concentrations of inorganic carbon dioxide at the beginning (6.64 mmol/L) and at the end of the channel (2.02 mmol/L). This amount is 4.62 mmol/L or 873.72 kg C/a. Furthermore, it is known that 3354.85 kg of calcite precipitate per year, which amounts to 402.58 kg of carbon per year (3354.85 kg/a/100 mol/L (molecular weight of $CaCO_3$)·12 mol/L (molecular weight of carbon)). The difference between the initial carbon concentration and the concentration, that is lacking at

4.3 Reactive transport

4.3.1 Lysimeter

Fig. 87 shows the concentration distribution of Ca, Mg, K, Cl, Fe, and Cd in the lysimeter column. Chloride behaves like an ideal tracer and flows through the lysimeter column only influenced by dispersion. Iron apparently does the same, but this is an artifact because no selectivity constant is defined for the predominating species Fe^{3+}. There is one selectivity constant defined for Fe^{2+}, but this species only occurs in negligible amounts (1.459e-07 mol/L). Calcium and magnesium are preferably exchanged for cadmium. This leads to the peaks, occurring after one complete column exchange, that are the sum of the concentrations in the initial water and the acid mine water. As soon as calcium and magnesium are completely exchanged for cadmium, the concentrations decrease to the level of the acid mine water, which is further added to the column. Cadmium only appears at the column's outlet, when all exchanger sites are occupied, i.e. when the entire volume of the column is exchanged 1.5 times. Thereby, Cd^{2+} ions occupy both the exchanger sites of Mg^{2+} and of Ca^{2+}. That is why cadmium already appears after 1.5 and not only after 2 exchanged column volumes. Potassium is only exchanged to a small extent, sorption and desorption balance one another.

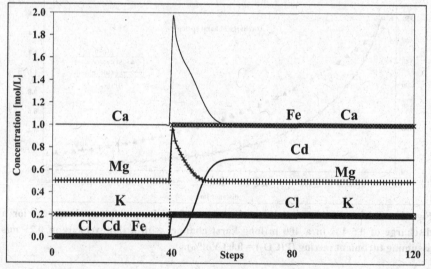

Fig. 87 Concentration distribution of Ca, Mg, K, Cl, Fe, and Cd in the lysimeter column

4.3.2 Karst spring discharge

Using the keyword TRANSPORT, PHREEQC always expects an initial solution in the cells, defined as SOLUTION 1-n (here: 1-40). For this exercise it is possible

concentration over a period of 5 years is used (climate station: 06/1962 - 06/1967 1022 TU). The "punch frequency" under the keyword TRANSPORT must be changed from 10 to 5, since every fifth time step (5 years) shall be printed in the output. The six further solutions from 1967-1997 with decreasing tritium concentrations are used as SOLUTION 0 instead of the modeling "30 years no tritium". The jobs are added one after another, separated by END. The definition of the transport parameters (number and length of the cells, time steps etc.) must only be done once, when the keyword TRANSPORT is used for the first time (for the modeling of the first 5 years). For the modeling of the further 6 times 5 years only the keyword TRANSPORT is sufficient, all parameters defined in there are taken over from the first definition.

Fig. 86 shows the modeled tritium concentrations in the unsaturated zone after 5, 10, 15, 20, 25, 30, and 35 years. Contrary to the modeling with an impulse-like tritium input (Fig. 59) the concentrations in the uppermost meters of the soil do not immediately drop back to zero because some tritium-containing water continues to infiltrate, even though with lower tritium concentrations. Thus, the tritium peaks do not show a symmetrical curve as with the impulse-like input, but a slightly left-sided distribution.

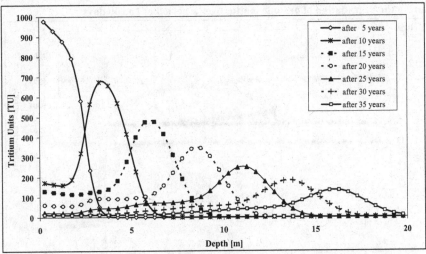

Fig. 86 Vertical cross section of tritium in the unsaturated zone (0-20 m depth) for the climate station Hof-Hohensaas, Germany after 5, 10, 15, 20, 25, 30, and 35 years

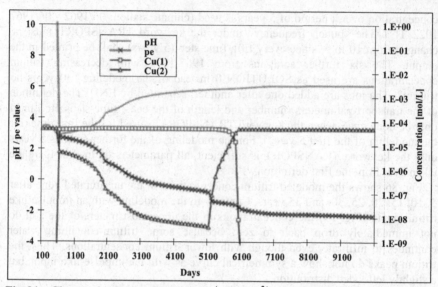

Fig. 84 Changes in the speciation of Cu^+ and Cu^{2+} in relation to pE and pH values during the degradation of organic matter over a period of 10,000 days

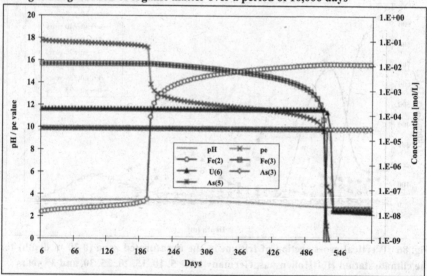

Fig. 85 Changes in the speciation of iron, arsenic, and uranium compared to pE and pH values during the degradation of organic matter over a period of 600 days

4.2.4 Degradation of tritium in the unsaturated zone

Instead of the fictitious initial solution given in the example of an impulse-like input function of a tritium concentration of 2,000 T.U., a solution of the averaged

is available over the whole period of time, in contrast to calcite, which is already consumed during the first reaction step. The continuous increase of inorganic carbon results from the formation of CO_2 by the degradation of organic matter. Regarding CO_2 the model assumes a closed system: CO_2 degassing is excluded. The overall influence of calcite is rather small. It causes the pH increase at the beginning of the modeling from 2.3 to 3.39 and has influence on the time of calcite precipitation. Since at the beginning only a small amount of calcite is dissolved, the saturation index of gypsum stays in equilibrium and no precipitation of gypsum was considered.

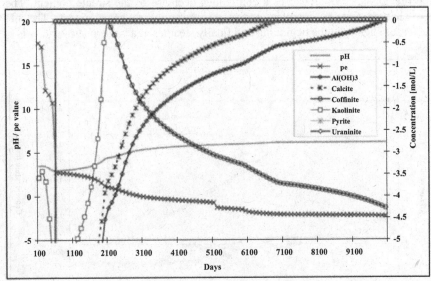

Fig. 83 Selected saturation indices compared to pE and pH values during the degradation of organic matter over a period of 10,000 days

Manganese does not change during the whole time of modeling and occurs as Mn^{2+}. Copper behaves in a different way; it is in the end responsible for the sudden changes in the pE value. The occurrence of Cu(1) together with As(3) (Fig. 84) and the re-transformation into Cu(2) at pE-values below -1.87 is also interesting.

For a closer look on the reactions at the beginning of the degradation, the modeling was redone with unchanged boundary conditions in 100 time steps for a period of 600 days. Fig. 85 shows better than Fig. 82 and Fig. 83 the stepwise decrease of the pE value. The first drop is related to the occurrence of Fe(2), the second to the elimination of Fe(3) and the reduction of As(5) to As(3). Shortly after that the reduction of U(6) to U(4) occurs. In the model uraninite and coffinite precipitate spontaneously and hence the uranium concentrations are significantly reduced.

saturation for K-feldspar in all four models, the simulation time would have to be about 1,000 years.

4.2.3 Degradation of organic matter within the aquifer on reduction of redox-sensitive elements (Fe, As, U, Cu, Mn, S)

At the beginning of the degradation of organic matter the pE-value decreases significantly (Fig. 82). During this decrease the sulfate contents increase by the dissolution of pyrite. From a pE value of +2.7 onwards pyrite is supersaturated and precipitates, which causes a continuous decrease of the sulfate content. The zero-charged $CaSO_4^0$ complex copies this behavior to some extent. The pH decreases slightly at the beginning and finally steadies at a value just over 6.

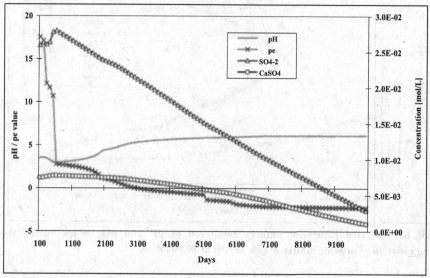

Fig. 82 pH, pE, and sulfate concentration over a period of 10,000 days (approximately 27 years) by degradation of organic matter

Fig. 83 shows the undersaturation of some mineral phases of interest. If the saturation index is attained, the respective mineral is precipitated by the model and acts as a limiting phase (kinetics are not considered). The possible limitation by coffinite, uraninite, and pyrite from 500 days onwards (not distinguishable in the figure; coffinite is not a limiting mineral phase any more from 2000 days on; furthermore it is questionable that coeffinite forms under these conditions) is remarkable. Kaolinite is supersaturated after 2,000, calcite after 7,000, and Al(OH)₃ after 10,000 days. Jurbanite is supersaturated from the beginning on. An important statement is that, at least under the defined boundary conditions, pyrite can form simultaneously with uranium minerals from a pE value of approximately 2.7 and lower. Before that, the occurrence of pyrite has no significant influence on the concentration of uranium. Moreover, it is important to note that organic matter

defined by the sub keyword -step. This step is done only once and it does not matter for which mineral. Numerical problems must be solved by choosing suitable parameters for -tol and -step divide.

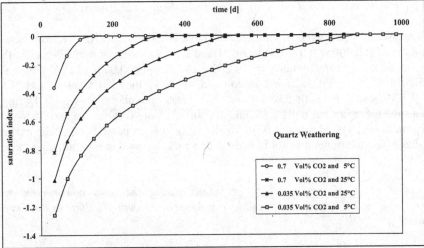

Fig. 80 Kinetics of the dissolution of quartz for four models with different temperatures and partial pressures

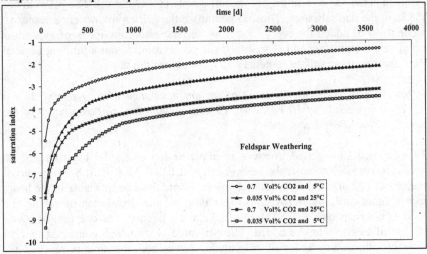

Fig. 81 Kinetics of the dissolution of K-feldspar for four models with different temperatures and partial pressures

Fig. 80 and Fig. 81 show, that both quartz and K-feldspar show different dissolution kinetics depending on temperature and CO_2 partial pressure. The difference between quartz and K-feldspar is significant: while quartz reaches dissolution equilibrium after 150 to 550 days, K-feldspar does not show any equilibration even after 10 years for all of the four possible scenarios. To reach

means the trivalent iron mainly remains in solution through complexation reactions.

3. How many years will it take until all pyrite in the heap is exhausted?

To answer this question one does not even have to use PHREEQC. The heap has a volume of 100,000 m^3 (100·100·10 m). 2% of it are 2,000 m^3 of pyrite, which with a density of 5.1 t/m^3 mounts to 10.200 t or 10,200,000,000 g/119.8 g/mol = 85,141,903 mol. With a pyrite dissolution of 1.347 mol/d it takes 85,141,903 mol/1.347 mol/d = 63,208,539 days or 173,2 years until all pyrite is gone. During that time the water has a pH 2.65, and contains 215 mg/L of sulfate and 75 mg/L of iron (as Fe(II)). This result is only valid if there is no passivation of the pyrite surfaces and the mineral is not imbedded in a rock matrix that is weathering more slowly.

4. How much carbonate has to be added during the heap construction to neutralise the pH value? Is it possible to reduce the amount of sulfate at the same time?

The existing input file is extended by setting up equilibrium not only with pyrite but also with calcite. 2.621 mmol of calcite dissolve. The amount of pyrite dissolved is the same as in the absence of calcite (1.347 mmol). The pH value of 7.58 is in the neutral range. Thus, to neutralize the pH approximately 2 moles of calcite must be added for every mol of pyrite. The saturation index of gypsum is still clearly undersaturated (SI = -1.09), i.e. that gypsum is not a limiting mineral phase and hence the sulfate contents stay more or less the same.

5. How does the necessary amount of carbonate change when assuming that a CO$_2$ partial pressure of 10 Vol% will develop within the heap as a result of the decomposition of organic matter?

The increased CO$_2$ partial pressure is implemented using the logarithm of its partial pressure in bar under the keyword EQUILIBRIUM_PHASES. For a partial pressure of 10 vol% CO$_2$ considerably more calcite must be available in the heap, since a significant amount of the CO$_2$ is used for the dissolution of calcite. To reach equilibrium now 6.288 mmol of calcite are needed. For one mol of pyrite 4.7 mol of calcite must be added. The pH value is with 6.65 compared to 7.58 lower by almost one order of magnitude. Again no saturation is reached for gypsum.

4.2.2 Quartz-feldspar-dissolution

The input file for the solution of this task consists of the keywords SOLUTION, EQUILIBRIUM_PHASES, KINETICS, RATES, and SELECTED_OUTPUT. In the KINETICS block the total time in seconds and the number of steps must be

2. What happens when water at the foot of the heap is in contact with atmospheric oxygen?

To answer this question, the result of question 1 has to be saved in the PHREEQC input file with SAVE_SOLUTION 3, recalled in a new job by USE_SOLUTION 3, and subsequently equilibrium with the atmospheric partial pressure has to be adjusted.

The divalent iron is oxidized by atmospheric oxygen into trivalent iron, but only 13% of this iron occurs as free Fe^{3+} cation. The rest is bound in hydroxo and sulfur complexes (Fig. 79).

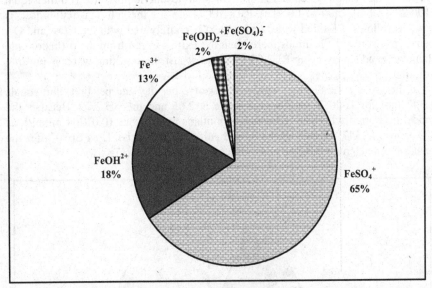

Fig. 79 Species distribution for iron in the oxidation state +3 in the seepage water discharging at the foot of the heap along the base sealing

After the reaction the following minerals are close to saturation or supersaturated (Table 52).

Table 52 Saturation index for some mineral phases after the discharge of the seepage water at the foot of the heap along the base sealing and after contact with atmospheric oxygen

Mineral	SI	Mineral	SI	Mineral	SI
$Fe(OH)_3(a)$	-0.41	JarositeH	-0.27	Goethite	5.48
Magnetite	-0.4	Maghemite	2.57	Hematite	11.93

Amorphous iron hydroxide, which precipitates rather spontaneously, is still undersaturated. Maghemite, goethite, and hematite do not usually precipitate spontaneously, but form as secondary mineral phases from hydroxides. That

4.2 Reaction kinetics

4.2.1 Pyrite weathering

Question 1: What is the chemical composition of the seepage water discharging at the foot of the heap along the base sealing?

The heap is covering an area of $100 \cdot 100 = 10,000 \text{ m}^2$. Hence, with a daily infiltration rate of 0.1 mm, 1000 liter of rainwater infiltrate every day. The volume of 0.1 m^3 O_2 equals 100 liter O_2 that are entering the heap each day by diffusion. Because one mol of gas equals 22.4 L gas at atmospheric pressure, 100 liter equal (100/22.4) 4.463 mol of O_2. The PHREEQC job for the solution of this task is done as follows: Distilled water (rainwater) is equilibrated with the CO_2- and O_2-partial pressures of the atmosphere, then the extra oxygen from the diffusion into the heap is added by using REACTION and at last the resulting water is put into equilibrium with pyrite.

In the process 1.347 mmol of pyrite dissolve per day and per liter, that equals 1.347 mol for 1000 liters. The pH value is 2.65 and the pE 2.79. Because the modeling started with distilled water, it contains only carbon (0.01704 mmol/L as CO_2), iron (1.347 mmol/L as Fe^{II}), and sulfur (2.695 mmol/L as S(6)) after the reaction. The element S(6) occurs in the following species (Fig. 78):

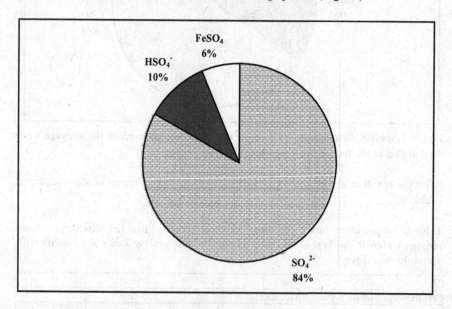

Fig. 78 **Species distribution for sulfur in the oxidation state +6 in the seepage water discharging at the foot of the heap along the base sealing**

mmol/L $UO_2(a)$ will precipitate, that is 30.1 mg/L, or 82.4 kg/m^2 for a flow-through of 500 L/d·m^2 in 15 years.

4.1.6.3 Increase in pH through a calcite barrier

By setting up a reactive calcite barrier in the aquifer, the pH value of the initial acid mine water is increased from 2.3 to 6.25 at a calcite saturation of 50%. Hereby, 17.3 mmol/L or 1.73 g/L calcite dissolves, i.e. for a flow of 500 L/d·m^2 this amount is 1.73 g/L · 500 L/d·m^2 = 865 g/d·m^2. The available 2500 kg/m^2 of calcite would thus be sufficient for 2500 kg/m^2 : 865 g/d·m^2 = 2890 days or 7.9 years, before the calcite barrier would be completely dissolved.

Yet after the reaction with calcite the water is strongly supersaturated with regard to gypsum, which consequently must be precipitated. After the precipitation of gypsum the pH is even slightly higher (6.356) than for pure reaction with calcite, 20.8 mmol/L, or 2.08 g/L of calcite dissolve. At a rate of 500 L/d·m^2 there would be 1040 g/d, i.e. it would take only 2402 days or 6.6 years until the barrier is completely consumed. Far more complicated is the precipitation of 17.5 mmol/L or 2.38 g/L of gypsum. For the assumed flow of 500 L/d·m^2 this quantity is 1190 g of gypsum precipitating each day, forming a coating on the calcite barrier, decreasing the permeability and thereby obstructing or even completely preventing any further calcite dissolution.

Alternatively dolomite (as a mixed mineral of Mg and Ca carbonate) or pure Mg carbonate (magnesite) could be used. Dolomite causes a pH increase to 6.439 dissolving 11.45 mmol/L or 2.11 g/L of dolomite. For a flow of 500 L/d·m^2 there are 1050 g/d, using up the supply of 2500 kg dolomite within 2500 kg : 1050 g/d = 2373 days or 6.5 years. As for the reaction with calcite, gypsum becomes supersaturated (SI gypsum = 0.26) and will precipitate. The resultant pH is 6.470 and dolomite dissolution is 12.15 mmol/L = 2.24 g/L (complete dissolution of the dolomite barrier after 2237 days or 6.1 year). Gypsum precipitation produces 9.475 mmol/L or 1.29 g/L gypsum, which is a reduction of 644.3 g/d (at a flow of 500 L/d·m^2) compared to the pure calcite barrier, even though it is still too much for an effective long-term run of the reactive barrier.

For a pure magnesite barrier the pH increases to 6.533. Gypsum stays slightly undersaturated (SI = -0.08), thus is not precipitating and not forming problematic incrustations. An amount of 26.4 mmol/L or 2.22 g/L of magnesite is dissolved, resulting in an average life of 2252 days or 6.2 years. The higher cost for pure magnesite can be justified by the long-term effectiveness compared to a calcite or dolomite barrier.

Already upon addition of small amounts of methanol (<1 mmol/L) a significant decomposition of NO_3 to N_2 occurs, the pE being in the oxidizing range (12 to 14). With 1.345 mmol/L methanol, the nitrate concentration decreases from 1.614 mmol/L to 0.155 μmol/L N(5) by more than 4 orders of magnitude. If the addition is further increased, the pE value drops notably (pE approx. -2) and N_2 is further reduced to NH_4^+, which is an undesirable side effect for the groundwater rehabilitation.

Thus, 1.345 mmol/L CH_3OH is the necessary amount for a total reduction of nitrate. Methanol has a density of 0.7 g/cm^3 = 700 g/dm^3 = 700 g/L and a molecular weight of 32 g/mol, therefore a 100% methanol-solution has 700g/L : 32 g/mol = 21.875 mol CH_3OH per liter of methanol solution. Thus 1.345 mmol CH_3OH per liter of groundwater : 21875 mmol CH_3OH per liter of methanol solution = $6.15 \cdot 10^{-5}$ L methanol solution per liter groundwater are required, or related to 1 m^3 groundwater 0.06 L of a 100% methanol solution.

4.1.6.2 Fe(0) barriers

Like in the previous exercise (3.1.6.1) the question about the dimension of the reactive iron barrier and the corresponding uraninite precipitation must be solved iteratively. Elemental iron is added step by step via the keyword REACTION and the saturation index of uraninite is registered. If for instance 1, 2, 3, 4, and 5 mmol/L of Fe are added, the following saturation indices are obtained: -14.3401, -13.6202, -12.8359, -11.3031, +9.5288, i.e. uraninite gets supersaturated when adding between 4 and 5 mmol/L of Fe. Further refining the range, one can assess the supersaturation at 4.40 mmol/L. The results in Table 51 are obtained, promoting uraninite precipitation and registering the amount of dissolved uranium after the reduction of U(VI) to U(IV) by Fe and the subsequent precipitation as (probably amorphous) UO_2.

Table 51 Decrease of the uranium concentration using Fe^0 barriers of different iron concentrations

Fe [mmol/L] in reactive barrier	4.40	4.42	4.43	4.44	4.46	4.48
U [mol/L] in solution after reaction	8.7366 e-05	6.7663 e-05	5.7854 e-05	4.8089 e-05	2.8811 e-05	1.0582 e-05
U [mg/L] in solution after reaction	20.79	16.10	13.77	11.45	6.86	2.52

Since the requirement was to reduce uranium at least to one third of the initial quantity of 40 mg/L, the target concentration is 13 mg/L. Thus, at least 4.43 mmol/L = 247.4 mg/L of Fe have to be available. Assuming a flow-through of 500 L/dm² these are 247.4 mg/L · 500 L/d·m² = 123.7 g/d·m². Furthermore, if the barrier is to be in effective operation for about 15 years (5475 days) then 123.7 g/d·m² · 5475 d = 677.3 kg of Fe per m² must be used. During operation 0.1115

50:50	6.81	6.93	-0.12	2.395	230.03	0.577	35.78
60:40	6.79	6.95	-0.16	2.333	224.08	0.467	28.95
70:30	6.76	6.98	**-0.22**	2.270	218.03	0.356	22.05
80:20	6.74	7.01	**-0.27**	2.208	212.07	0.246	15.28
90:10	6.72	7.04	**-0.32**	2.146	206.12	0.136	8.45
100:0	6.70	7.08	**-0.38**	2.083	200.07	0.024	1.50

If the proportion of the water from the old well is too high, the mixed water shows sulfate and nitrate concentrations exceeding drinking water standards (bold), if it is too low, the mixture is calcite aggressive (bold), which may lead to pipe corrosion. The optimum ratio is between 40 : 60 to 60:40, where the water can be discharged to the drinking water distribution network without further treatment.

4.1.6 Rehabilitation of groundwater

4.1.6.1 Reduction of nitrate with methanol

To determine the amount of methanol required to reduce the nitrate, one has to proceed iteratively, i.e. a certain amount of methanol is added step by step using the keyword REACTION (e.g. 0.1 1 5 10 50 100 mmol/L) and according to the results the step width is refined. In this example a higher resolution was chosen between 1.3 and 1.35 mmol/L. The following result is obtained (Fig. 77).

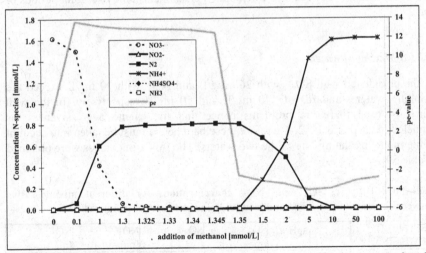

Fig. 77 Successive reduction of penta-valent NO_3 in an aquifer into zero valent N_2 and -3-valent NH_4^+ by addition of methanol (the species NO_2^-, $NH_4SO_4^-$, NH_3 occur in trace amounts only)

occur for Fe(II). For $P(O_2) = 1$ Vol% Fe (II) is at $3.019 \cdot 10^{-14}$ mol/L and for $P(O_2)$ = 100 Vol% at $9.547 \cdot 10^{-15}$ mol/L.

The pH value of 6.462 after aeration is too low according to the drinking water standards. Further water treatment is required.

The amounts of the precipitating mineral phases $Al(OH)_3(a)$ and $Fe(OH)_3(a)$ can be found under "phase assemblage". Multiplying these concentrations (in mol/L) with the molecular weight in g/mol and the production rate of the waterworks (in L/s) one gets a concentration (in g/s), which in turn can be transformed into kg/d (Table 49).

Table 49 Accumulating amounts of sludge resulting from the precipitation of $Al(OH)_3$ and $Fe(OH)_3$

	mol/L	mole mass	yield	kg/day
$Al(OH)_3(a)$	$6.139 \cdot 10^{-6}$	78	30 L/s	1.24
$Fe(OH)_3(a)$	$4.425 \cdot 10^{-6}$	106.8		1.22

The amount of sludge, resulting from precipitation of Al- and Fe-hydroxides, sums up to 2.46 kg/d of dry mineral phases. Considering the high content of water in the sludge yields a factor of 2.5 (for 60% water content) to 10 (for 90% water content) and an amount of sludge of 6.15 kg/d or 24.6 kg/d, or about 185 - 740 kg/month.

In the simulation, N and S are completely oxidized, which is not necessarily true for a water treatment plant, since redox reactions show appreciable kinetics (slow reactions). Partly reduced forms may persist metastable over long periods of time.

4.1.5.5 Mixing of waters

In the abandoned well SO_4^{2-} with 260 mg/L and NO_3^- with 70 mg/L exceed the drinking water standards of 240 mg/L and 50 mg/L respectively. In the well currently used there are problems concerning the calcite aggressiveness, as modeled in chapter 3.1.5.2. Therefore these parameters must be taken into account while modeling the mixing of the two waters. The following values were obtained (Table 50).

Table 50 pH, pHc, SO_4^{2-} and NO_3^- concentrations for different mixing ratios between the water from the abandoned (old) and the current (new) well

new : old	pH	pHc	ΔpH	SO_4^{2-} [mmol/L]	SO_4^{2-} [mg/L]	NO_3^- [mmol/L]	NO_3^- [mg/L]
0:100	6.99	6.84	0.15	2.707	**260.00**	1.129	**70.01**
10:90	6.95	6.86	0.09	2.644	**253.95**	1.019	**63.18**
20:80	6.91	6.87	0.04	2.582	**248.00**	0.908	**56.33**
30:70	6.87	6.89	-0.02	2.520	**242.04**	0.798	49.50
40:60	6.84	6.91	-0.07	2.457	235.99	0.688	42.67

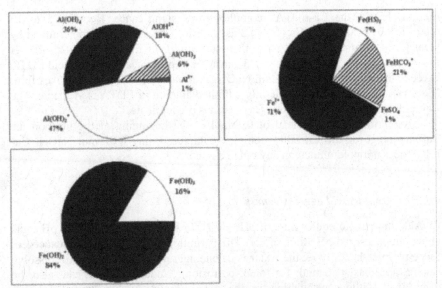

Fig. 75 Al-, Fe(II)- and Fe(III) species distribution prior to aeration

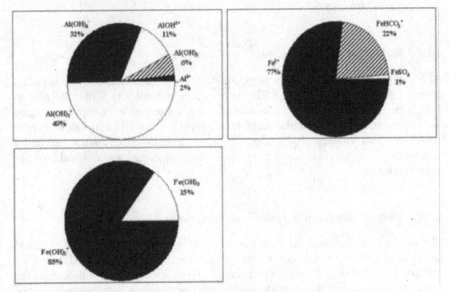

Fig. 76 Al-, Fe(II)- and Fe(III) species distribution after aeration

Variation of the oxygen partial pressure scarcely leads to any changes because in an open system under steady state conditions any amount of oxygen can be dissolved. Hence, all species can be oxidized almost independent of the partial pressure. The concentration of Fe(III) does not change at all, while slight changes

mmol/L EDTA the Ca-EDTA^{2-} complex gains significance. Between 5 to 10 mmol/L EDTA at last all Ca is bound as Ca-Edta^{2-} complex and is determined by means of a color indicator. If more than 10 mmol/L of EDTA are added, the pH drops immediately from 13 to about 3, since the deprotonization of the acid EDTA exceeds the alkaline buffering with NaOH. Preferably H$^+$-EDTA-complexes form (EdtaH$_2$$^{2-}$, EdtaH$_3$$^-$, etc.). For Ca only a limited amount of EDTA is available. The CaHEdta$^-$ complex and again free Ca^{2+}-cations predominate.

Using 1 mol NaOH instead of 0.1 mol in the beginning of the titration the stability range of the Ca-Edta^{2-} complex enlarges. Using 0.01 mol NaOH, Ca-Edta^{2-} does not predominate in any range anymore.

4.1.5.2 Carbonic acid aggressiveness

Considering calcite equilibrium, a pHc of 7.076 results which is 0.376 pH units above the measured pH value of 6.7. The permitted deviation of 0.2 is exceeded. Since pH-pHc is negative, the water is calcite aggressive, i.e., it can still dissolve calcite and has potential for pipe corrosion. Undersaturation can also be determined without calculation of the pHc, because within "initial solution calculations" in the PHREEQC output, calcite already shows a saturation index of -0.63 (= 23% saturation).

4.1.5.3 Water treatment by aeration – well water

After aeration by adjustment of an equilibrium with the atmospheric CO$_2$ partial pressure (0.03 Vol%, CO$_2$(g) -3.52) the pH value increases to 8.783, the pHc to 7.57. Thus ΔpH is +1.213, i.e., the water is supersaturated with regard to calcite and calcite precipitation might occur in the pipe systems. The SI calcite (under "batch reaction calculations") is +1.35. Thus, aeration deteriorates the initial conditions regarding calcite equilibrium. The drinking water standards are exceeded by far.

4.1.5.4 Water treatment by aeration – sulfur spring

The species distribution of Al, Fe(II), and Fe(III) is depicted in Fig. 75. Al(III) and Fe(II) predominate as OH-complexes. There are almost no free Al^{3+} or Fe^{3+} cations, while the majority of Fe(II) occurs as free cations (71%), followed by the FeHCO$_3$$^+$ complex (21%). Considering the total iron content, the concentration of Fe(II) (4.44 · 10^{-6} mol/L) is significantly higher than Fe(III) (5.69 · 10^{-15} mol/L).

After aeration there are no significant species changes (Fig. 76), beside the fact that the FeII(HS)$_2$ complex is not formed under oxidizing conditions anymore. Iron is almost completely oxidized to Fe(III) (4.44 · 10^{-6} mol/L compared to 1.41 · 10^{-14} mol/L for Fe(II)). Al(OH)$_3$(a) and Fe(OH)$_3$(a) are precipitating mineral phases, possibly also some more.

With a very small uncertainty of 0.006 for the gaseous phase CO_2, the mineral phases gypsum and halite (for the marine environment), quartz, K-mica, albite, and anorthite (from the Quaternary aquifer) as well as calcite and dolomite (from the Cretaceous limestone) and assuming that halite, gypsum, K-mica, albite, and anorthite can only be dissolved, the following three models were found (Table 48). Since quartz, feldspar and mica are considered as significant mineral phases in the Quaternary aquifer and these are only represented in the first model, this one is chosen. Independent of that, the proportion of seawater to groundwater is 22.55% to 77.45% in all three models.

4.1.5 Anthropogenic use of groundwater

4.1.5.1 Sampling: Ca titration with EDTA

In order to get the sample alkaline first, 0.1 mol NaOH is added using the keyword REACTION. This addition causes an increase in pH value from 6.7 to 13.343. This alkaline solution is saved, and recalled in a second job. Using REACTION, EDTA is added (for this example 1e-5, 5e-5, 1e-4, 5e-4, 1e-3, 5e-3, 1e-2, 5e-2, 1e-1, 5e-1, 1, 5 and 10 mol/L).

Fig. 74 shows the predominant Ca-complexes at the described conditions.

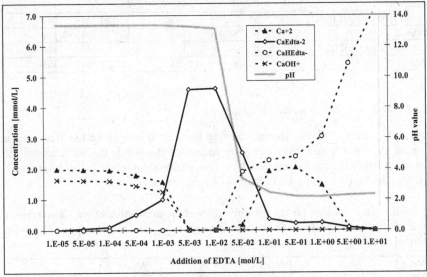

Fig. 74 **Stability of the Ca-EDTA complex upon addition of 5e-3 to 1e-2 mol/L EDTA to a solution, which is alkalinized with 0.1 mol NaOH to a pH of 13.34; larger amounts of EDTA in solution lead to deprotonization and thus to a decrease in pH value, EDTA is preferably bound to H^+ ions, the $CaEdta^{2-}$ complex loses significance.**

Upon addition of small quantities of EDTA to the alkaline solution, free Ca^{2+} cations and the Ca-hydroxo complex $CaOH^+$ predominate. From about 0.5 to 1

1000 m · 10,000 m = 50,000,000 m³ or 50,000,000,000 L it takes 50,000,000,000 L : 2,683,152 L/d = 18635 d or 18635 d : 365 = approximately 51 years until the reservoir is completely exploited, and only recent groundwater is available anymore. Thus, assuming a constant supply, this amount will be only 38% of the present production, i.e. 19 L/s instead of 50 L/s, which are also subject to larger variations independent of the rainfall.

Table 47 Two models, showing the share of fossil groundwater compared to recent groundwater in an arid region (precipitating mineral phases +, dissolving mineral phases -, concentration in mol/L)

Isotopic composition of phases	Model 1		Model 2	
13C Calcite	2 + -2 = 0		2 + -2 = 0	
13C CO2(g)	-25 + -5 = -30		-25 + -5 = -30	
Solution fractions	share	percentage	share	percentage
Solution 1 (fossil water)	6.21E-01	62.11	6.21E-01	62.11
Solution 2 (recent groundwater)	3.79E-01	37.89	3.79E-01	37.89
Solution 3	1.00E+00	100.00	1.00E+00	
Phase mole transfers				
Calcite CaCO3	-2.59E-04	pre	-2.59E-04	pre
CO2(g)	-2.48E-04	pre	-2.48E-04	pre
Quartz SiO2	7.69E-06	dis		
Kmica KAl3Si3O10(OH)2	-1.88E-05	pre	-1.88E-05	pre
Albite NaAlSi3O8	-1.75E-04	pre	-1.71E-04	pre
Anorthite CaAl2Si2O8	1.16E-04	dis	1.14E-04	dis
Gypsum CaSO4	2.80E-04	dis	2.82E-04	dis

4.1.4.2 Salt water/fresh water interface

Just as with every task of inverse modeling there is not one correct solution, but a number of possible solutions. First, by means of the sub keyword "charge" the electrical balance must be corrected because the analytic error is too high with -4.65%. The best way is to use calcium to attain a balanced charge.

Table 48 Three models for the determination of the proportion of sea water relative to fresh water in the irrigation water (precipitating mineral phases +, dissolving mineral phases -, concentration in mol/L)

Model 1		Model 2		Model 3	
CO2(g)	4.91E-04	CO2(g)	4.93E-04	CO2(g)	4.93E-04
Gypsum	1.25E-04	Gypsum	1.28E-04	Gypsum	1.28E-04
Quartz	9.79E-06	Calcite	-2.00E-04	Quartz	-9.71E-08
K-Mica	1.65E-06	Dolomite	-1.16E-04	Calcite	-2.00E-04
Albite	-4.94E-06			Dolomite	-1.16E-04
Calcite	-1.97E-04				
Dolomite	-1.17E-04				

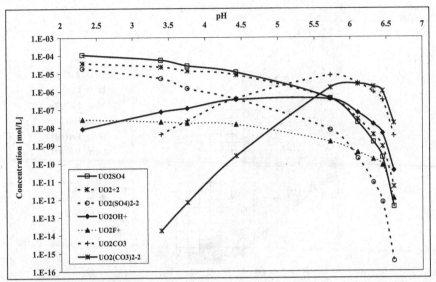

Fig. 73 Development of uranium species during the mixing of an acid mine water (pH= 2.3) with a groundwater (pH=6.6)

For low pH values the zero-charged $UO_2SO_4^0$ complex predominates. The positively charged UO_2^{2+} complex reaches similar concentrations though. From pH=5 on, the carbonate complexes predominate, first the zero-charged $UO_2CO_3^0$ complex, at pH values exceeding 6 the negatively charged $UO_2(CO_3)_2^{2-}$ complex. Both carbonate complexes are of no importance in an acid environment (pH values < 3.5). For transport and sorption processes, especially the zero-charged complexes have to be taken into account, since they show only little interactions, hence can hardly be retarded.

4.1.4 Origin of groundwater

4.1.4.1 Pumping of fossil groundwater in arid regions

The mineral phases calcite, dolomite, halite, and gypsum for the Cretaceous limestone, as well as albite, quartz, anorthite, K-mica for the sandstone, and the gaseous phase CO_2 have to be defined. Furthermore it is assumed that dolomite, gypsum, and halite only dissolve, while calcite precipitates and CO_2 degasses. Under those conditions and with an uncertainty of 4%, two models are obtained (Table 47).

Both models differ only slightly; model 2 does not use quartz as a mineral phase. The ratio fossil to recent groundwater is equal for both models: 62%:38%, which means that almost two thirds of the extracted groundwater is not recharged. With a pumping rate of 50 L/s or $50 \cdot 60 \cdot 60 \cdot 24$ L/d = 4,320,000 L/d, $0.6211 \cdot 4,320,000$ L/d = 2,683,152 L/d fossil water are extracted. For a reservoir of 5 m \cdot

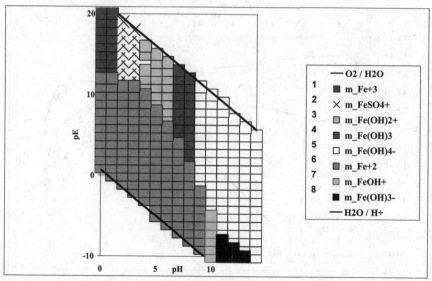

Fig. 72 **pE-pH diagram for the system iron – sulfur [initial solution 10 mmol Fe + 10 mmol Cl + 10 mmol C], numbers as indicated in Fig. 70**

4.1.3.3 The pH dependency of uranium species

First of all, both solutions, the acid mine water and the groundwater, are defined in the PHREEQC input file and mixed applying the keyword MIX. Then this solution is saved as solution 3 (SAVE_SOLUTION) and the job is finished by END. A second job follows, which uses again SOLUTION 2 (groundwater) and SOLUTION 3 (1:1 diluted water) via the keyword USE, mixes both solutions 1:1, and saves the result as SOLUTION 4, etc. SELECTED_OUTPUT facilitates the further data processing in EXCEL by providing the pH values and the "molalities" of all uranium species. The keyword itself has to be repeated for every job, as well as the definition of the desired parameters pH and molalities. Yet the file name (e.g. 3_uranium_species_pHdependent.csv) should only appear within the first SELECTED_OUTPUT block and not be repeated. This way PHREEQC writes the parameters of all modeling steps in one single SELECTED_OUTPUT file. The headline, however, is repeated for every modeling run. The sub keyword "- reset false", also applied just once within the first SELECTED_OUTPUT block, suppresses the standard output for all other modeling, which are written into the same file.

With seven mixings plus the initial solution of acid mine water and the resulting solution of groundwater the variations in uranium species are as shown in (Fig. 73).

4.1.3.2 The Fe pE-pH diagram considering carbon and sulfur

In SELECTED_OUTPUT $FeHCO_3^+$, and $FeCO_3$ for the iron - carbon system as well as $FeSO_4^+$, $FeHSO_4^{2+}$, $Fe(SO_4)_2^-$, $FeHSO_4^+$, and $FeSO_4$ for the iron - sulfur system must be defined for the output besides the iron species from chapter 4.1.3.1. For both systems numerical problems occur at pH 4 and pH 14.

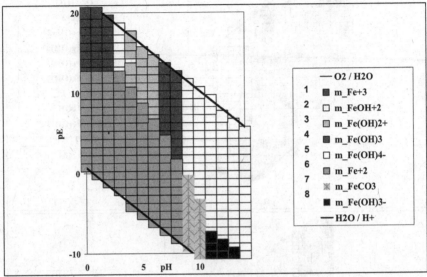

Fig. 71 pE-pH-diagram for the system iron-carbon (initial solution 10 mmol Fe + 10 mmol Cl + 10 mmol C), numbers as indicated in Fig. 70

In the iron - carbon system (Fig. 71) the $FeOH^+$ - field vanishes, the zero-charged $FeCO_3^0$ - field predominates instead under the same pE - pH conditions. In the iron - sulfur system (Fig. 72) the predominance field of the iron - sulfate species $FeSO_4^+$ enlarges at the expense of Fe^{3+}, while $FeOH^{2+}$ disappears completely.

The pE-pH diagrams, as the ones modeled and presented in Fig. 70 to Fig. 72, provide a good overview of possible predominating species. However, they have the significant disadvantage that for setting up a complete diagram covering all ranges (i.e. from extremely oxidizing to extremely reducing, and from extremely acid to extremely alkaline) only idealized solutions can be modeled. Those idealized solutions contain only few defined species, as e.g. in the example, only C or S apart from Fe and Cl as the corresponding anion. The ion balance frequently shows larger deviations than 2%. The requirement of a constant ionic strength through all pE - pH fields can only be partially maintained. Moreover, species that occur in almost the same concentration as the predominating species, and are possibly significant for reactive transport, are totally neglected in predominance diagrams. These weaknesses of pE - pH diagrams must be kept in mind for modeling and interpretation.

$Fe(OH)_3$-field is somewhat smaller in the example and an additional field for the $FeOH^+$ species is indicated, which is lacking in the diagram of Langmuir (1997).

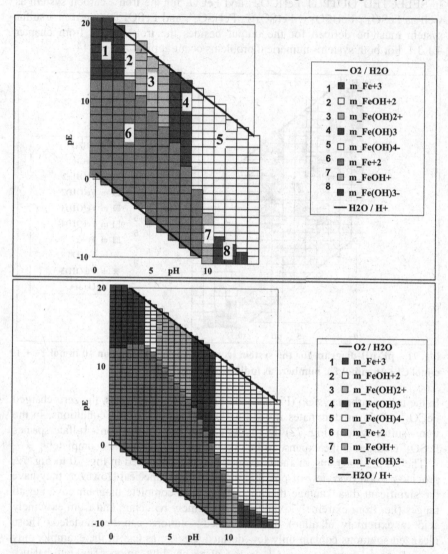

Fig. 70 pE-pH diagram for the system iron (initial solution 10 mmol Fe + 10mmol Cl); Variation of pE, pH in steps of 1 (above) and 0.5 (below, higher raster resolution, numbers as indicated in the figure above)

Table 46 Groundwater recharge with and without consideration of evaporation

Groundwater recharge without consideration of evaporation		Groundwater recharge with consideration of evaporation	
C	3.85e-03 mol/L	C	3.11e-03 mol/L
Ca	1.84e-03 mol/L	Ca	4.61e-03 mol/L
Cl	2.30e-05 mol/L	Cl	7.95e-04 mol/L
K	7.00e-06 mol/L	K	2.42e-04 mol/L
Mg	2.90e-05 mol/L	Mg	1.00e-03 mol/L
N(5)	8.00e-05 mol/L	N(5)	2.77e-03 mol/L
Na	8.00e-06 mol/L	Na	2.77e-04 mol/L
S(6)	8.20e-05 mol/L	S(6)	2.83e-03 mol/L
Si	9.13e-05 mol/L	Si	9.10e-05 mol/L
pH = 7.294		pH = 7.161	
SI (gypsum) = -2.60		SI (gypsum) = -0.93	

Under PHASE ASSEMBLAGE one can find the amount of calcite dissolved (-2.169 mmol/L, respectively 2.169/L \cdot 100 mg/mmol = 216.9 mg/L). The groundwater recharge can be calculated from 5 mm/a (250 mm rainfall - 20 mm runoff - 225 mm evaporation) related to the recharge area of 50 km \cdot 30 km to 5 mm/a \cdot 1500 km^2 = 0.005 m/a \cdot 1.5 \cdot 10^9 m^2 = 7.5 \cdot 10^6 m^3/a or 7.5 \cdot 10^9 L/a. For this groundwater recharge, a dissolved amount of calcite of 216.9 mg/L \cdot 7.5 \cdot 10^9 L/a = 1.627 \cdot 10^{12} mg/a = 1627 t/a results.

For a calcite density of 2.71 g/dm^3 that amounts to a cavity volume of 1627 t/a : 2.71 \cdot 10^{-6} t/dm^3 = 6.0 \cdot 10^8 dm^3/a or 6.0 \cdot 10^5 m^3/a. Recalculated to an area of 50 km \cdot 30 km, a subsidence of 6.0 \cdot 10^5 m^3/a : (50 km \cdot 30 km) = 6.0 \cdot 10^5 m^3/a : 1.5 \cdot 10^9 m^2 = 4.0 \cdot 10^{-4} m/a = 0.4 mm/a can be calculated.

4.1.3 Groundwater

4.1.3.1 The pE-pH diagram for the system iron

The following species must be defined within the keyword SELECTED_OUTPUT to assess whether they predominate and if so, under which pH-pE-conditions: Fe^{2+}, Fe^{3+}, $FeCl^+$, $FeOH^+$, $Fe(OH)_2$, $Fe(OH)_3^-$, $Fe(OH)_2^+$, $Fe(OH)_3$, $FeOH^{2+}$, $Fe_2(OH)_2^{4+}$, $Fe(OH)_4^-$, $Fe_3(OH)_4^{5+}$, $FeCl_2^+$, $FeCl^{2+}$, $FeCl_3$.

Fig. 70 shows the predominance diagram as a result of the modeling. The second raster, created by the 4-fold number of data by cutting down the step width by half, reveals a higher resolution. However, no additional species appear, that might have been missed by the lower resolution in the first raster. The gaps within the 0.5-step raster at the pH-pE combinations of pH 3.5/pE 12.5, pH 3.5/pE 13, pH 4/pE 14.5, pH 4/pE 15.5 and pH 3.5/pE 16 arise from numerical problems that occurred during the modeling and allowed no convergence of the model. The corresponding SOLUTIONS were removed from the PHREEQC input file.

Comparing the created pE-pH diagram to the one for the system $Fe-O_2-H_2O$ according to Langmuir (1997; Fig. 16), clear similarities can be shown. Just the

the amount of precipitating sulfur varies from 0.419 mg S/L to 11.26 mg S/L at maximum O_2 - solubility.

4.1.2.4 Formation of stalactites in karst caves

The rainwater infiltrates in the soil of the karst area. Under the increased CO_2 partial pressure of 3 vol% in the soil the dissolution of 2.613 mmol/L calcite (simulation1/batch reactions/phase assemblage) occurs and karst cavities form. From the cave ceilings, water saturated with regard to calcite drips. As soon as the infiltrating water creates a karst drainage system, which finally discharges to a river, the CO_2 content drops to the level of atmospheric partial pressure (0.03 vol%). With decreasing $P(CO_2)$, calcite precipitation inevitably results (see also chapter 3.1.1.6), leading to the precipitation of 2.116 mmol/L (simulation2/batch reactions/phase assemblage) or 211.6 mg/L $CaCO_3$ (2.116mmol/L · mole mass 100 mg/mmol = 211.6 mg/L). Assuming a daily amount of 100 liter of water dripping from the cave's ceiling, that amounts to 211.6 mg/L · 100 L/d = 21.16 g/d, or for one year (365 day) about 7.7 kg/a.

Taking 2.71 g/cm^3 as density, a precipitated volume of calcite of 7.7 kg/a : 2.71 kg/dm^3 = 2.84 dm^3/a results. Because only about 15% of the ceiling of the karst cave is covered by stalactites, this volume is spread on 0.15 ·10 m (length) · 10 m (width) = 15 m^2. Thus the stalactites grow by 2.84 dm^3/a : 15 : 10^2 dm^2 = 0.0019 dm/a = 0.19 mm/a.

4.1.2.5 Evaporation

The negative amount of water, which must be used for titration, equals 54.38 moles. The rainfall of 250 mm must be reduced by 20 mm for the runoff, which leaves 230 mm for infiltration. That comes up with 225 mm evaporation/230 mm infiltration = 98 % of evaporation; this means that 98% of the amount of water (pure H_2O without any ions) must be removed (98% of 55.5 moles = 54.38 moles). That leaves 2% of highly concentrated solution, which must be multiplied 50 times by itself to get back to 100% of highly concentrated solution (50 · 2% = 100%). Additionally, equilibrium with calcite, quartz, and 0.01 bar of CO_2 ($CO_2(g)$ -2.0) must be adjusted.

This calculation results in the solution composition shown in Table 46 with and without consideration of evaporation (in mol/L).

Considering evaporation, the elements Cl, K, Mg, N(5), Na, and S(6) yield a concentration about 35 times higher than without considering evaporation. For Ca, Si, and HCO_3 the difference is smaller, since for those elements an additional input - independent of the evaporation - is assumed by the equilibrium reactions in the underground. The increase in the gypsum saturation index is remarkable, showing that at high evaporation rates even gypsum precipitation might occur.

The buffered pH value is 6.718 and thus almost in the neutral pH range. The most effective buffer is the carbonate buffer, which is responsible for buffering most of the systems in the pH range of 5.5 to 8.0. After the reaction with calcite, the pH of rainwater increases from 4.775 to 7.294.

Because of the slow kinetics of feldspar weathering, the modeling of a silicate buffer is impossible by equilibrium reactions only. Kinetics must be considered, which will not be done here.

4.1.2.3 Mineral precipitations at hot sulfur springs

At 45°C a maximum of about 6.5 mg O_2 can dissolve in one liter of water. The gas solubilities given in Table 45 first must be recalculated to the respective temperatures (T), for 0 °C e.g.:

0.0473 cm^3 water/cm^3 water = 0.0473 L gas/L water;

since 22.4 L = 1 mol gas: 0.0473 : 22.4 mol gas/L water = $2.11 \cdot 10^{-3}$ mol/L

since the mole mass of O_2 = 32 g/mol: $2.11 \cdot 10^{-3}$ mol/L \cdot 32 g/mol = 0.0676 g/L = 67.6 mg/L

The calculated value would be correct for 100 vol% O_2. However, there are only 21 vol% in the atmosphere. Thus, 67.6 mg/L must be multiplied by 0.21 to get 14.19 mg/L O_2-solubility at 0°C.

Table 45 Dependency of O_2 solubilities on temperature at $P(O_2)$ =21 vol%

T	Gas solubility [cm^3/cm^3]	Gas solubility [mg/L]	T	Gas solubility [cm^3/cm^3]	Gas solubility [mg/L]	T	Gas solubility [cm^3/cm^3]	Gas solubility [mg/L]
0	0.0473	14.19	20	0.0300	9.00	50	0.0204	6.12
5	0.0415	12.45	25	0.0275	8.25	60	0.0190	5.70
10	0.0368	11.04	30	0.0250	7.50	70	0.0181	5.43
15	0.0330	9.90	40	0.0225	6.75	90	0.0172	5.16

Thus, using REACTION 1, 2, 3, 4, 5, 6, and 6.5 mg/L O_2 (converted into mol/L) are added. For CO_2, equilibrium with the atmospheric partial pressure can be defined simply by using the keyword EQUILIBRIUM_PHASES, since all the subsequent reactions depend only on the diffusion of the CO_2 and its dissociation in water. Contrary to redox reactions with oxygen both processes are fast reactions, hence can be described by equilibrium reactions, neglecting kinetics.

As long as sulfur-rich thermal waters circulate in the underground, all mineral phases except for the Si compounds are undersaturated. Upon discharge as spring water, the exposure to a small quantity of oxygen is sufficient to reach a supersaturation with regard to elemental sulfur (SI = 0.04 at 1 mg O_2/L to SI = 0.47 at 6.5 mg O_2/L). Even at higher O_2 contents, gypsum stays undersaturated (SI = -6.6 at 1 mg O_2/L to -3.25 at 6.5 mg O_2/L). Close to the spring's discharge the supersaturated sulfur precipitates spontaneously together with SiO_2(a) forming the characteristic yellow – red sulfur sinter incrustations. Depending on the O_2 content

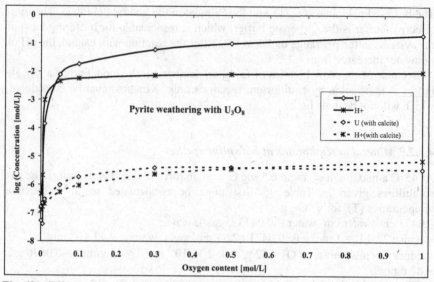

Fig. 69 Effects of pyrite weathering in the presence of the mineral phase U_3O_8 on the concentrations of uranium and H^+ in the absence and in the presence of calcite (y-axis logarithmic).

4.1.2 Atmosphere – Groundwater – Lithosphere

4.1.2.1 Precipitation under the influence of soil CO_2

The increased soil CO_2 partial pressure of 1 vol% - compared to atmospheric $P(CO_2) = 0.03$ vol% - causes an increase in the concentration of the H^+ ions (see chapter 3.1.1.6). Thus, the pH value of the rainwater decreases from 5.1 to 4.775, while at the same time the concentration of dissolved carbon increases from 13 µmol/L to 390 µmol/L.

4.1.2.2 Buffering systems in the soil

The pH value of the infiltrating rainwater under increased CO_2 partial pressures in the soil is 4.775. In this pH range the <u>iron hydroxide buffer</u> shows no effect at all. The pH value remains at 4.775 even after the reaction with goethite. Iron buffers only play a role for reactions in very acid mine waters (pH 2 to 4), by the transformation of goethite into Fe (III) under proton consumption: $FeOOH + 3H^+ = Fe^{3+} + 2H_2O$. The reaction with <u>aluminum hydroxide</u> (boehmite $AlOOH + H_2O + 3H^+ = Al^{3+} + 3H_2O$) shows little buffering capacity. The pH is 4.91 after the reaction. Similarly, <u>manganese hydroxides</u> ($MnOOH + 3H^+ + e^- = Mn^{2+} + 2H_2O$) buffers only slightly from pH 4.775 to 5.032. In the <u>exchanger buffering system</u> the protons are sorbed on the exchanger while (earth) alkaline ions are released.

weathering in the absence of calcite. The reason for this increase is that H^+ ions are consumed for the formation of the HCO_3^- complex, which results from calcite dissolution. This consumption of H^+ reduces the formation of the HSO_4^- complex, and the formation of SO_4^{2-} is increased. The Fe^{2+} concentration on the other hand decreases. Significant amounts of Fe^{2+} are bound in the $FeHCO_3^+$-complex due to higher concentrations of HCO_3^- in the presence of calcite. Most important, however, is the influence of calcite on the pH value, which is decreasing from 6.9 to 5.1 only. The presence of calcite causes a significant buffering of the waters formed during pyrite weathering.

In the presence of the mineral phase U_3O_8, $5.32 \cdot 10^{-8}$ mol/L and $1.98 \cdot 10^{-1}$ mol/L uranium can dissolve at 0.001 mol/L O_2 and 1 mol/L O_2 respectively (Fig. 69). In the absence of calcite, the pH drops from 6.3 to 2.0. In the presence of calcite the pH value is buffered as in the example described above (6.9 to 5.1). Up to an oxygen concentration of 0.005 mol/L the uranium solubility in the presence of calcite is higher than in its absence because more uranium carbonate complexes can form. However, at higher oxygen contents, the uranium solubility in the presence of calcite is significantly restricted. It reaches $3.56 \cdot 10^{-6}$ mol/L at 1 mol/L O_2, hence only one hundred thousandth of the amount that is soluble in the absence of calcite. Thus, calcite effectively contributes to the reduction of uranium concentrations in the groundwater during pyrite weathering.

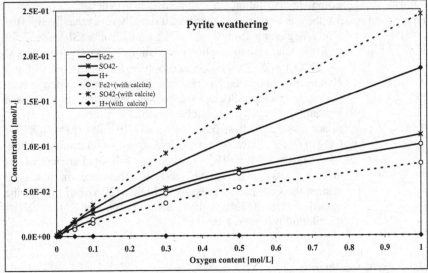

Fig. 68 Effects of pyrite weathering on the concentrations of Fe^{2+}, SO_4^{2-} and H^+ in the absence and in the presence of calcite

4.1.1.8 Comparison of the calcite solubility in an open and a closed system

At a $P(CO_2)$ of 2 vol% the calcite dissolution is lower in the open system (hence the pH value higher) than in the closed system. At 20 vol% $P(CO_2)$ it is the other way around, in the open system the calcite dissolution is higher, the pH value is lower (Table 44).

Table 44 Calcite dissolution in an open and a closed system at $P(CO_2)$ = 2 vol%, respectively $P(CO_2)$ = 20 vol%

	2 Vol% open system	2 Vol% closed system	20 Vol% open system	20 Vol% closed system
pH	7.144	7.028	6.485	6.594
Calcite [mmol/L]	-0.8290	-1.250	-4.385	-3.552

The explanation can be found by modeling the well analysis without any equilibrium reactions. The well sample itself already has a CO_2 partial pressure of 3.98 vol% (under „initial solution" - „saturation indices" SI $CO_2(g)$ = -1.40 → $P(CO_2)$ = 3.98 vol%), i.e. the following processes occur in the open and the closed system:

in the open system: a complete gas exchange is possible:

 2 vol% complete degassing from 3.98 vol% to 2 vol%

20 vol% complete dissolution from 3.98 vol% to 20 vol%

in the closed system: the gas exchange is suppressed (ideally no exchange at all)

 2 vol% minor degassing from 3.98 vol% to 3.02 vol% (SI = -1.52 for $CO_2(g)$ under „batch reaction calculations" - „saturation indices" → $P(CO_2)$ = 3.02 vol%), since only a limited amount of gas (1liter) is assumed for the reaction. Because in the open system the partial pressure $P(CO_2)$ = 2 vol% is lower than in the closed system (3.02 vol%), the calcite dissolution is less.

20 vol% minor dissolution from 3.89 vol% to 13.49 vol% (SI = -0.87 for $CO_2(g)$ under „batch reaction calculations" - „saturation indices" → $P(CO_2)$ = 13.49 vol%)%), since only a limited amount of gas (1liter) is assumed for the reaction. Therefore, in the open system the CO_2 partial pressure is higher (20 vol%) than in the closed system (13.49 vol%), and, consequently, the calcite dissolution is higher, too.

4.1.1.9 Pyrite weathering

As can be seen from Fig. 68, with increasing oxygen the pyrite weathering has a crucial influence on the concentrations of Fe^{2+} and SO_4^{2-}, which increase from 0.001 mol/L to 1 mol/L O_2 by about 3 orders of magnitude. The pH value drops significantly from 6.3 to 0.7. The resulting water is extremely acid.

In the presence of calcite, the total concentration of SO_4^{2-} at oxygen concentrations exceeding 0.05 mol/L strongly increases compared to the pyrite

temperature the lower the gas solubility. Consequently, initially, the calcite solubility increases with temperature due to the endothermic reaction of $CaCO_3^0$ complexation, but with increased temperature the exothermic reaction of $CaCO_3(s)$ dissolution and the significantly reduced CO_2 dissolution decrease the total calcite solubility.

4.1.1.7 Calcite precipitation and dolomite dissolution

In the presence of both calcite and dolomite, dolomite dissolves while calcite precipitates (Table 43, Fig. 67), because the solubility-product of $CaCO_3$ is exceeded. This process is called incongruent dissolution (see chapter 1.1.4.1.3). The maximum of dissolution/ precipitation shifts to lower temperatures (6°-7°C).

Table 43 Dependency of calcite dissolution and dolomite precipitation on temperature

Temperature [°C]	CO$_2$ [Vol%]	Calcite [mmol/L]	Dolomite [mmol/L]
0	0.03	2.68	-1.11
5	0.5	4.10	-2.90
8	0.9	4.19	-3.17
15	2	3.79	-3.12
25	4.5	3.02	-2.86
30	7	2.60	-2.65
40	10	1.79	-2.00

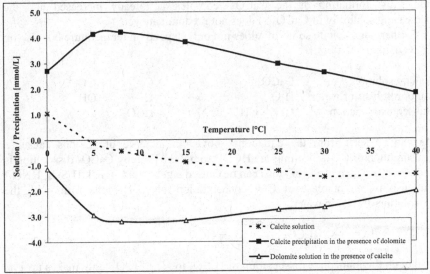

Fig. 67 Calcite solubility and incongruent solution calcite-dolomite (calcite – precipitation and dolomite dissolution)

4.1.1.5 Temperature dependency of gypsum solubility in pure water

Compared to well water, distilled water can dissolve more gypsum (Fig. 66), since the initial concentrations of calcium and sulfate are lower.

4.1.1.6 Temperature- and P(CO₂)-dependent calcite solubility

The optimum calcite solubility occurs at 30°C (Fig. 67), not at the maximum temperature of 40°C (Table 42).

Table 42 Dependency of calcite solubility on temperature and P(CO₂)

Temperature [°C]	CO₂ [Vol%]	P(CO₂)	Calcite [mmol/L]
0	0.03	-3.5	1.07
5	0.5	-2.3	-0.08
8	0.9	-2.05	-0.40
15	2	-1.70	-0.83
25	4.5	-1.3	-1.32
30	7	-1.15	-1.46
40	10	-1	-1.34

Different factors have an influence on the calcite solubility. First of all, like for gypsum (chapter 4.1.1.4) the formation of the $CaCO_3^0$ complex is endothermic $(\Delta H(CaCO_3^0) = +3.5)$, while the mineral dissolution is exothermic $(\Delta H(CaCO_3(s)) = -2.3)$. Thus, the maximum solubility occurs at some medium temperature, at which the formation of the $CaCO_3^0$ complex is already increased and the decreasing solubility of $CaCO_3(s)$ does not predominate yet.

Furthermore, calcite solubility does not only depend on temperature but also on $P(CO_2)$.

Calcite solution:	$CaCO_3$	\leftrightarrow	Ca^{2+}	$+\,CO_3^{2-}$
Autoprotolysis of water:	H_2O	\leftrightarrow	H^+	$+\,OH^-$
Subsequent reaction:	$CO_3^{2-} + H^+$	\leftrightarrow	HCO_3^-	

As can be seen from the equations above, an increase of H^+-ions causes a consumption of CO_3^{2-} forming the HCO_3^- complex. Thereby $CaCO_3$ dissolution is increased. An increase in H^+-ions can be caused e.g. by acids (HCl, H_2SO_4, HNO_3) but also by an increase of CO_2 concentration, since H^+ ions form with the dissolution of CO_2 in water.

$$CO_2 + H_2O \;\leftrightarrow\; H_2CO_3 \;\leftrightarrow\; H^+ + HCO_3^-$$

Although the immediate dissociation of H_2CO_3 to $H^+ + HCO_3^-$ only makes up 1%, subsequent reactions cause a much higher CO_2 dissolution.

That means, the higher the $P(CO_2)$, the more $CaCO_3$ can be dissolved. Yet, the solubility of CO_2 as gas in water depends on the temperature: The higher the

4.1.1.4 Temperature dependency of gypsum solubility in well water

The following amounts of gypsum dissolve at the corresponding temperatures:
Δ gypsum -7.217e-03 mol/L at 10°C
Δ gypsum -7.736e-03 mol/L at 20°C
Δ gypsum -8.074e-03 mol/L at 30°C
Δ gypsum -8.229e-03 mol/L at 40°C
Δ gypsum -8.213e-03 mol/L at 50°C
Δ gypsum -8.047e-03 mol/L at 60°C
Δ gypsum -7.753e-03 mol/L at 70°C

The maximum solubility of gypsum occurs at 40°C (Fig. 66). The first increase of solubility with temperature is related to the endothermic formation of the $CaSO_4^0$ complex, the significance of which was already shown in the example 2 in chapter 2.2.2.1.2 ($\Delta H(CaSO_4^0)$) = + 1.6 → $\Delta G > 0$, since $\Delta G = -R \cdot T \cdot \ln K$ it follows, if T ↑ -lnK ↓, thus K ↑). The solubility of the mineral phase $CaSO_4(s)$ on the other hand decreases with increasing temperature (exothermic process) ($\Delta H(CaSO_4(s))$) = -0.1 → $\Delta G < 0$, since $\Delta G = -R \cdot T \cdot \ln K$ it follows, if T ↑ lnK ↓, thus K↓). Both effects overlap and lead to the fact that the maximum gypsum solubility occurs at some medium temperature, at which the formation of the $CaSO_4^0$ complex is already increased and the decreasing solubility of $CaSO_4(s)$ does not predominate yet. As a consequence of the decreasing mineral solution over 40°C, also the amount of $CaSO_4^0$ decreases.

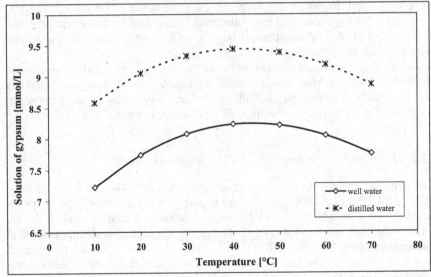

Fig. 66 Temperature dependency of gypsum solubility in well water and in distilled water.

The species distribution of Ca, Mg, Zn, and Pb can be seen in Fig. 63. It is noteworthy that Ca, Mg, and Zn predominantly occur as free ions in contrast to lead, which typically forms complexes. The most important complexing anion for calcium and magnesium is sulfate, for lead and zinc it is hydrogen carbonate.

Fig. 64 and Fig. 65 show the supersaturated Al and Fe mineral phases. As already mentioned in chapter 2.2.2.1.1, the amorphous mineral phases precipitate initially. In this example, it is only $Fe(OH)_3(a)$ because $Al(OH)_3(a)$ is undersaturated. Because of the low total concentrations of 0.056 mg/L for Al and 0.067 mg/L for Fe, further mineral precipitations are unlikely to occur.

4.1.1.2 Equilibrium reaction – solubility of gypsum

Because of its general flow direction from the east to the west the groundwater flows through the gypsum deposit before it enters the planned new well. In contact with the mineral deposit 1.432e-02 mol/L gypsum can dissolve (delta gypsum from the section "phase assemblage", the minus sign indicates that gypsum dissolves). Thus, the total mineralization increases from 1.190e-02 mol/L in the old well (assumed to be characteristic for this aquifer) to 4.795e-02 mol/L, which is 4 times higher than the initial value. The Ca concentration increases from 1.872e-03 mol /L (75 mg/L) for the old well to 1.618e-02 mol/L (645 mg/L) and the sulfate concentration from 2.083e-03 mol/L (200 mg/L) to 1.639e-02 mol/L (1570 mg/L).

Thus, the drinking water standards of 400 mg/L for Ca and 240 mg/L for SO_4^{2-} are exceeded by far. While the level for Ca is of rather technical significance, since high Ca values may lead to calcite precipitation in the pipe system (also see chapter 3.1.5.2), the sulfate standard has a medical background, because sulfate can cause diarrhea in high concentrations.

To calculate the sulfate content, not only the SO_4^{2-} ion as listed in the species distribution but all S(6) species were considered. Most analytical methods determine all S(6) compounds as "sulfate" and, moreover, also the drinking water standard refers to this rather "theoretical" total sulfate content.

4.1.1.3 Disequilibrium reaction – solubility of gypsum

Assuming an incomplete dissolution of gypsum (50% \rightarrow log 0.5 = 0.3 \rightarrow EQUILIBRIUM_PHASES gypsum 0.3) only 7.832e-03 mol/L of gypsum dissolve. After the reaction, the total mineralization is 3.259e-02 mol/L, the Ca content 388 mg/L, sulfate 950.4 mg/L. Hence, the Ca content is slightly below the standard, while the limit for sulfate is still clearly exceeded. All in all, the planned well location can not be recommended. At least the high sulfate concentrations would make an expensive water treatment indispensable.

lower values so that Se (-2) is already completely oxidized, and there are small quantities of Se(+6). However, the partly reduced form Se(+4) still predominates.

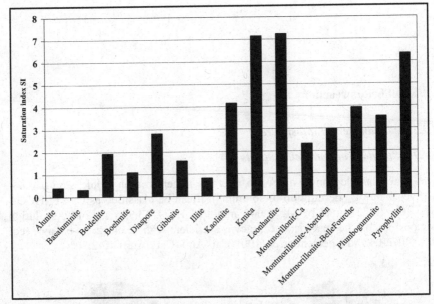

Fig. 64 EXCEL bar chart presenting the supersaturated aluminum mineral phases

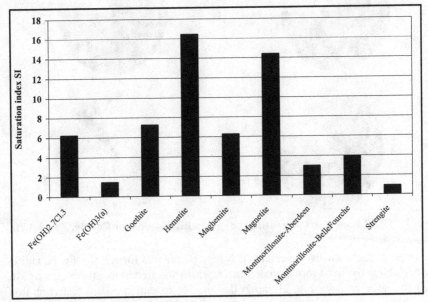

Fig. 65 EXCEL bar chart presenting the supersaturated iron mineral phases

4 Solutions

4.1 Equilibrium reactions

4.1.1 Groundwater – Lithosphere

4.1.1.1 Standard output well analysis

The water sample shows a low to average mineralization (ionic strength I = 1.189e-02 mol/L „description of solution"). It can be classified as Ca-Mg-HCO₃-type (Ca 1.872 mmol/L, Mg 1.646 mmol/L, HCO₃⁻ 3.936 mmol/L; „solution composition"). The analytical accuracy is sufficient with an electrical balance (eq) of -3.407e-04 and a percent error (100*(Cat-|An|)/(Cat+|An|)) of -2.36%.

Fig. 63 EXCEL pie chart presenting the species distribution for Ca, Mg, Zn, and Pb

In terms of redox-sensitive elements it is remarkable that for As, Cu, Fe, N, and U the respective oxidized forms predominate, while Mn predominantly occurs as Mn (+2) and Se as Se (+4). Fig. 21 shows that the Mn oxidation does not start up to a pE > +10, while the present analysis has a pE of 6.9. The oxidation of Se starts at

Additionally, you will have to define EQUILIBRIUM_PHASES 2 within the WPHAST GUI and you have to adapt the *.chem.dat file by adding EQUILIBRIUM_PHASES 2 with iron as phase to be dissolved and uraninite as phase to be precipitated only. Since REACTION is not available in PHAST and iron is not a defined phase in WATEQ4F (which is named PHAST.dat in your case) you have to define zero-valent iron as phase via the keyword PHASES in the input file (HINT: LLNL-database does contain iron as phase).

As a final step, extend now the surface complexation for uranium species. Checking the WATEQ4F database (named phast.dat in this particular case) you will find at the very end of the file the defined surface complexation species. For uranium only UO_2^{2+} is defined. At a pH of >6 under natural conditions UO_2-carbonate species are dominant, but they are not defined as candidates for surface complexation. Thus, define a surface complexation species for $UO_2(CO_3)^{2-}$ in the PHREEQC control file of the PHAST job by adding a SURFACE_SPECIES block with two weak surface species: SURFACE-$UO_2(CO_3)_2^-$ with log_k of 12.0 and SURFACE-$UO_2(CO_3)_2^{2-}$ with log_k 5.0. Hint: take the sulphate complexation as an example.

The simulation time is supposed to be 200 days. Thus, the water of the fractures will be exchanged 10 times in the 200 m long aquifer section.

The discretisation shall be carried out in elements of 10 m length. The connection of the immobile cells to the mobile cells is done by a box for each cell (Fig. 62) and the exchange between mobile and immobile cells by the means of a 1st order reaction (for theory see chapter 1.3.3.3.1). Present the concentrations of the elements U, Fe, Al, and S at the pumping well over a period of 200 days.

Change the parameter "immobile pore volume" from 0.15 to 0.05 and the matrix thickness on each side of each fracture from 0.1 to 0.01. Compare the results.

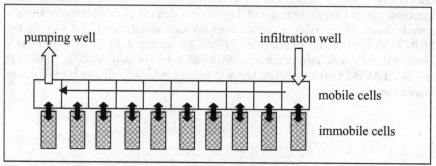

Fig. 62 Scheme for the model approach of a double porosity aquifer

3.3.6 3D Transport – Uranium and arsenic contamination plume

In the introductory example for 3D transport modeling with PHAST (chapter 2.2.2.5.3), distribution of a uranium contamination from an in-situ leaching mine was modeled. Comparing the concentrations of uranium and arsenic in that example shows a significantly better sorption for arsenic by surface complexation on iron-hydroxides than for uranium. To demonstrate the influence of surface complexation on the contamination plume, change the PHAST input file and/or the PHREEQC control file by removing the calculation for surface complexation. Now you will see a significant change in particular for arsenic. It might be a good idea to copy the *.phast and the *.chem.dat file to new filenames before making any changes, since you can then readily compare between different versions.

In a second step, implement an iron permeable reactive barrier (PRB) in the 3D PHAST model! Reactive barriers with zero valent iron are commonly used for natural attenuation remediation measures. Assuming that zero-valent iron is available (which is probably oversimplification) we can model this by implementing a reactive wall 100 m downstream of the mine by using the "new zone" tool: simply draw a rectangular box and adjust it by clicking on the new zone with the red arrow symbol. Zone dimension boxes will open in the lower left corner where you can set x to 100 & 115, y to 100 & 400 and z to 50 & 100. Thus, the new zone (5) and the reactive wall will be only in the upper 30 m.

Apply 1 m/s as flow velocity so that the total contact time in the channel is 500 seconds. The modeling should be done as 1D transport model with 10 cells (dispersivity: 0.1 m) and last over 750 seconds. Also take into account the contact with the atmosphere. Therefore, run the model once with a CO_2 partial pressure of 0.03 Vol% and a second time with 1 Vol%, both times assuming an oxygen partial pressure of 21 Vol% O_2. The latter case corresponds rather to a closed carbonate channel.

Illustrate the results of the model by presenting the water characteristics over the whole length of the channel at the end of the modeling (pH value, SI calcite, Ca, Fe, C, SO_4^{2-}, $CaSO_4^0$). Additionally indicate the amounts of calcite dissolved and of gypsum and iron hydroxide precipitated.

3.3.5 In-situ leaching

Aquifers with double porosity (e.g. sandstones with fractures and pore volume) require special considerations with regard to transport modeling even if no reactive mass transport in its proper sense is taken into account. This problem is demonstrated with the following example of an aquifer regeneration in a uranium mine. The ore was leached in this mine by in-situ leaching (ISL) using sulfuric acid. The hydrochemical composition of the water that is in the aquifer after this in-situ leaching process is shown as "ISL" in Table 41:

Table 41 Water analysis of a natural groundwater (GW) and groundwater influenced by in-situ leaching (ISL) (concentrations in mg/L)

Parameter	GW	ISL	Parameter	GW	ISL	Parameter	GW	ISL
pe	6.08	10.56	Cu	0.005	3	Ni	0.005	5
Temp.	10 °C	10	F	0.5	1	NO_3^-	0.5	100
Al	3.0	200	Fe	0.6	600	Pb	0.05	0.2
As	0.004	2	K	1.5	4	pH	6.6	2.3
C(4)	130		Li	0.02	0.1	Si	3.64	50
Ca	36.6	400	Mg	3.5	50	SO_4^{2-}	14.3	5000
Cd	0.0003	1	Mn	0.07	20	U	0.005	40
Cl	2.1	450	Na	5.8	500			

The simulation will be done in a zone of 200 m between an infiltration well and a pumping well. This zone shows a k_f value of $5 \cdot 10^{-5}$ m/s along the fracture and 10^{-8} m/s within the pores (those k_f values are only for orientation and are not needed directly for the modeling). The flow velocity is 10 m/day due to the potential head. The dispersivity is 2 m. Natural groundwater ("GW" in Table 41) will be infiltrated in the infiltration well and extracted at the pumping well.

Assume that the exchange between pores and fractures only takes place by diffusion ($2 \cdot 10^{-10}$ m²/s). The fracture volume is 0.05, and the pore volume is 0.15. Presuppose that the fractures are planar and that the distance between them is 20 cm. Thus, on average each fracture has a pore matrix of 10 cm thickness to each side. Homogeneous and heterogeneous reactions shall be ignored.

calcite saturation index shall be displayed along the 300 m long fracture after a single exchange with the infiltrating rainwater.

3.3.4 The pH increase of an acid mine water

Acid mine drainages (AMD) cause great problems in the mining industry as they typically contain high concentrations of iron, sulfate, and protons due to the pyrite oxidation. Consequently, other elements (e.g. metals and arsenic) may be increased as well. A simple method of water treatment is to conduct these acid waters through a carbonate channel. This process causes an increase of the pH value due to carbonate dissolution. Furthermore, it can result in supersaturation of other minerals that can precipitate spontaneously. The high sulfate concentrations combined with increasing calcium values from the calcite dissolution often exceed the gypsum solubility-product. Iron minerals are also supersaturated as a result of these reactions, and consequently e.g. amorphous iron hydroxide precipitates spontaneously. Even though the dissolution of calcite is relatively fast this exercise shows that the reaction kinetics still has to be taken into account to plan the dimensions of such a carbonate channel correctly. An acid mine drainage ("AMD") and a natural surface water are given (Table 40).

Table 40 Water analysis of an acid mine drainage ("AMD") and of a natural surface water ("SW")

Parameter	AMD	SW	Parameter	AMD	SW
pe	6.08	6.0	K	3.93e-05 mol/L	1.5 mgl/L
Temp.[°C]	10	10	Li	2.95e-06 mol/L	
pH	1.61	8.0	Mg	1.47e-04 mol/L	3.5 mg/L
Al	1.13e-04 mol/L		Mn	1.30e-06 mol/L	
As	5.47e-07 mol/L		NO_3^-	2.47e-04 mol/L	0.5 mg/L
TIC*)	3.18e-03 mol/L		Na	2.58e-04 mol/L	5.8 mg/L
HCO_3^-		130 mgl/L **)	Ni	8.72e-07 mol/L	
Ca	9.19e-04 mol/L	36.6 mgl/L***)	Pb	2.47e-07 mol/L	
Cd	2.27e-07 mol/L		SO_4^{2-}	5.41e-02 mol/L	14.3 mg/L
Cl	6.07e-05 mol/L	2.1 mg/L	Si	6.20e-05 mol/L	3.64 mg/L
Cu	8.06e-07 mol/L		U	2.15e-07 mol/L	
F	2.69e-05 mol/L		Zn	1.09e-05 mol/L	
Fe	2.73e-02 mol/L	0.06 mgl/L			

*) total inorganic carbon
**) adjust inorganic C to the partial pressure of the atmosphere (CO2(g) -3.5)
***) set Ca to "charge" in the PHREEQC input file

At the beginning of the modeling the 500 m long carbonate channel is filled with the surface water ("SW"). Then, the acid mine water is added. Calculate how the composition of the mine water changes, how much calcite is dissolved and how much gypsum and iron hydroxide precipitate. Additional problems like coating of the carbonate by gypsum and iron hydroxide crusts as well as the kinetics of the formation of gypsum and iron hydroxide are ignored in this model.

atmosphere. Because of the resulting carbonate precipitation, the creek forms a small carbonate ridge over the years, on top of which it flows in a small channel (Fig. 61).

Model the carbonate precipitation in this carbonate channel by means of a 1D transport with 40 cells of 10 m length each. Dispersivity is assumed with 1m. Use the keywords KINETICS and RATES and the BASIC program for calcite from the database PHREEQC.dat describing the kinetics for both the calcite dissolution and the calcite precipitation. How much calcite precipitates each year within the channel's first 400 meter after the discharge? How much CO_2 degasses at the same time?

[Note: For all n cells a SOLUTION has to be defined at the beginning of the modeling (SOLUTION 1-n). The same applies for the keywords KINETICS and EQUILIBRIUM_PHASES. If you use 1 instead of 1-n, the kinetic or the equilibrium reactions would only be modeled for the first cell.]

3.3.3 Karstification (corrosion along a karst fracture)

Talking about karstification often the question arises why karst phenomena do not only occur at the surface but in greater depths as well. The reason is that the carbonate dissolution is a comparatively fast process, but still takes some time, while water may cover quite a long distance along a fracture.

This shall be modeled with the following example. A fracture with an extension of 300 meters is given. Assume that, at the beginning of the simulation, this fracture is filled with groundwater that is in carbonate equilibrium. To simplify matters the following data shall be used:

pH 7.32
Temp 8.5
C 4.905 mmol/L
Ca 2.174 mmol/L

Infiltrating rainwater now dissolves CO_2 according to the increased partial pressure of 1 Vol% in the unsaturated zone. Thus, the seepage water has the following characteristics:

pH 4.76
Temp 8.5
C 0.5774 mmol/L

This water enters the model fracture with a velocity of 10 m per 6 minutes. Calculate the carbonate dissolution in the 300 meter long fracture that will be modeled as a one dimensional pipe with 30 elements of 10 m length each. Furthermore, consider a dispersivity of 0.5 m and assume that the whole water column will be exchanged once. Moreover, the fracture is not completely filled with water, but contains air, too. This air has a CO_2 partial pressure of 1 Vol%. The kinetics of the carbonate dissolution shall be assumed according to chapter 2.2.2.3.1. Further, use the keyword USER_GRAPH to visualize the result graphically within PHREEQC. The concentrations of Ca and C as well as the

pH = 8.0, pE = 12, temperature = 10.0 °C, Ca = 1, C = 2.2, Mg = 0.5, K = 0.2, SO_4^{2-} = 0.5

At a time T1, an acid mine drainage of the following composition is added (concentration in mmol/L):
pH = 3.2, pE = 16, temperature = 10.0° C, Ca = 1, C = 2.0, Mg = 0.5, K = 0.2, SO_4^{2-} = 4.0, Fe = 1, Cd = 0.7, Cl = 0.2

Calculate the distribution of the concentrations within the lysimeter column taking into account the cation exchange (discretisation and time steps as in the example in chapter 2.2.2.5). Selectivity coefficients are taken from the exemplary data of WATEQ4F.dat database and an exchange capacity of 0.0011 mol per kg water is assumed. Neither diffusion nor dispersion is considered. Present your results graphically.

3.3.2 Karst spring discharge

A karst water has the following chemical composition:
pH = 7.6, pE = 14.4, temperature = 8.5 °C, Ca = 147, HCO_3^- = 405, Mg = 22, Na = 5, K = 3, SO_4^{2-} = 25, Cl = 12, NO_3^- = 34 (concentrations in mg/L)

Fig. 61 Calcite ridge at a karst spring discharge near Weißenburg, Germany.

It is in equilibrium with a CO_2 partial pressure of 0.74 Vol% and is slightly supersaturated with regard to calcite (SI = 0.45). This karst water discharges at a spring with a mean discharge of 0.5 L/s and flows in a small channel downhill with a mean velocity of 0.25 m/s. Due to the turbulent flow, CO_2 will degas spontaneously until equilibrium is reached with the CO_2 partial pressure of the

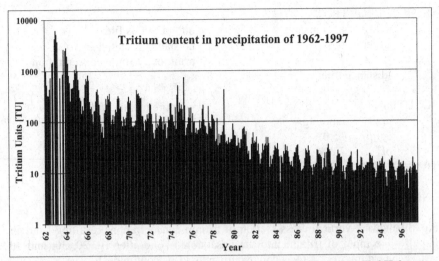

Fig. 60 Tritium concentration in rainwater, measured at the station Hof-Hohensaas, Germany (latitude 50.32 °N, longitude 11.88 °E, height 567 m NN) from 1962 to 1997

The definition of a more realistic tritium input function based on the available data of the tritium concentrations in the rainwater is done in time intervals of 5 years each (Table 39).

Table 39 Tritium concentrations in the atmosphere from 1962 to 1997

Intervall of 5 years	Tritium in the atmosphere (T.U.)
1 (06/1962 - 06/1967)	1022
2 (07/1967 - 07/1972)	181
3 (08/1972 - 08/1977)	137
4 (09/1977 - 09/1982)	64
5 (10/1982 - 10/1987)	24
6 (11/1987 - 11/1992)	17
7 (12/1992 - 12/1997)	13

Remodel the degradation of tritium in the unsaturated zone with this new input function. Compare your results with the results obtained from the assumption of an impulse-like tritium input in Fig. 59.

3.3 Reactive transport

3.3.1 Lysimeter

A lysimeter filled with sediments was equilibrated with the following water (concentrations in mmol/L):

```
SELECTED_OUTPUT
        -file      tritium.csv              # output to this file
        -reset     false                    # no standard output
        -totals    T                        # print total tritium concentration
        -distance true
END                                         # end of 3rd job
SOLUTION 0                                  # no more tritium after 10 years of
        units      umol/kgw                 # infiltrating water with 2000 TU
        temp       25.0
        pH         7.0
TRANSPORT
        Shifts     30                       # for another 30 years
END
```

Fig. 59 shows a vertical cross section of tritium concentrations resulting from an impulse-like input of tritium into the unsaturated zone after 10, 20, 30, and 40 years. The tritium peak moves downward and widens continuously.

The actual task now is to change the PHREEQC job in such a way that the tritium input function is not impulse-like but more realistic. Fig. 60 illustrates the increase of tritium concentrations in precipitation water from 1962 to 1963 and the subsequent decrease from 1963 to 1997, as determined at the climate station Hof-Hohensaas, Germany.

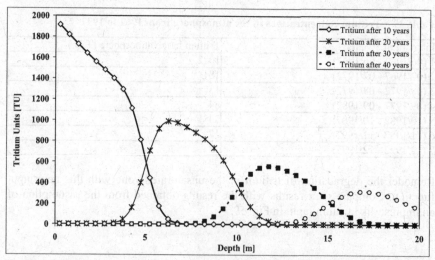

Fig. 59 Vertical cross section of tritium in the unsaturated zone (0-20 m depth) for the time intervals 10, 20, 30, 40 years assuming an impulse-like input during the first ten years

PHREEQC Job: Tritium in the unsaturated zone – impulse-like input function

```
TITLE                           tritium in the unsaturated zone
PRINT
        -reset false                            # no standard output
SOLUTION_MASTER_SPECIES  # define master species tritium
T       T+      -1.0    T       1.008
SOLUTION_SPECIES                        # define solution species tritium
T+ = T+
        log_k   0.0                             # dummy
        -gamma 0.0      0.0             # dummy
SOLUTION 0      tritium 1st phase       # tritium conc. 2000 T.U.after
                                        # the initial column water with 0 T.U.
        units   umol/kgw
        temp    25.0
        pH      7.0
        T       2000                    # unit umol/kgw, only fictitious
SOLUTION 1-40                           # initial column water without tritium
        units   umol/kgw
        temp    25.0
        pH      7.0
END                                     # end of the 1st job
RATES                                   # define degradation
T                                       # for tritium
-start
        10 rate = MOL("T+") * -(0.63/parm(1))    # 1st order kinetics (Table 13)
        20 moles = rate * time
        30 save moles
-end                                    # end of the 2nd job
KINETICS 1-40
T
        -parms 3.8745e+8                # 12.3 years in seconds (half-life of
                                        tritium)

TRANSPORT
        -cells  40                      # 40 cells
        -length 0.5                     # 0.5 m each, 40 * 0.5 = 20 m length)
        -shifts 10                      # 10 years
        -time_step      3.1536e+7       # 1 year in seconds
        -flow_direction forward         # forward simulation
        -boundary_cond flux     flux    # flow boundary condition at inlet
                                        # and outlet
        -diffc  0.0e-9                  # diffusion coefficient
        -dispersivity  0.05             # dispersivity
        -correct_disp   true            # correction of dispersivity yes
        -punch_cells  1-40              # cell 1 to 40 in Selected_Output
        -punch_frequency 10             # print every 10th time interval
```

3.2.4 Degradation of tritium in the unsaturated zone

If the unsaturated zone is composed of relatively fine sediment (silt and fine sands) a quasi-uniform seepage flow can be assumed for the unsaturated zone in humid climate zones over long time spans. Therefore, the transport of infiltrated water can be simulated in PHREEQC as a monotonous movement in accordance with the "piston flow" model. A constant flow of infiltration water of 0.5 m per year is assumed for the following simulation. Furthermore, it is considered simplistically that the infiltrating precipitation has a tritium activity of 2000 TU (tritium units) over a period of 10 years. Then, it is assumed that the tritium activity decreases to zero again.

The following example shows how this can be modeled in PHREEQC. First of all, a master and a solution species tritium T or T^+ have to be defined. Since the input of data for log_k und -gamma within the keyword SOLUTION_SPECIES is required, but unknown, any value can be entered here as a free parameter ("dummy", e.g. 0.0). This value is not used for kinetic calculations and thus, does not cause any problems. However, all results based on equilibrium calculations (e.g. the calculation of the saturation index) are nonsense for this "species". The tritium values have to be entered in tritium units (T.U.). However, in order not to have to define or convert them in an extra step, they are entered fictitiously with the unit umol/kgw instead of T.U. in PHREEQC. As no interactions of tritium with any other species are defined, the unit is eventually irrelevant. After modeling, remember that the result is displayed in mol/kgw as always in PHREEQC and has to be recalculated to the fictitious tritium unit umol/kgw. Entering mol/kgw in the input file, the solution algorithm quits due to problems with too high total ionic strengths.

The unsaturated zone is 20 m and is subdivided into 40 cells, 0.5 m each, so that a "time step" is exactly 1 year = 86400 * 365 seconds = 3.1536e+7 seconds. The half-life of tritium (12.3 years) has to be entered in seconds in PHREEQC. First, the created 1D soil column is saturated with water containing no tritium (solution 1-40). Then, water with 2000 T.U. is added over a period of 10 "shifts" (= 10 years) *(Note: solution 0 is always the solution which is added on top of the column)*. After this high tritium impulse, the solution is changed again to water containing no tritium, which percolates through the column for another 30 years. The two changes from water with 0 T.U. to 2000 T.U. and back again from 2000 T.U. to 0 T.U. are two different jobs that have to be separated by END.

The degradation of tritium is described as a 1^{st} order kinetic reaction as follows (see also Table 13):

$$\frac{d(A)}{dt} = -K_k \cdot (A)$$

$$t_{1/2} = \frac{1}{K_k} \cdot \ln 2$$

3.2.3 Degradation of organic matter within the aquifer on reduction of redox-sensitive elements (Fe, As, U, Cu, Mn, S)

The degradation of organic matter results in the consumption of oxygen. Under certain circumstances, this may lead to the reduction of oxygen-containing anions like nitrate (see also the exercise in chapter 3.1.6.1) and sulfate, as well as to the reduction of redox-sensitive elements like iron, manganese, or uranium. The decomposition of organic matter depends on the presence of microorganisms and is thus always connected to kinetics.

The reactions in an aquifer shall be modeled in the presence of calcite and large concentrations of pyrite and organic matter for the acid mine drainage from the exercise in chapter 3.1.3.3. As no inorganic carbon is given in the analysis and calcite is to be used as kinetically reacting mineral in the model, the analysis has to be completed by e.g. 1 mg/L carbon, formally.

PHREEQC always refers to one liter or one kg of water. The model describes a batch reaction with 1 liter water. 10 mmol calcite as well as 1 mol pyrite and 1 mol organic matter shall be present in the respective sediment/rock. To describe the kinetics of calcite and pyrite, the BASIC program given at the end of the database PHREEQC.dat is used. For the degradation of organic matter the PHREEQC.dat notation is used, too. However, the lines 50 and 60 have to be changed as follows to accelerate the decomposition of the organic matter. Nitrate is not taken into account in this example.

 50 rate = 1.57e-7*mO2/(2.94e-4 + mO2)
 60 rate = rate + 1.e-10*mSO4/(1.e-4 + mSO4)

Since there is no general definition for organic matter in any of the databases which are installed with the PHREEQC program, a name has to be assigned in the kinetics data block (e.g Organic_C) and the organic matter has to be specified using the keyword "-formula". Use the general formula CH_2O.

 -formula CH_2O

KINETICS needs three parts for organic matter, pyrite, and calcite, respectively. It is not relevant, in which block the time steps are defined. Using "-step_divide 1000000", the step width is cut down at the beginning of the kinetic calculations according to the quotient total time/step_divide.

Since all calcite is dissolved after 100 days at the latest, the following line for the calcite kinetics is inserted at the beginning of the BASIC program to save calculation time:

 5 if time > 8640000 then goto 200

The simulation time is 10,000 days in 100 intervals (steps). To obtain a higher temporal resolution at the beginning of the simulation, calculate a second model with only 600 days in 100 intervals.

3. How many years will it take until all pyrite in the heap is consumed?
4. How much carbonate has to be added during the heap construction to neutralise the pH value? Is it possible to reduce the amount of sulfate at the same time?
5. How does the necessary amount of carbonate change when assuming that a CO_2 partial pressure of 10 Vol% will develop within the heap as a result of the decomposition of organic matter?

Instead of assuming an oxygen diffusion rate as in this example, it is also possible to define a pyrite oxidation rate R that is a function of e.g. O_2, pH, temperature, the amount of microorganisms and the nutrient supply. Examples using direct reaction rates in PHREEQC follow in the next exercises.

3.2.2 Quartz-feldspar-dissolution

Model the dissolution of quartz and K-feldspar (adularia) over time. Are the parameters temperature and CO_2 partial pressure of any importance? Within the keyword RATES use the BASIC program from the database PHREEQC.dat. The calculation is done with distilled water (pH = 7, pE = 12) as a batch reaction over a time span of 10 years in 100 time steps at a temperatures of 5 °C and of 25 °C and at CO_2 partial pressures of 0.035 Vol% (atmosphere) and of 0.7 Vol% (soil). Calculate also the kinetics of the dissolution with 0.035 Vol% CO_2 and 25 °C for a period of 10 minutes.

[Note: The database WATEQ4F.dat uses the name adularia for K-feldspar. Use EQUILIBRIUM_PHASES to fix the oxygen concentration to 21 Vol%. Enter quartz with "0 0" under the same keyword. While the first zero limits the solubility to 100% saturation, the second zero indicates the possible amount of quartz added in moles. Zero means no further quartz addition (dissolution), i.e. that the 100% saturation can only be achieved through precipitation at supersaturation, but not through dissolution at undersaturation. This step is necessary, since the dissolution will be defined using KINETICS and RATES. It is quite useful, too, to limit the solubility of aluminium by the precipitation of e.g. kaolinite. In the simplest case this can be done by EQUILIBIUM_PHASES as well since this precipitation occurs spontaneously and fast. Thus, a kinetic modeling is not necessary.

Using the minerals quartz and kaolinite in EQUILIBRIUM_PHASES causes a problem in PHREEQC regarding the elements Si and Al because they do not occur within the keyword SOLUTION. Therefore you have to specify them in very small quantities in the solution (e.g. 1 µg/L). Furthermore, the sub keyword step_divide 100 within the keyword KINETICS is necessary. The output can be obtained most effectively using SELECTED_OUTPUT.]

3.1.6.2 Fe(0) barriers

Reactive barriers of elemental iron are used to reduce groundwater constituents in-situ and thus, to convert e.g. mobile uranium(VI) into uranium(IV) that precipitates as uraninite (UO_2). At the same time, the elemental iron in the reactive barriers oxidizes and iron hydroxide and subsequently crusts of iron oxide form. Precipitated iron hydroxides and uraninite reduce the reactivity of the barrier after a certain time.

The uranium containing mine water of the exercise in chapter 3.1.3.3 shall be cleaned by means of such a reactive barrier. How much iron per m^2 has to be used considering a percolation of the reactive barrier of 500 L/d·m² to reduce the amount of uranium from 40 mg/L to at least one third taking into account that the barrier shall be in operation for approximately 15 years? How much uraninite will precipitate?

3.1.6.3 Increase in pH through a calcite barrier

To increase the pH of the acid mine drainage from the exercise in chapter 3.1.3.3 a reactive wall of 1 m thick calcite (density of calcite = 2.71 g/cm³) shall be installed within the aquifer. Thickness and permeability of the wall are chosen in a way that a 50 % saturation of lime in the aquifer can be reached with a daily percolation of 500 L/m².

Does the calcite wall lead to the desired increase of the pH value? Why are there still objections against the reactive calcite wall taking into account the long-term efficiency and premature alteration? Which carbonates could be chosen alternatively to calcium carbonate to avoid a premature alteration?

3.2 Reaction kinetics

3.2.1 Pyrite weathering

Diffusion calculations for a covered heap containing pyrite show that 0.1 m³ of oxygen enter the heap every day by diffusion. It is assumed that this oxygen is completely consumed by pyrite oxidation within one day. Therefore, reaction kinetics is exclusively determined by the diffusion rate of the oxygen into the heap. An average of 0.1 mm of rainwater infiltrates through the heap cover daily. The rainwater has a pH of 5.3, a temperature of 12 °C and is in equilibrium with the CO_2 and O_2 partial pressure of the atmosphere. The heap covers an area of 100 m x 100 m, has a height of 10 m, and a pyrite concentration of 2 Vol%. The following questions are to be solved:
1. What is the chemical composition of the seepage water discharging at the foot of the heap along the base sealing?
2. What happens when water at the foot of the heap gets in contact with atmospheric oxygen?

Vary the partial pressure of oxygen. What is remarkable?

Is the pH value after the aeration still within the limits required for potable water?

To set up the dimensions of a water treatment plant correctly, it is important to know the amount of sludge that will form every day as a result of the precipitation of mineral phases. Enforce the precipitation of the mineral phases that are most likely to precipitate during aeration in your model and calculate the accumulating amount of sludge per day assuming a production rate of 30 L/s in the future water treatment plant. Do not forget that sludge does not only consist of the precipitated mineral phases but mainly of water (60-90 %).

Evaluate your model with regard to the elements N and S. What will the results rather look like in reality and why?

3.1.5.5 Mixing of waters

Not far from the drinking water well B3 in the model area (Fig. 57) there is an older, abandoned well B4 that has been shut down for several years as it did not meet the quality requirements for potable water anymore. Recent investigations showed the following result: pH = 6.99, temperature = 26.9°C, Ca^{2+} = 260 mg/L, Mg^{2+} = 18 mg/L, Na^+ = 5 mg/L, K^+ = 2 mg/L, HCO_3^- 4 = mmol/L, SO_4^{2-} = 260 mg/L, Cl^- = 130 mg/L, NO_3^- = 70 mg/L.

It is planned to reactivate the well B4 to support peak times of water consumption and to mix the extracted water with that of the current drinking water well B3. Check with the help of PHREEQC modeling if and in which shares this can be done with regard to general requirements of drinking water standards and to the technical requirements in terms of the calcite-carbondioxide equilibrium (chapter 3.1.5.2). *[keyword for mixing of two waters see exercise in chapter 3.1.3.3.]*

3.1.6 Rehabilitation of groundwater

3.1.6.1 Reduction of nitrate with methanol

Groundwater from the exercise in chapter 3.1.5.1 in an area with intensive agriculture shows extremely high concentrations of nitrate due to years of excessive fertilization. Methanol as a reducing agent shall be pumped into the aquifer via infiltration wells to reduce the pentavalent nitrogen (nitrate) to the zero valent gas nitrogen. The latter can degas leading to a decrease of nitrate concentrations in the aquifer. How many liters of a 100 % methanol solution (density of methanol = 0.7 g/cm^3) per m^3 aquifer have to be pumped into the aquifer to guarantee an effective reduction of nitrate concentrations? What effect could an "overdose" of methanol have?

pH value shall only differ ± 0.2 pH units from the pHc (the pH value at calcite saturation) (ΔpH = pH – pHc). The aim is to have a pH value that is slightly above the pHc value (0.05 pH units) because then a protective layer can develop on the pipe walls. On the contrary, significant supersaturation (ΔpH > 0.2) leads to noticeable calcite deposits within the pipes and potential blockages which is as undesirable as undersaturation (ΔpH < -0.2), which leads to corrosion.

Additionally, potable water should not exceed pH values of 9.5 or fall below pH values of 6.5.

Consider these technical requirements when checking if the potable water extracted from the drinking water well B3 in the model area (chapter 3.1.1.1, Fig. 57) can be used without further treatment.

3.1.5.3 Water treatment by aeration – well water

Check whether an open aeration (equilibrium with atmospheric CO_2, open system) would help to meet the requirements concerning the pH as well as the ΔpH for the drinking water which is extracted from well B3 in the model area (Fig. 57).

[Note: For simulating the open aeration and the calculation of the new pHc in one job, use the commands SAVE_SOLUTION, END and USE_SOLUTION 1 like in the exercise in chapter 3.1.3.3.]

3.1.5.4 Water treatment by aeration – sulfur spring

For the little village as well as for some individual farms in the eastern part of the model area (Fig. 57), a possibility for drinking water supply is sought. The spring discharging east of the village shall be investigated for suitability. The hydrogeochemical data can be found in Table 38.

Table 38 Water analysis of a spring water (concentrations in mg/L)

pH	6.5		
Redox potential	-120 mV	Al	0.26
Temperature	10.7 °C	SiO_2	24.68
O_2	0.49	Cl	12.76
Ca	64.13	HCO_3	259.93
Mg	12.16	SO_4	16.67
Na	20.55	H_2S	2.33
K	2.69	NO_3	14.67
Fe	0.248	NH_4	0.35
Mn	0.06	NO_2	0.001

Illustrate the species distribution for the elements aluminium, iron(II), and iron(III). Then, model a water treatment in terms of an open aeration with atmospheric oxygen (oxidation!). What happens to the Al and Fe species? Which mineral phases will presumably precipitate during the aeration?

K = 399.1 mg/L, HCO_3^- = 141.682 mg/L, SO_4^{2-} = 2712.0 mg/L, Cl = 19353.0 mg/L, Si = 4.28 mg/L, Mn = 0.0002 mg/L, Fe = 0.002 mg/L. Furthermore, consider a higher density for seawater (1.023 g/cm^3)!

The following analysis is given for the Quaternary aquifer: pH = 6.9, temperature = 18 °C, Ca = 65.9 mg/L, Mg = 40.1 mg/L, Na = 3.5 mg/L, K = 7.5 mg/L, HCO_3^- = 405.09 mg/L, SO_4^{2-} = 23.4 mg/L, Cl = 15.8 mg/L, PO_4^{3-} = 0.921 mg/L.

Determine the origin of the mixed groundwater (i.e. the share of seawater and fresh groundwater) taking into account the geological features around the irrigation water well. Keep in mind that there is no distinct aquiclude between the Quaternary and the Cretaceous aquifer.

Note: In general, check each analysis regarding the analytical error and enforce, if necessary, a charge balance when the deviations are too high <u>before</u> starting the modeling.

3.1.5 Anthropogenic use of groundwater

3.1.5.1 Sampling: Ca titration with EDTA

To determine the amount of calcium in a water sample, e.g. titration with EDTA (ethylenediaminetetraacetate, $C_2H_4N_2(CH_2COOH)_4$) can be used. First of all, NaOH is added to the sample to obtain a pH value of at least 12. Then, a color indicator is added and the titration with EDTA is performed until the color changes. In doing so, all Ca is converted to a Ca-EDTA complex and detected in this form.

Model the determination of the concentration of Ca for the following analysis with PHREEQC: pH = 6.7, temperature = 10.5 °C, Ca^{2+} = 185 mg/L, Mg^{2+} = 21 mg/L, Na^+ = 8 mg/L, K^+ = 5 mg/L, C(4) = 4.5 mmol/L, SO_4^{2-} = 200 mg/L, Cl = 90 mg/L, NO_3^- = 100 mg/L.

The amount of EDTA that has to be added until the color changes is unknown. Therefore, EDTA is added step by step and the titration is continued beyond the point of color change. The point of color change will be determined afterwards using the obtained graph.

[EDTA cannot be found in the previously used database WATEQ4F.dat. It is only defined in the database MINTEQ.dat. Therefore, use this one. The keyword for the addition of EDTA is the same as for the exercise in chapter 3.1.1.9.]

3.1.5.2 Carbonic acid aggressiveness

In drinking water standards it is often required that "water should not be aggressive". In most cases this "aggressiveness" refers to the carbonic acid. The reason for the requirement of a low aggressiveness is not of toxicological but of technical nature since carbonic acid waters easily corrode pipeline materials (concrete, metals, plastics). Regulations therefore recommend that the measured

Note: Remember the explanation in the introduction of chapter 3.1.4 that the portions of several initial solutions on the final solution can be modeled with the help of the inverse modeling!

To include the isotopes in the modeling, they have to be defined under each respective SOLUTION using the sub keyword "isotope".

SOLUTION
 -isotope [name of the isotope in the following form: mass number element]
[value in %, pmc or as ratio] [uncertainty in % (possible, but not necessary)], e.g.
 -isotope 13C -6 0.8
 Instead of the sub keywords –isotope the abbreviation –i can be used.

Isotope data can only be used for inverse modeling. There, the respective isotopes have to be listed again under the keyword Inverse_Modeling and under the sub keyword –isotopes, e.g.
 INVERSE_MODELING
 -isotopes
 13C
 2H
 18O
 Additionally for each mineral or gas phase containing these isotopes their share has to be defined (mean value, in the example 2 ‰ and deviation, in the example ± 2 ‰) and whether the respective phase shall be dissolved or precipitated, e.g.
 -phases
 calcite pre 13C 2.0 2

Consider an average concentration of ^{13}C between 1-5 ‰ for dolomite, 0-4 ‰ for calcite and -20 to -30 ‰ for CO_2. The isotopes 2H and ^{18}O can only be found in the water molecule. Therefore they do not have to be defined for a mineral phase. If you want to keep the option of dissolution or precipitation open, define the mineral phases twice, once using dis (dissolve), and a second time using pre (precipitate).

3.1.4.2 Salt water/fresh water interface

As a result of the groundwater extraction in coastal areas, seawater intrusions occur, leading to a mixture of salt water and fresh water. Such a mixed groundwater of the following chemical composition is extracted from the irrigation water well B1 in the model area west of the town (Fig. 57): pH = 6.58, temperature = 13.4 °C, Ca = 3.724e-03 mol/L, Mg = 1.362e-02mol/L, Na = 1.080e-01 mol/L, K = 2.500e-03 mol/L, C = 7.067e-03 mol/L, S = 6.780e-03 mol/L, Cl = 1.261e-01 mol/L, P = 7.542e-06 mol/L, Mn = 8.384e-10 mol/L, Si = 1.641e-05 mol/L, Fe = 8.248e-09 mol/L.

The results of the analysis of the seawater are as follows: pH = 8.22, temperature = 5.0 °C, Ca = 412.3 mg/L, Mg = 1291.8 mg/L, Na = 10768.0 mg/L,

3.1.4.1 Pumping of fossil groundwater in arid regions

50 L/s groundwater of the following composition (Table 35) are extracted from a well in an arid zone.

Table 35 Water analysis of a groundwater (pH = 6.70, temperature = 34.5 °C, concentrations in mg/L)

K	2.42	Na	12.96	Ca	247.77	Mg	46.46
Alkalinity	253.77	Cl	6.56	NO_3^-	2.44	SO_4^{2-}	637.75
SiO_2	4.58	^{13}C	-6 ± 0.8	2H	-68 ± 0.6	^{18}O	-9.6 ± 0.3

It is known that only a small amount of the extracted groundwater originates from recent groundwater resources (Table 36). The rest is extracted from a reservoir of fossil water that has formed 20,000 years ago when temperatures were considerably lower in that area than they are today.

The fossil water is characterised by high total mineralization as a result of long residence times in the subsurface as well as by lower 2H and ^{18}O isotope values as a result of the lower temperatures during formation (Table 37). The different amounts of ^{13}C can be explained by the establishment of equilibrium of the fossil groundwater with marine limestones with higher amounts of ^{13}C than recent groundwater, which reflects the lower concentrations of ^{13}C in the atmosphere.

Table 36 Water analysis of a recent groundwater (pH = 6.70, temperature = 28.0 °C, concentrations in mg/L)

K	2.87	Na	14.60	Ca	72.60	Mg	20.50
Alkalinity	247.97	Cl	4.00	NO_3^-	4.52	SO_4^{2-}	69.96
SiO_2	32.16	^{13}C	-22 ± 1.4	2H	-52 ± 0.5	^{18}O	-7.5 ± 0.3

Table 37 Water analysis of a fossil groundwater (pH = 6.90, temperature = 40 °C, concentrations in mg/L)

K	3.33	Na	18.41	Ca	351.80	Mg	65.96
Alkalinity	298.29	Cl	9.00	NO_3^-	1.35	SO_4^{2-}	906.15
SiO_2	20.74	^{13}C	0 ± 0.4	2H	-76 ± 0.7	^{18}O	-10.5 ± 0.4

Apply inverse modeling to determine how much of the extracted groundwater originates from the reservoir of fossil water. Also take into account that the extracted groundwater has been in contact with sandstones, dolomitic limestones, gypsum and halite and that under the given conditions neither dolomite nor gypsum nor halite will precipitate. Assume precipitation for calcite and degassing of CO_2.

If the amount of fossil water in the extracted groundwater is known an estimation can be given on how long it will take to completely exploit the approximately 5 m high, 1 km wide and 10 km long reservoir assuming a constant rate of production of 5 L/s.

as well as the involved mineral- and gas phases as PHASES. The structure of such a job follows:

```
TITLE Inverse Modeling
SOLUTION 1              # original water (rainwater)
SOLUTION 2              # water after the reaction with minerals and gases
                       # (well water)
INVERSE MODELING
        - solutions 1 2    # solution 1 transforms into solution 2
        - uncertainty 0.1  # 10 % uncertainty equally defined for all elements in
                           #the analysis and both waters 1 and 2
        - balance Ca   0.2  0.3     # for special elements higher uncertainties can
                                    # be defined, e.g. for elements whose
                                    # determination underlies a greater error,
                                    # e.g. 20 % error for the amount of Ca in
                                    # solution 1 and 30 % error for the amount of
                                    # Ca in solution 2
        - phases                    # definition of involved phases
            K-mica     dissolve     # mica can only be dissolved
            CO2(g)                  # both dissolution and degassing possible
            SiO2(a)                 # both dissolution and precipitation possible
            Kaolinite   precip      # allow only for precipitation

END                                 # end of the job
```

Note: For each element in solution 1 or solution 2, a mineral or gas phase has to be defined under PHASES that contains this element. Otherwise PHREEQC reports the following problem: "element is included in solution 1, but is not included as a mass-balance constraint". The modeling can still be continued, however the respective element is not considered for the mass balance.

The number of the mineral phases as well as the size of the uncertainty should be varied to simulate different possible situations. Maybe the program does not find a valid model after the first calculation. Then the mineral phases have to be changed or completed or the uncertainty has to be increased, whereas of course uncertainties of > 10 % do not permit any reliable predictions anymore. Also including as many mineral and gas phases as possible, does not help. The main goal is to exclude as many reaction pathways as possible and find others with a minimum of necessary gas and mineral phases.

Depending on the number of mineral phases and the uncertainty chosen the program displays one or more models in the output. Each model describes how much of each mineral was dissolved or precipitated to transform solution 1 (rainwater) into solution 2 (well water) (keyword: phase mole transfers). If you enter several initial solutions (e.g. 5 analyses of rainwater from 5 individual altitudes), the program will also calculate the share of the respective rainwater solutions contributing to the final solution (well water).

Table 34 **Water analysis of an acid mine drainage AMD (pH = 2.3) and of a groundwater GW (pH = 6.6) (concentrations in mg/L)**

	GW	AMD		GW	AMD			GW	AMD
pE	6.08	10.56	Cu	0.005	3	Ni	0.005	5	
Temperature	10	10	F	0.5	1	NO_3^-	0.5	100	
Al	3.0	200	Fe	0.6	600	Pb	0.05	0.2	
As	0.004	2	K	1.5	4	pH	6.6	2.3	
C(4)	130		Li	0.02	0.1	Si	3.64	50	
Ca	36.6	400	Mg	3.5	50	SO_4^{2-}	14.3	5000	
Cd	0.0003	1	Mn	0.07	20	U	0.005	40	
Cl	2.1	450	Na	5.8	500				

Note: The PHREEQC keyword for mixing two waters is MIX. Here you have to enter the number of the solution and the percentage, to which the solution contributes to the mixture. Assuming a mixture of 25 % from solution 1 and 75 % from solution 2 may be expressed in the one or the other form:

MIX MIX
1 0.25 1 1
2 0.75 2 3

When mixing the acid mine drainage, assume that it will be diluted 1:1 with groundwater. Dilute this water again 1:1 with groundwater and so on until you obtain more or less pure groundwater. Save the first 1:1 diluted solution using the keyword SAVE_SOLUTION 3, terminate the job with END, and start the next job with USE_SOLUTION 3, etc.

3.1.4 Origin of groundwater

Inverse modeling
The determination of the origin of groundwater is an important aspect of hydrogeological investigations. For establishing drinking water protection zones e.g. it is necessary to know the groundwater's origin to determine possible geogenic or anthropogenic contamination potential and its impact on the extracted groundwater.

The basic idea is to reconstruct geochemical evolution of the groundwater from its chemical composition. For example, knowing the chemical composition of a well on the one hand and an analysis of the rainwater on the other, it will be possible to reconstruct which geological formation the rainwater must have passed after its infiltration to change its chemical composition as the result of reactions with mineral and gas phases (dissolution, precipitation, degassing) in a way that accounts for the composition of the water from the well.

The keyword in PHREEQC is "Inverse Modeling". The primary solution(s) (rainwater) and the final product (well water) have to be defined as SOLUTION

program will overwrite a column of the original data!). Note: The macro neither closes automatically nor displays the end of the calculation. The calculation will be finished after approximately 5 seconds at the most. After that, the Microsoft Visual BASIC window has to be closed manually to go back to the modified EXCEL table.

With the 3 columns pE, pH, and predominant species, a pE-pH-diagram can be generated as a raster image in Excel. The first step is to sort all three columns according to the column "predominant species" (menu Data/Sorting). The most suitable diagram type is scatter plot (XY) with X = pH and Y = pE. When highlighting the columns pE and pH and creating a scatter diagram all points will appear automatically in the same color (Note: To obtain a raster object choose a filled rectangle as point symbol by double clicking on the XY points. Vary the size of the rectangles so that a completely filled surface results, approximately 20 pt).

For the individual predominant species to appear each in a different color, click with the right mouse button in the diagram and choose the window "data source". Under "row" you can define a data series for each species (per default, there is only one database with the name "pe" comprising all species). Further data series can be defined by using "Add", e.g. the series Fe2+, with name (Fe2+), X value (as found in the table, e.g. in column A from row 146 to 268) and the respective Y values (B 146 – B 268). The X and Y values can be defined most simply by clicking with the mouse on the red arrow beside the cells for X values and Y values and mark the respective cells in the table (A146-A268 for X, B146-B268 for Y). As soon as a data serie has been defined for each species, different colors will be assigned automatically. A raster-pE-pH-diagram is obtained reflecting the predominance of individual species by differently colored zones.

Create a pE-pH-diagram of the predominant iron species in a solution, which contains 10 mmol/L Fe and 10 mmol/L Cl. Vary pH and pE values from 0 to 14 and from -10 to +20, respectively, in steps of 1 as well as of 0.5.

3.1.3.2 The Fe pE-pH diagram considering carbon and sulfur

How does the pE-pH diagram created in chapter 3.1.3.1 change when 10 mmol/L S(6) or 10 mmol/L C (4) in solution are taken into account?

3.1.3.3 The pH dependency of uranium species

An acid mine water mixes downstream of a mine with groundwater of the following chemical composition (Table 34).

How do the uranium species change? Which species predominate at which pH value? What are the effects of the change in uranium species concerning processes of transport and sorption?

stability field of water are missing. The water constituents defined under SOLUTION (e.g. Fe, Ca, Cl, C, S, etc.) are alike in all 311 jobs.

To avoid looking for the predominant species in 311 output jobs manually after modeling, two means are offered: At first, a SELECTED_OUTPUT (see also chapter 2.2.1.4) has to be defined in the PHREEQC master input file. Besides pE and pH, it will list all species of interest, for example all Fe species, in a .csv file. These species have to be specified explicitly under the sub keyword "-molalities", e.g. Fe2+, Fe3+, FeOH+, etc. The BASIC-reproduction program inserts the 311 SOLUTION jobs before the keyword SELECTED_OUTPUT. Since the SOLUTIONs are not separated by an END, one SELECTED_OUTPUT will be created for all SOLUTIONs displaying for each of the 311 jobs a row with the columns pH, pE, m_Fe2+ (concentration of Fe2+ in mol/L), m_Fe3+, m_FeOH+, etc.

To open and to view this .csv file use GRID in PHREEQC. The species with the highest concentration (predominant species) have to be determined for each row (i.e. for each pE-pH combination). To avoid doing this manually, the data have to be copied into EXCEL and to be treated with a macro, which can also be found on the CD enclosed in this book. The macro can be activated by opening the Excel file "macro.xls" from the book´s CD and by clicking on "activate macros". Now, one can either copy data instead of the given test data into table 1 or open the .csv file directly in Excel. The activated macro is available for all open Excel files. The macro itself can be opened under menu Extras/Macro/Macros under the name "maxwert". Using the menu "edit", the macro can be viewed and edited. The data range as well as the number of rows and columns for the data range has to be defined under "edit". The definition for the test data follows:

```
Sub maxvalue
' adjust N% and M% as well as the data range
N% = 6: M% = 4    ' N% = number of rows, M% = number of columns
Dim name As Range
Dim wert As Range
Set name = Worksheets("Table1").Range("A1:D1")
Set wert = Worksheets("Table1").Range("A1:D6")
```

The values marked in bold have to be changed according to the current data range. If data has been pasted into table 1 replacing the test data, the name of the worksheet needs no further modification. If the .csv file has been opened directly, the name of the current worksheet has to be entered in the macro.

The macro is started using the play button (▶) or the menu Execute/Execute SubUserForm. Then the macro automatically scans each row for the cell with the highest value (= the highest concentration). The columns pH and pE are skipped automatically. For each cell found with a maximum value the respective header cell is written into the first empty row right next to the defined data range. The completed EXCEL table finally has one column more than the original .csv file, in which the names of the predominant species for each pE-pH combination are given (Attention: If the data range has been defined too small by mistake, the

Calculate the amount of calcite being dissolved every year in an area of 50 km ⋅ 30 km. How large is the volume of cavities created by this kind of karst weathering assuming a density of calcite of 2.71 g/cm^3? How much is the theoretical subsidence resulting from the calcite dissolution per year over the whole area of 50 km ⋅ 30 km? (Formation of caverns first prevents an immediate subsidence. Only after those caverns collapse, site-specific subsidence structures appear at the surface. This aspect of time and spatial distribution shall be neglected for the calculations above.)

3.1.3 Groundwater

3.1.3.1 The pE-pH diagram for the system iron

In chapter 1.1.5.2.3, using the system $Fe-O_2-H_2O$ as an example, it was demonstrated that the species distribution can be determined analytically under different pH- and redox conditions and illustrated in a pE-pH-diagram. In the following examples, the numerical solution will be modeled with the help of PHREEQC.

The modeling is relatively simple. In the input file, certain pE- and pH values have to be defined besides the species in solution. After the modeling, the dominant species (i.e. the species with the highest concentration) has to be determined from the species distribution in the output. Varying the pH value between e.g. 0 (acid) and 14 (alkaline) as well as the pE value between e.g. -10 (reducing) and +20 (oxidizing) and listing the dominant species for each pE-pH combination creates a pE-pH-diagram as a raster image. The smaller the increment (=step width) for the variation of pE and pH is chosen, the finer the raster of the pE-pH-diagram will be.

To avoid entering every pE and pH combination individually (e.g.: using an increment of 1 for pH and pE there would be 15 pH values x 31 pE values = 465 combinations!), a BASIC program was written. It copies a PHREEQC master input file, in which the job is defined for any pE and pH value once, and changes pE and pH step by step. The program is enclosed on the CD to this book ("ph_pe_diagramm.exe"). The program is asking for pH and pE minimum values, maximum values, and the increment ("delta"). Furthermore, the existing PHREEQC master input file and a new output file have to be chosen.

The program takes into account that aquatic species are limited in every pE-pH-diagram by the stability field of water. Therefore, the program deletes automatically all pE-pH combinations above the line of transformation O_2-H_2O or below the line of transformation H_2O-H_2. Assistance for the program can be found within the menu HELP.

When considering the increment of 1 for pE and pH, i.e. 15 pH values ⋅ 31 pE values, the output file would comprise 465 jobs, numbered from SOLUTION 1 to SOLUTION 465, each containing different pE- and pH values. In fact, there will be only 311 jobs since the SOLUTIONs with pE-pH values above or below the

Approximately 100 liter of the infiltrated, calcareous water is dripping daily from the ceiling into the cavern, in which the CO_2 partial pressure is the same as in the atmosphere. Stalactites form (Fig. 58) - why and in which amount per year?

How many mm per year do the stalactites grow assuming that the density of calcite is 2.71 g/cm^3 and that approximately 15 % of the cavern ceiling is covered with stalactites?

3.1.2.5 Evaporation

Evaporation changes the rainwater chemistry in the sense of a relative depletion of volatile components and a relative enrichment of non-volatile components.

As the calculation of the evaporation is quite tricky in PHREEQC, the following example is given as an introduction. It is important to know that 1 kg of water consists of approximately 55.5 mol of H_2O. First, a titration with a negative amount of water (in mol) will be done, in order to remove pure water. Afterwards, the resulting, enriched solution has to be reconverted to 55.5 mol by mixing the solution with itself.

```
Title 90 % evaporation as example
Solution 1 rainwater
.......
REACTION 1              # evaporation
H2O      -1.0           # remove water by -H2O!
         49.95 moles    #90 % evaporation; 100% = 1 kg H2O = 55.5 mol =>
                        #90% = 49.95 mol
                        #the resulting 10 % of the original amount of water
                        #have the same chemical composition as the 100 %
                        #before => the same amount of substance in less
                        #solvent, i.e. enrichment has taken place
save solution 2
END
MIX
2      10               # mix SOLUTION 2 10 times with itself
                        # to get back to 100 % of enriched solution
save solution 3
END
....further reactions, e.g. equilibrium reactions etc.
```

Calculate the composition of seepage water with and without considering evaporation assuming that the annual average precipitation in an area is 250 mm, the current evaporation is 225 mm, and the surface runoff is 20 mm. Use the rainwater analysis of exercise chapter 3.1.2.1. Furthermore, there is an increased CO_2 partial pressure of 0.01 bar in the unsaturated zone. This unsaturated zone consists mainly of limestone and sandstone.

Table 33 Dependency of O_2 solubility on temperature at $P(O_2) = 100 \%$

Temperature	Gas solubility	Temperature	Gas solubility	Temperature	Gas solubility
0	0.0473	20	0.0300	50	0.0204
5	0.0415	25	0.0275	60	0.0190
10	0.0368	30	0.0250	70	0.0181
15	0.0330	40	0.0225	90	0.0172

Estimate from Table 33 how much O_2 per liter water is dissolved at the given temperature and at an atmospheric O_2 partial pressure. For this approximation it can further be assumed that there is 1 mole O_2 in 22.4 liter gas.]

3.1.2.4 Formation of stalactites in karst caves

The rainwater of exercise chapter 3.1.2.1 infiltrates in a karst area. There is enough time that an equilibrium regarding the predominant mineral phase and an elevated CO_2 partial pressure of 3 Vol% can be reached.

Fig. 58 Formation of stalactites in karst caverns

In the underground, there is a karst cavern with an extension of 10 m length, 10 m width, and 3 m height connected via a natural tunnel to the atmosphere.

gas can reach approximately 1-5 Vol% in a humic climate. This amount is a significant increase compared to the CO_2 partial pressure in the atmosphere of 0.03 Vol% (see also the exercise in chapter 3.1.1.6). Simulate the effect that a soil CO_2 partial pressure of 1 Vol% has on the following rainwater: Na = 8, K = 7, Ca = 90, Mg = 29, SO_4^{2-} = 82, NO_3^- = 80, C(+4) = 13 and Cl = 23 [all units in µmol/L]. Value of pH: 5.1, temperature: 21°C.

Attention: In PHREEQC, C(+4) has indeed to be expressed as C(+4) and not as alkalinity as we did it so far. Because of the low concentrations in rainwater, a "conventional" determination of the alkalinity by titration is not possible, only the determination of the TIC (total inorganic carbon, C(+4)) can be done.

3.1.2.2 Buffering systems in the soil

How do different buffer systems in the soil (Al-hydroxide-, exchanger- (50 % NaX, 30 % CaX$_2$, 20 % MgX$_2$), carbonate-, Fe-hydroxide-, Mn-hydroxide buffer) affect the chemical composition of the rainwater of the previous exercise (chapter 3.1.2.1) upon infiltration (CO_2 partial pressure 1 Vol%)?

[For modeling the exchanger buffer use the keyword EXCHANGE and then define the exchanger species and their respective amounts (e.g. NaX 0.5).]

3.1.2.3 Mineral precipitates at hot sulfur springs

The following analysis of a sulfur-rich thermal water is given (Table 32):

Table 32 Water analysis of a sulfur-rich thermal water (concentration in mol/L)

pH	4.317	pe	-1.407	Temperature	75°C
B	2.506e-03	Ba	8.768e-08	C	1.328e-02
Ca	7.987e-04	Cl	5.024e-02	Cs	9.438e-06
K	3.696e-03	Li	1.193e-03	Mg	2.064e-06
Na	4.509e-02	Rb	1.620e-05	S	8.660e-03
Si	7.299e-03	Sr	3.550e-06		

Model what happens when this water discharges at a spring outlet and comes into contact with atmospheric oxygen and CO_2. Take into account that the diffusion of gas in water proceeds relatively quickly but that the contact with oxygen results in redox reactions of much slower kinetics. Therefore, restrict the addition of oxygen with the help of the keyword REACTION. Starting from 1 mg O_2/L add increasing concentrations up to the maximum amount of O_2 that can be dissolved assuming that the water close to the spring cools down to 45 °C (gas solubility decreases with increasing temperature, see chapter 1.1.3.1).

[Hint: Table 33 presents the O_2 gas solubility in cm^3 per cm^3 water at a partial pressure of 100 Vol%):

slow transformations affect the pH value or other (equilibrium) reactions in solution.

For mine flooding oxidation and reduction processes are of great importance. Due to the supply of oxygen, protons and sulfate are formed changing the chemistry of groundwater fundamentally, e.g. triggering the mobilisation of metals as a result of decreasing pH ("acidification").

Model the oxidation of pyrite assuming exposure of the groundwater given in Table 31 to different quantities of oxygen (0.0, 0.001, 0.005, 0.01, 0.05, 0.1, 0.3, 0.6, 1.0 mol). Plot the changes for the two major elements resulting from pyrite dissolution as well as for the pH value.

Table 31 Water analysis of a groundwater (concentrations in mg/L).

pH	6.5		
Redox potential	-120 mV	Al	0.26
Temperature	10.7 °C	SiO_2	24.68
O_2	0.49	Cl	12.76
Ca	64.13	HCO_3	259.93
Mg	12.16	SO_4	16.67
Na	20.55	H_2S	2.33
K	2.69	NO_3	14.67
Fe	0.248	NH_4	0.35
Mn	0.06	NO_2	0.001

[Note: The keyword for the addition of definite amounts of a reactant to a solution is REACTION. The command SELECTED_OUTPUT, which has already been mentioned in chapter 2.2.1.4, is very useful here. It directly displays all required data in an extra file (.csv) in a spreadsheet format, so that the user does not have to look through the whole output manually. Under "molalities" and under "totals" the species of interest and the total concentration of an element can be defined, respectively.

Additionally, show if it is possible to attenuate the reactions when adding calcium carbonate. Add $U_3O_8(c)$ as a mineral phase and test if a diminution in the concentration of uranium can be observed when adding calcium carbonate.

[It is worthwhile remarking that many of these slow reactions do not proceed linearly and therefore they can only be modeled to a first approximation. The weathering of pyrite, e.g., will be catalyzed by microbes which are subject to exponential growth. Such kinetics is considered in chapter 3.2.1.]

3.1.2 Atmosphere – Groundwater – Lithosphere

3.1.2.1 Precipitation under the influence of soil CO_2

Considerable amounts of carbon dioxide are produced in the soil as a result of microbial degradation. Particularly during the summer, concentrations of CO_2 soil

concentrations in the soil are a product of microbial decomposition reactions). Simulate the theoretical solubility of calcite for a whole year with temperatures on winter days of 0 °C and a low CO_2 partial pressure (corresponding to the value of the atmosphere) up to temperatures of 40 °C and a high bioproductivity ($P(CO_2)$ = 10 Vol%) during summer times.

The following pairs of temperature and CO_2 partial pressure are given:

Temp.(°C)	0	5	8	15	25	30	40
CO_2 (Vol%)	0.03	0.5	0.9	2	4.5	7	10

Where is the maximum of karst weathering (tabular and graphic illustration) and why?

[Note: Gas phases can be put into equilibrium like mineral phases. Instead of SI use the gas partial pressure p: Convert CO_2 Vol% into [bar] and form the logarithm; e.g. 3 Vol% = 0.03 bar = -1.523 $P(CO_2)$.]

3.1.1.7 Calcite precipitation and dolomite dissolution

What happens when not only pure calcium carbonate (calcite) but also magnesium calcium carbonate (dolomite) exists? Present your results graphically. How is this kind of reaction called? *[For simulation use mineral phase dolomite(d) = dispersive distributed dolomite]*

3.1.1.8 Calcite solubility in an open and a closed system

While simulating the two previous exercises 3.1.1.6 and 3.1.1.7 you always assumed that the amount of CO_2 was unlimited. Such systems are called "open systems". In reality, this is very rare. Usually, there is only a restrained amount of gas available (closed system).

Simulate for the drinking water well B3 the solution of calcite for an open and a closed system using a temperature of 15 °C and partial pressures of 2 and 20 Vol% respectively. Where is the difference between the two systems? What changes with increasing partial pressure and why? Consider, besides the solution of calcite, changes in pH values, too.

[Note: closed system: keyword GAS_PHASE; here, the following parameters have to be defined: the total pressure = 1 bar, the volume = 1 L gas per L water, and the temperature of the gas = 35 °C; additionally: which gas is being used (CO_2) and which partial pressure exists (here not the log $P(CO_2)$ is used like in EQUILIBRIUM_PHASES, but the CO_2 partial pressure in bars!]

3.1.1.9 Pyrite weathering

Many reactions are so slow that it is impossible to describe them using equilibrium reactions (e.g. the weathering of quartz, or pyrite in the absence of microorganisms). However, it is often interesting to figure out to what extent these

(what is remarkable?). Illustrate the supersaturated Fe- and Al-mineral phases in two bar charts.

3.1.1.2 Equilibrium reaction – solubility of gypsum

The town council plans to drill a new well for drinking water supply. From a logistic point of view (lengths of water pipes), it should be closer to the town than the present drinking water well B3. The new, planned location can be found as "B2" in Fig. 57. Is the planned location advisable from a hydrogeochemical point of view? Assume that the general groundwater flow direction is from the East to the West. Furthermore, consider the analysis of the drinking water well B3 as representative for the aquifer east of B2. Point out changes in the water chemistry and take into account drinking water standards when drawing a final conclusion.

3.1.1.3 Disequilibrium reaction – solubility of gypsum

How does the water quality change when assuming that the retention time in the underground is so short that only a 50 %-saturation with regard to the predominant mineral phase will occur? (*Note: Using the keyword* EQUILIBRIUM_PHASES, *it is not only possible to specify equilibria, but to determine defined disequilibria with the help of the saturation index as well. A saturation of 80% (undersaturation) would mean e.g.: IAP/KT = 80 % = 0.8; log IAP/KT = SI = log 0.8 \approx -0.1; see also Eq.35*).

3.1.1.4 Temperature dependency of gypsum solubility in well water

Data of more recent drilling holes show a certain geothermal influence in the area of B2. How would different temperatures in the underground affect the water quality in the planed well B2 (simulation range 10, 20, 30, 40, 50, 60, 70°C with a saturation of 50 %)? [*keyword* REACTION_TEMPERATURE]

3.1.1.5 Temperature dependency of gypsum solubility in pure water

Only for comparison: How much gypsum will be solved in distilled water at the same temperatures? How can the difference be explained in comparison to the well water?

3.1.1.6 Temperature- and P(CO$_2$)-dependent calcite solubility

In the well B3, seasonally changing amounts of calcium have been measured. This phenomenon is ascribed to karst weathering, which is not only dependent on temperature but also on the CO_2 partial pressure in the soil (often increased CO_2

3.1 Equilibrium reactions

3.1.1 Groundwater – Lithosphere

3.1.1.1 Standard output well analysis

The following hydrogeochemical analysis (Table 30) is given for the drinking water well ("B3") in the model area shown in Fig. 57 (concentrations in mg/L):

Table 30 Hydrogeochemical analysis of the drinking water well B3 from Fig. 57

Temperature = 22.3°C	pH = 6.7	pE = 6.9	
Ca = 75.0	Mg = 40.0	K = 3.0	Na = 19.0
HCO_3^- = 240.0	SO_4^{2-} = 200.0	Cl^- = 6.0	NO_3^- = 1.5
NO_2^- = 0.05	PO_4^{3-} = 0.60	SiO_2 = 21.59	F^- = 1.30
Li = 0.030L	B = 0.030	Al = 0.056	Mn = 0.014
Fe = 0.067	Ni = 0.026	Cu = 0.078	Zn = 0.168
Cd = 0.0004	As = 0.005	Se = 0.006	Sr = 2.979
Ba = 0.065	Pb = 0.009	U = 0.003	

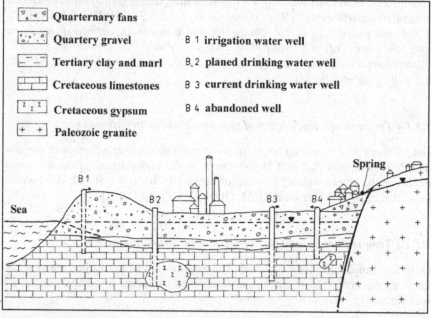

Quarternary fans

Quartery gravel B 1 irrigation water well

Tertiary clay and marl B.2 planed drinking water well

Cretaceous limestones B 3 current drinking water well

Cretaceous gypsum B 4 abandoned well

Paleozoic granite

Fig. 57 Model area for exercises in the chapters 3.1.1.1 - 3.1.1.8, chapter 3.1.4.2, chapters 3.1.5.2 - 3.1.5.5

How would you interpret the analysis? Have a close look at the redox-sensitive elements (which elements do not fit in the general scheme and why?). Plot the species distribution of the Ca-, Mg-, Pb- and Zn-species in the form of a pie chart

SOLUTION_MASTER_SPECIES exercise 2.4
SOLUTION_SPECIES exercise 2.4
EXCHANGE exercises intro 2a, 5a; 1.2.2; 3.1
SURFACE_MASTER_SPECIES exercise intro 2c
SURFACE_SPECIES exercise intro 2c
SURFACE exercises intro 2b, 2c, 5b, 5c

Advanced features
INVERSE_MODELING exercises 1.4.1; 1.4.2
KINETICS exercises intro 3, 5b; 2.2; 2.3; 2.4; 3.2; 3.3; 3.4
RATES exercises intro 3, 5b; 2.2; 2.3; 2.4; 3.2; 3.3; 3.4
ADVECTION exercise 3.1
TRANSPORT exercises intro 5a, 5b; 2.4; 3.2; 3.3; 3.4; 3.5
USER_GRAPH exercises intro 2c, 5b; 3.3

Modeling isotopes
ISOTOPES exercise intro 4

Beyond the examples presented in this book, users can also do more exercises using the 18 examples that are automatically installed with the installation of the PHREEQC program in the folder "Examples". They include:
Example 1.--Speciation calculation
Example 2.--Equilibration with pure phases
Example 3.--Mixing
Example 4.--Evaporation and homogeneous redox reactions
Example 5.--Irreversible reactions
Example 6.--Reaction-path calculations
Example 7.--Gas-phase calculations
Example 8.--Surface complexation
Example 9.--Kinetic oxidation of dissolved ferrous iron with oxygen
Example 10.--Aragonite-strontianite solid solution
Example 11.--Transport and cation exchange
Example 12.--Advective and diffusive flux of heat and solutes
Example 13.--1D transport in a dual porosity column with cation exchange
Example 14.--Advective transport, cation exchange, surface complexation, and
 mineral equilibria
Example 15.--1D Transport: Kinetic biodegradation, cell growth, and sorption
Example 16.--Inverse modeling of Sierra spring waters
Example 17.--Inverse modeling with evaporation
Example 18.--Inverse modeling of the Madison aquifer

A detailed description of the solutions for these examples can be found in the PHREEQC manual (Parkhurst & Appelo 1999).

3 Exercises

The following chapter contains several exercises from simple modeling of equilibrium reactions (chapter 3.1) to more advanced options like kinetics (chapter 3.2) and reactive mass transport (chapter 3.3). The solutions of all exercises are explained in detail in chapter 4. All exercises have been modeled with PHREEQC version 2.14.03. This latest version (as of the time of book printing) can be found on the enclosed CD (with different installation versions for Windows, Mac or Unix workstations). The input files of each exercise are also enclosed on the CD (folder PhreeqC_files).

For users who want to define their own modeling the suggestion is to use an existing input file, keep the input file structure and modify only the respective data. Individual keywords are used in the following examples (SOLUTION, TITLE and END are not considered as they are used in all examples):

Basic keywords

DATABASE	exercises intro 2a, 2b, 4, 5b
EQUILIBRIUM_PHASES	exercises intro 1b, 1c, 2b, 3, 5b, 5c; 1.1.2; 1.1.3; 1.1.4; 1.1.5; 1.1.6; 1.1.7; 1.1.8; 1.1.9; 1.2.1; 1.2.2; 1.2.3; 1.2.4; 1.2.5; 1.5.2; 1.5.3; 1.5.4; 1.5.5; 1.6.2; 1.6.3; 2.1; 2.2; 2.3; 3.2; 3.3; 3.4
MIX	exercises intro 5b; 1.2.5; 1.3.3; 1.5.5
GAS_PHASE	exercises intro 4; 1.1.8
REACTION	exercises 1.1.9; 1.2.3; 1.2.5; 1.5.1; 1.6.1; 1.6.2; 2.1
REACTION_TEMPERATURE	exercises intro 4; 1.1.4; 1.1.5
SAVE /USE	exercises intro 1c, 2b, 2c, 4, 5c; 1.2.4; 1.2.5; 1.3.3; 1.5.1; 1.5.3; 1.5.5; 2.1; 2.3
SELECTED_OUTPUT	exercises intro 3, 4, 5a, 5c; 1.1.9; 1.2.3; 1.3.1, 1.3.2; 1.3.3; 1.5.1; 1.6.1; 1.6.2; 2.2; 2.3; 2.4; 3.1; 3.2; 3.4; 3.5
USER_PUNCH	exercise intro 5c
PRINT	exercises intro 4, 5a, 5b; 2.2; 2.4; 3.2; 3.3; 3.4; 3.5
KNOBS	exercises intro 2c, 5b, 5c

Defining data

PHASES	exercise intro 2c
SOLID_SOLUTIONS	exercise intro 4

With Tools/Data the user can chose the parameter (pH, E_H, As, U, SO_4, Head, etc.) to be displayed. Using Mine_isl.xyz.chem any contourline program (e.g. Surfer) or GeoInformationSystem (GIS) can be used to plot the data according to the time steps defined and selected in WPhast (Fig. 56, Uranium concentrations in µg/L).

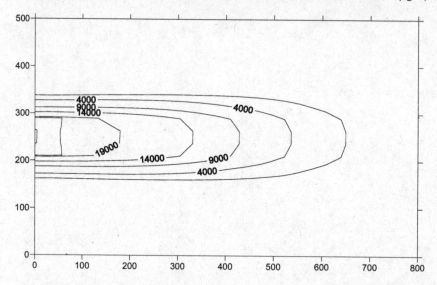

Fig. 56 Map of uranium concentrations [µg/L] downstream of the in-situ leaching mine after 30 years

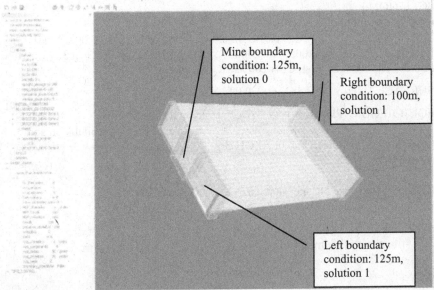

Fig. 54 Screen shot of the aquifer downstream of an in-situ leaching mine (30 x 20 x 2 finite difference discretization)

Results can be viewed from the file mine_isl.h5 via the visualization tool ModelViewer which is installed in the PHAST program group. Select File/New and choose mine_isl.h5 and select under View the **solid** and the **color bar** option to get this result (Fig. 55):

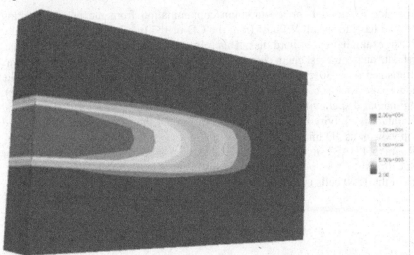

Fig. 55 Distribution of uranium concentrations [µg/L] downstream of the in-situ leaching mine after 30 years (graphical presentation in Model Viewer)

SOLUTION 1
temp 14; pH 6.6; pe 12; units mg/l
S(6) 14.3; Cl 2.1; F 0.5; N(5) 0.5; U 0.005; Fe 0.06; Zn 0.07; As 0.004; Mn 0.07
Pb 0.05; Ni 0.005; Cu 0.005; Cd 0.00025 ; Li 0.02; Na 5.8; K 1.5; Mg 3.5; Ca 36.6
Sr 0.09; Al 0.003; Si 3.64; C(4) 200 as HCO3 charge

SURFACE 1; Hfo_sOH 5e-6 600. 0.09; Hfo_wOH 2e-4

EQUILIBRIUM_PHASES 1; O2(g) -.7 ; Calcite 0 1.1
 # 1.1 mol Calcite available in aquifer
Gypsum 0 0 ; Fe(OH)3(a) 0 0; Al(OH)3(a) 0 0

SAVE Solution 1

KNOBS; -step_size 50; -pe_step_size 2.5; -iterations 1000
END

SELECTED_OUTPUT
 -file mine_isl.dummy.sel
 -reset false
-pH; -pe

USER_PUNCH # Prints concentrations in mg/kgw to mine_isl.xyz.chem
-heading SO4 As U
10 PUNCH TOT("S(6)")*1e3*96.0616 # mg/L SO4
20 PUNCH TOT("As")*1e6*74.296 # µg/L
30 PUNCH TOT("U")*1e6*238.0290 # µg/L

END

To run the 3D model for the uranium contamination from the in-situ leaching mine you have to install WPhast from the CD or the Internet and copy the folder WPhast_example to your hard disk. This folder contains the files mine_isl.wphast, phast.dat, and mine_isl.chem.dat. Part of the confined aquifer downstream was discretized with 30 columns (x), 20 rows (y) and 2 layers (z). The hydraulic conductivity was set uniform to $2 \cdot 10^{-6}$ m/s in x and y $(2 \cdot 10^{-7}$ m/s for z). Longitudinal dispersivity was assumed to be 100 m and 5 m for the vertical and horizontal dispersivity. As can be seen from Fig. 54 the 3D model can be viewed in top view or as 3D image.

Running PHAST may take considerable time since PHREEQC is called for each cell and time step. In the example given the number of cells is 30 x 20 x 2. Each of the 1200 cells is called 30 times (36,000 PHREEQC calls).

Fig. 53 Templates to define a new 3D finite difference groundwater model in WPhast

the CD of this textbook, however, it is recommended to download the most recent software. Independent from the GUI chosen PHAST has to be installed separately and it is highly recommended to install the programs according to the default settings. Following we will refer to the use of WPhast as GUI für PHAST since it offers a professional graphical user interface for setting up the 3D flow model. PHAST offers 3 output formats:

1. suitable for viewing with any text editor
2. suitable for exporting to spreadsheets
3. binary, hierarchical data format (HDF)

With the installation of PHAST two software tools will be installed as well: PHASTHDF and ModelViewer. The utility program PHASTHDF is used to extract HDF files into a text format. The ModelViever utility program can be used to display the results from h5 files.

The following sequences of screen shots (Fig. 53) show how easy a new reactive transport model can be set up with WPhast. The information will be saved in a file with the extension **.wphast** (e.g. mine_isl.wphast).

Not included in this GUI is the definition of the chemical part of the model. This has to be done separately e.g. by means of PHREEQC for Windows or any text editor. The name of the PHREEQC input file must be identical with the PHAST project name with the extension **.chem.dat** (e.g. TEST.chem.dat). Furthermore, both files have to be in the same folder (5c_Transport_PHAST) together with a third file named phast.dat. By installing WPhast a file phast.dat is supplied which is a renamed phreec.dat. However, any valid PHREEQC data file can be renamed to phast.dat and copied into the project folder. The PHREEQC input file has to define at least one solution and may contain the keywords EQUILIBRIUM_PHASES, SURFACE, EXCHANGE, GAS_PHASE, KINETICS, and SOLID_SOLUTIONS.

Additionally, the PHREEQC input file must define the output of results by means of the keywords SELECTED_OUTPUT and USER_PUNCH. Nothing is printed to the file with the extension .dummy.sel. However, the statement is obligatory for the printing of the results to the file with the extension .xyz.chem. The frequency of printing is defined in WPhast through the properties menu and Print Frequency.

TITLE minewater with surface complexation

SOLUTION 0 Acid mine water with 20 ppm uranium
units mg/l; pH 3.5; Temp 14; pe 16
Ca 60; Mg 10; Na 20; K 5; S(6) 660 charge; Cl 14; F 0.15; Fe 210; U 20; Cu 0.05
Ni 4; Zn 11 ; Sr 0.09; Ba 0.03; Pb 0.065; As 0.265; Cd 0.14; Al 23; Si 50

END

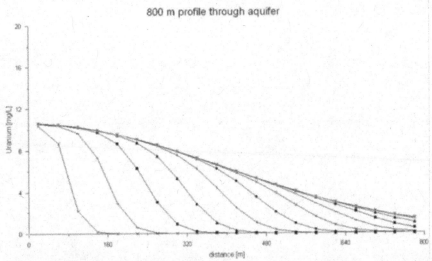

Fig. 52 Profile through downstream area of mine with dilution and surface complexation of uranium on ironhydroxides

Dilution and surface complexation are in this case the dominant factors for natural attenuation, however, in particular the way of assuming mixing ratios in this example is straight forward but not in all cases sufficient. This main disadvantage of any 1D simulation along a stream path can be overcome only by means of a 2D or 3D model. How this can be done by means of PHAST will be demonstrated with the next and last introductory example of this chapter.

2.2.2.5.3. 3D transport with PHAST

The restriction of PHREEQC with respect to reactive transport modeling to 1D is overcome by PHAST (Parkhurst et al. 2004). Simulation of flow and transport are based on HST3D (Kipp 1997), a 3D flow and transport finite difference code for steady state and transient conditions. Within PHAST the HST3D code is restricted to constant fluid density and constant temperature. PHREEQC is embedded in PHAST offering many of PHREEQC's options of geochemical reactions (EQUILIBRIUM_PHASES, EXCHANGE, SURFACE, GAS_PHASE, SOLID_SOLUTIONS, KINETICS). The keyword "REACTIONS" is not available within PHAST. Flow, transport, and geochemical reactions are treated as separate processes without feedback from each other. Thus, e.g. precipitation of a mineral does not affect the hydraulic permeability or flow and transport simulation.

Two graphical user interfaces (GUI) are available: GoPhast and WPhast. Both can be downloaded as well as PHAST from the USGS web page (http://wwwbrr.cr.usgs.gov/projects/GWC_coupled/phast/index.html). The recent version of PHAST and WPhast (as of the date of printing) are included on

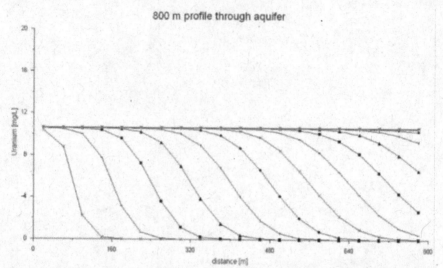

Fig. 50 **Uranium breakthrough according to 1D transport simulation taking into account surface complexation on ironhydroxides but no dilution; concentrations were plotted every 4 years; the uranium concentrations are reduced to about 50%, however, this value depends significantly on the assumptions for ironhydroxide surface area and pyrite oxidation rate.**

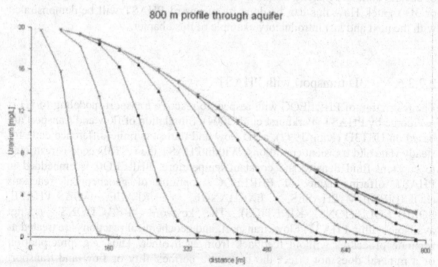

Fig. 51 **Profile through downstream area of mine with dilution but no surface complexation of uranium on ironhydroxides**

```
 50 if (moles >= (mol("O2")/3.5)) then moles = mol("O2")/3.5
 200 save moles
 -end
```

TRANSPORT 800 m downstream
-cells 20 ; -shifts 40 ; -lengths 40; -time_step 6.3072e7 # 2 years, V = 20 m/year
-flow_direction forward; -boundary_conditions flux flux
-dispersivities 20*5.0; -warnings true; -stagnant 1
-punch_frequency 2 # print profile every 4 years
-punch_cells 1-20 # print all 20 cell concentrations

USER_GRAPH
-chart_title "800 m profile through aquifer" ; -heading DISTANCE U
-axis_scale y_axis 0 20 ; -axis_scale x_axis 0 800 ; -axis_titles m mg/L(Uran)
-axis_scale secondary_y_axis 0 0.005 ; -plot_concentration_vs x ; -
initial_solutions false
-start
10 GRAPH_X DIST
20 GRAPH_Y tot("U")*1e3*238
#30 GRAPH_SY tot("As")*1e3*75, tot("Fe")*1e3*56
-end

PRINT; reset false
KNOBS; -step_size 50; -pe_step_size 2.5; -iterations 1000
END

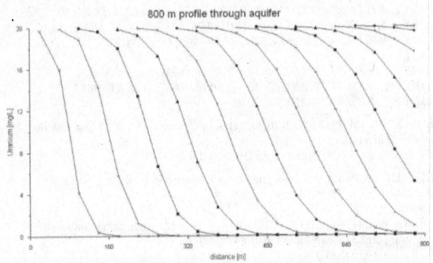

Fig. 49 **Uranium breakthrough according to 1D transport simulation taking into account neither dilution nor surface complexation on ironhydroxides; concentrations were plotted every 4 years; no retardation with respect to groundwater flow (20 m/year) can be seen.**

A look at the input file 5b_Transport_mine_dilution.phrq shows that it makes intensive use of the semicolon as an equivalent for carriage return (new line) in order to make the file as compact as possible. Further the definition of the SURFACE and the MIX statements are disabled by "#" (marked in italic). By removing the "#" in front of the respective statement blocks this option can be easily switched on and off which produces very different results as can be seen from Fig. 49 to Fig. 52 (screen shots from the PHREEQC for Windows Chart option).

DATABASE Wateq4F.dat
TITLE 1D Transport with dilution and surface complexation
SOLUTION 0 Acid mine water with 20 ppm uranium
units mg/L; pH 3.5; Temp 14; pe 16
Ca 60; Mg 10; Na 20; K 5; S(6) 660 charge; Cl 14; F 0.15; Fe 210; U 20; Cu 0.05
Ni 4; Zn 11 ; Sr 0.09; Ba 0.03; Pb 0.065; As 0.265; Cd 0.14; Al 23; Si 50

SOLUTION 1-42 1-20 GW, 22-41 stagnant water for dilution (mix)
temp 14; pH 6.6; pe 12; units mg/L
S(6) 14.3; Cl 2.1; F 0.5; N(5) 0.5; U 0.005; Fe 0.06; Zn 0.07; As 0.004; Mn 0.07
Pb 0.05; Ni 0.005; Cu 0.005; Cd 0.00025 ; Li 0.02; Na 5.8; K 1.5; Mg 3.5; Ca 36.6
Sr 0.09; Al 0.003; Si 3.64; C(4) 200 as HCO3 charge

#SURFACE 1-20; Hfo_wOH Fe(OH)3(a) e 0.2 5.34E4
#Hfo_sOH Fe(OH)3(a) e 0.005; -equil 1
#MIX 1; 1 1; 22 0; MIX 2; 2.99; 23.01; MIX 3; 3.98; 24.02; MIX 4; 4.97; 25.03
#MIX 5; 5.96; 26.04; MIX 6; 6.95; 27.05; MIX 7; 7.94; 28.06; MIX 8; 8.93; 29.07
#MIX 9; 9.92; 30.08; MIX 10; 10.91; 31.09; MIX 11; 11.9; 32.1; MIX 12; 12.89; 33.11
#MIX 13; 13.88; 34.12; MIX 14; 14.87; 35.13; MIX 15; 15.86; 36.14
#MIX 16; 16.85; 37.15; MIX 17; 17.84; 38.16; MIX 18; 18.83; 39.17
#MIX 19; 19.82; 40.18; MIX 20; 20.81; 41.19

EQUILIBRIUM_PHASES 1-20; O2(g) -.7 ; Calcite 0 1.1 # 1.1 mol Calcite available in aquifer
Gypsum 0 0 ; Fe(OH)3(a) 0 0; Al(OH)3(a) 0 0

KINETICS 1; Pyrite; -tol 1e-8; -m0 1; -m 1; -parms -5.0 0.1 .5 -0.11
RATES; Pyrite
 -start
 1 rem parm(1) = log10(A/V, 1/dm) parm(2) = exp for (m/m0)
 2 rem parm(3) = exp for O2, parm(4) = exp for H+
 10 if (m <= 0) then goto 200
 20 if (si("Pyrite") >= 0) then goto 200
 20 rate = -10.19 + parm(1) + parm(3)*lm("O2") + parm(4)*lm("H+") + parm(2)*log10(m/m0)
 30 moles = 10^rate * time
 40 if (moles > m) then moles = m

Keyword	example	default	comments
-print_frequency	5	1	Identifier to select shifts for which results will be written to the output file.
-punch_cells	2-5	1-n	Identifier to select cells for which results will be written to the selected-output file.
-punch_frequency	5	1	Identifier to select shifts for which results will be written to the selected-output file.
-dump	dump.file	phree qc.dmp	Identifier to write complete state of advective-dispersive transport simulation after every *dump_modulus* advection shifts or diffusion periods. The file is formatted as an input file that can be used to restart calculations.
-dump_frequency	10	shifts/2 or 1	Complete state of a advective-dispersive transport simulation will be written to dump file after *dump_modulus* advection shifts or diffusion periods.
-dump_restart	20	1	Starting shift number for the calculations, if restarting from a dump file. The shift number is written in the dump file by PHREEQC. It equals the shift number at which the dump file was created
-warnings	false	true	If true, warning messages are printed to the screen and the output file

2.2.2.5.2. 1D transport, dilution, and surface complexation in an abandoned uranium mine

A second, more complex 1D reactive transport example is demonstrated with the input file (5b_Transport_mine_dilution.phrq). It is a simplified version of a model to predict what happens when a uranium mine is closed down with no action taken. Since the mine was an in-situ leaching mine it contains huge amounts of sulfuric acid leading to a composition of the mine drainage as described in SOLUTION 0. Furthermore, it was assumed that some calcite and pyrite is available in the downstream aquifer which will control the sulfate concentrations due to precipitation of gypsum. Since oxygen is available as well pyrite will be oxidized. To be realistic in terms of reaction kinetics, the pyrite oxidation was modeled via KINETICS and RATES. The subsequent precipitation of $Fe(OH)_3$ is assumed to be fast and was therefore modeled by the thermodynamic approach (EQUILIBRIUM_PHASE). By checking the saturation indices it becomes obvious that no uranium mineral is oversaturated and thus able to control the uranium concentrations in the groundwater. Thus, as long as we assume that no redox processes occur (e.g. decay of organic matter reducing the redox potential) only surface complexation of uranium on ironhydroxide (formed from pyrite weathering) can limit the uranium concentration in the downstream area. Another important aspect is the dilution of the contaminant (see chapter 1.3.3.4.2) which was solved via the MIX statements by mixing increasing shares of groundwater with increasing distance from the source of contamination.

Table 29 Syntax of the keyword TRANSPORT in PHREEQC (Parkhurst & Appelo 1999)

Keyword	example	default	comments
-cells	5	0	Number of cells in a 1D column to be used in the advective-dispersive transport simulation
-shifts	25	1	number of advective shifts or time steps, which is the number of times the solution in each cell will be shifted to the next higher or lower numbered cell; the total time simulated is *shifts* * *time_step*
-time_step	3.15e7	0	Time, in seconds, associated with each shift or diffusion period
-flow_direction	forward	forward	forward, back, or diffusion_only
-boundary_conditions	flux constant	flux flux	constant, closed, flux for first cell and last cell
-lengths	4*1.0 2.0	1	Length of each cell (m). Any number of *lengths* up to the total number of cells (*cells*) may be entered
-dispersivities	4*0.1 0.2	0	Dispersivity assigned to each cell (m). Any number of *dispersivities* up to the total number of cells (*cells*) may be entered.
-correct_disp	true	true	true or false: When *true*, dispersivity is multiplied with $(1 + 1/cells)$ for column ends with flux boundary conditions. This correction is recommended when modeling effluent composition from column experiments.
-diffusion_coefficient	1.0e-9	0.3e-9	Diffusion coefficient in m^2/s
-stagnant	1 6.8e-6 0.3 0.1 5	0 0 0 0	Defines the maximum number of stagnant (immobile) cells associated with each cell in which advection occurs (mobile cell). The immobile cells are usually defined to be a 1D column that is connected to the mobile cell; however, the connections among the immobile cells may be defined arbitrarily with **MIX** data blocks. Each immobile cell that is used must have a defined solution and either a **MIX** data block must be defined or, for the first-order exchange model, the *exchange_factor* must be defined, for details refer to manual
-thermal_diffusion	3.0 0.5e-6	2 1e-6	temperature-retardation-factor and thermal diffusion coefficient; for details refer to manual
-initial_time	1000	cummulative time	Time (seconds) at the beginning of the transport simulation. The identifier sets the initial value of the variable controlled by **-time** in the **SELECTED_OUTPUT** data block.
-print_cells	1-3 5	1-n	Identifier to select cells for which results will be written to the output file.

```
       pe          12.5   O2(g)  -0.68
       Ca          0.5
       Cl          1.0
SOLUTION 1-40  Initial solution for column     # NaNO3 + KNO3
       units       mmol/kgw
       temp        25.0
       pH          7.0    charge
       pe          12.5   O2(g)  -0.68
       Na          1.0
       K           0.2
       N(5)        1.2
EXCHANGE 1-40                                   # all cells of column (exchanger)
       equilibrate 1                            # equilibrate with solution 1
       X           0.0015                       # exchanger capacity in mole
TRANSPORT
       -cells      40                           # 40 cells
       -length     0.2                          # each 0.2 m; 40*0.2= 8 m length
       -shifts     120                          # refill each cell 120 times
       -time_step      720.0                    # 720 s per cell; --> v = 24 m/day
       -flow_direction  forward                 # forward simulation
       -boundary_cond  flux    flux             # flow boundary condition at inlet and
                                                outlet
       -diffc      0.0e-9                        # diffusion coefficient m2/s
       -dispersivity  0.1                       # dispersivity in m
       -correct_disp   true                     # correction for dispersivity: yes
       -punch_cells    40                       # only cell 40 in Selected_Output
       -punch_frequency 1                       # print each time interval
       -print      40                           # print only cell 40 (outlet)
SELECTED_OUTPUT
       -file       exchange.csv                 # output in this file
       -reset      false                        # print no standard output
       -step                                    # default
       -totals     Na Cl K Ca                   # output total concentrations
END
```

It is important to notice that the same solution is defined by default for all 40 cells of the column at the beginning of the job (SOLUTION 1-40). If additionally kinetics and equilibrium reactions are taken into account, the same applies for the keywords KINETICS and EQUILIBRIUM_PHASES. Writing KINETICS 1 instead of KINETICS 1-40, the kinetic reaction would only be taken into account for cell 1. The syntax of the keyword TRANSPORT is explained in detail in Table 29.

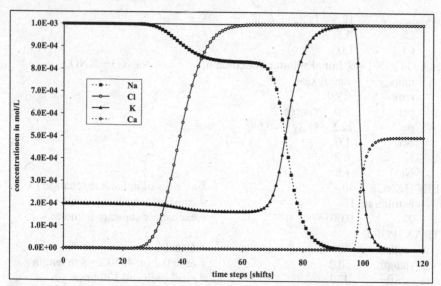

Fig. 48 **Laboratory column experiment: changes in chloride, sodium, potassium, and calcium concentrations at the column´s outlet; 40 "shifts" correspond to a complete exchange of the water volume within the column**

Chloride behaves like an ideal tracer and is only affected by dispersion. Calcium is not detected in solution after the first exchange of all the water in the column (shift = 40) as it is exchanged for sodium and potassium. After all sodium is removed from the exchanger, calcium can only exchange for potassium. Because calcium ions have two positive charges while potassium has only one, each calcium ion removes two potassium ions which leads to a peak in the potassium-concentrations. Only after the water in the column has been exchanged about 2.5 times, the calcium is detected at the outlet.

In the following the PHREEQC job is shown that simulates the experiment (5a_Transport-column-experiment.phrq). To adjust the model to the data observed, the exchange capacity (X under EXCHANGE, here 0.0015 mol per kg water), the selectivity coefficients in the database WATEQ4F.dat and the chosen dispersivity (TRANSPORT, dispersivity, here 0.1 m) are decisive besides the spatial discretisation (number of cells, here 40). Changing the dispersivity to a very small value (e.g. $1 \cdot 10^{-6}$), no numerical dispersion occurs which shows that numerical stability criteria are fulfilled.

```
TITLE column experiment with exchangers
PRINT
    -reset false                           # create no standard output
SOLUTION 0  CaCl2                           # new solution: CaCl2
    units       mmol/kgw
    temp        25.0
    pH          7.0     charge
```

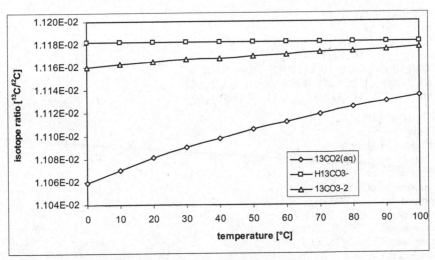

Fig. 47 Calculated δ^{13} C-values in relation to temperature

2.2.2.5 Introductory examples for reactive mass transport

2.2.2.5.1. Simple 1D transport: column experiment

After equilibrium reactions and kinetically controlled reactions, the reactive mass transport will be described as a final introductory example (for theory see chapter 1.3). Within PHREEQC there are two options to simulate one-dimensional (1D) transport with constant velocity. Using the keyword ADVECTION, simple simulations can be carried out by a mixing cell approach. With the keyword TRANSPORT dispersion, diffusion and double porosity (mobile and immobile pores) can be taken into account. The units used are basically meter and seconds. One-dimensional modeling is well suited for simulating laboratory column experiments or to model processes in an aquifer along a theoretical flow path. Concerning the consideration of dilution processes during 1D-modeling in groundwater, see chapter 1.3.3.4.2.

The following example shows the result of a column experiment with an 8 m long column filled with a cation exchanger. Initially, the column was equilibrated with a solution containing 1 meq/L $NaNO_3$ and 0.2 meq/L KNO_3, i.e. the conditioning solution was applied until the composition determined at the inlet of the column equaled that at the outlet. Then, the input solution was changed to a 0.5 meq/L $CaCl_2$ solution. The concentrations monitored at the outlet can be seen in Fig. 48. The time scale on the x-axis starts at 0, the time when the input solutions were changed. The x-axis is scaled in water volumes and represents a threefold exchange of the water within the column (shift = 120).

GAS_PHASE
fixed_volume 1
H2O(g) 0; HDO(g) 0; D2O(g) 0; H2[18O](g) 0; HD[18O](g) 0; D2[18O](g) 0
HTO(g) 0; HT[18O](g) 0; DTO(g) 0
CO2(g) 0; CO[18O](g) 0; C[18O]2(g) 0
[13C]O2(g) 0; [13C]O[18O](g) 0; [13C][18O]2(g) 0
[14C]O2(g) 0; [14C]O[18O](g) 0; [14C][18O]2(g) 0

SOLID_SOLUTION
Calcite
component Calcite 0
component CaCO2[18O] 0
component CaCO[18O]2 0
component CaC[18O]3 0
component Ca[13C]O3 0
component Ca[13C]O2[18O] 0
component Ca[13C]O[18O]2 0
component Ca[13C][18O]3 0
component Ca[14C]O3 0
component Ca[14C]O2[18O] 0
component Ca[14C]O[18O]2 0
component Ca[14C][18O]3 0

END

Fig. 46 shows the results of ^{13}C fractionation at 25°C for CO_2 (as gas), calcite (as solid solution), and the three aqueous species of inorganic C. Fig. 47 shows the ^{13}C fractionation dependent on temperature.

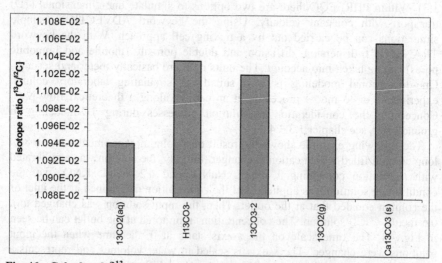

Fig. 46 Calculated δ^{13} C-values at 25°C in the three phases gas (CO_2), water, and mineral (calcite)

[13C]O2 + C[18O]2 = [13C][18O]2 + CO2
log_k 0.0

0.5[13C]O2 + 0.5[13C][18O]2 = [13C]O[18O]
log_k 0.301029995663 # log10(2)

[14C]O2 + C[18O]2 = [14C][18O]2 + CO2
log_k 0.0

0.5[14C]O2 + 0.5[14C][18O]2 = [14C]O[18O]
log_k 0.301029995663 # log10(2)

CO2 + 2H2[18O] = C[18O]2 + 2H2O
-add_logk Log_alpha_18O_CO2(aq)/H2O(l) 2.0
~~~~~~~~clipped~~~~~~~~~~~~~~~~~~~~~~

Adding even one isotope is thus a considerable effort and not advisable for an input file. The iso.dat comes with the distribution of PHREEQCI and will be automatically installed in the appropriate folder. However, iso.dat can also be used with the PHREEQC batch version and PHREEQC for Windows. To model the fractionation of $^{13}C$ for the carbon species the following input file can be used. The standard output is turned off via PRINT and -reset false. By using the semicolon (instead of carriage return) consecutive lines are written in one line to make the file more compact. The results for $^{14}C$, tritium, deuterium, and $^{18}O$ input are not used and explained in this example (4_Isotope_fractionation.phrq).

DATABASE iso.dat

SOLUTION 1
pH 8.2; temp 25
Na 1 charge; Ca 1 Calcite .1; C 2
[13C] -13                          # permil
[14C] 123                          # pmc
T 20                               # TU
D -80                              # permil
[18O] -25                          # permil

PRINT
-reset false                       # no standard print out

SELECTED_OUTPUT
-file isotopes.csv
-temperature 25
-calculate_values      R(13C)_CO2(aq)      R(13C)_HCO3-      R(13C)_CO3-2
Alpha_13C_CO2(aq)/CO2(g)

REACTION_TEMPERATURE
0 100 in 11 steps
END

USE solution 1                     # calculate fractionation with calcite and gas phase

```
                                                       # 13.56 Modern Carbon dpm (Kalin in
                                                           Cook & Herczeg 2000)
C(4)
  -isotope   [13C](4)   permil  0.0111802             # VPDB, Vienna Pee Dee Belemnite
                                                       # (Chang & Li 1990)
...-isotope  [14C](4)   pmc   1.175887709e-12         # Mole fraction of 14C in Percent
                                                           Modern Carbon
                                                       # 13.56 Modern Carbon dpm (Kalin in
                                                           Cook & Herczeg 2000)
O
   -isotope      [18O]      permil 2005.2e-6 # VSMOW (Clark & Fritz 1997)
~~~~~~~~~clipped~~~~~~~~~~~~~~~~~~~~~~~~
```

Furthermore, the ISOTOPE_RATIOS, ISOTOPE_ALPHAS, and fractionation factors have to be defined. An example for using NAMED_EXPRESSION and CALCULATE_VALUES in the database is given here:

```
NAMED_EXPRESSIONS
H2O fractionation factors
 Log_alpha_D_H2O(l)/H2O(g) # 1000ln(alpha(25C)) = 76.4
 # 0-100 C
 -ln_alpha1000 52.612 0.0 -76.248e3 0.0 24.844e6
 Log_alpha_T_H2O(l)/H2O(g) # 1000ln(alpha(25C)) = 152.7
 # 0-100 C
 -ln_alpha1000 105.224 0.0 -152.496e3 0.0 49.688e6
 Log_alpha_18O_H2O(l)/H2O(g) # 1000ln(alpha(25C)) = 9.3
 # 0-100 C
 -ln_alpha1000 -2.0667 0.0 -0.4156e3 0.0 1.137e6
~~~~~~~~~clipped~~~~~~~~~~~~~~~~~~~~~~~~
CALCULATE_VALUES
   R(13C)_CH4(aq)
   -start
       10 ratio = -9999.999
       20 if (TOT("[13C]") <= 0) THEN GOTO 100
       30 total_13C = sum_species("{C,[13C]}{H,D}4","[13C]")
       40 total_C = sum_species("{C,[13C]}{H,D}4","C")
       50 if (total_C <= 0) THEN GOTO 100
       60 ratio = total_13C/total_C
       100 save ratio
   -end
~~~~~~~~~clipped~~~~~~~~~~~~~~~~~~~~~~~~
```

Finally, SOLUTION_SPECIES have to be defined for all possible permutations as can see from this example:

```
CO2 reactions
 0.5CO2 + 0.5C[18O]2 = CO[18O]
 log_k 0.301029995663 # log10(2)
```

|  | integration method |
|---|---|
| TK | Temperature in Kelvin |
| TOT("Fe(2)") | Total molality of element or element redox state. TOT("water") is total mass of water (kg) |
| TOTAL_TIME | Cumulative time (s) including all advective (for which **-time_step** is defined) and advective-dispersive transport simulations from the beginning of the run or from last **-initial_time** identifier |

### 2.2.2.4 Introductory example for isotope fractionation

Isotopes can be modeled within PHREEQC easily in reverse modeling. Another option is to define an isotope in RATES and calculate the distribution of stable and radioactive isotopes via KINETICS (see example section 4.2.4 and Apello & Postma 2005). The most powerful option, however, is to define isotopes in a database via the keyword ISOTOPES which is possible since version 2.7 (2003).

PHREEQC can model the distribution of $^2H$, $^3H$ (tritium), $^{18}O$, $^{13}C$, $^{14}C$, and $^{34}S$ of species and phases by using the database iso.dat. In the following, a clipping from a definition of SOLUTION_MASTER_SPECIES taken from iso.dat (Thorstenson & Parkhurst 2002) is displayed:

```
SOLUTION_MASTER_SPECIES
~~~~~~~~~~clipped~~~~~~~~~~~~~~~~~~~~~~~~~~~~~~~~~
C(4)    CO2        0     HCO3
[13C]   [13C]O2    0     13        13
[13C](4) [13C]O2   0     13
[14C]   [14C]O2    0     14        14
[14C](4) [14C]O2   0     14
[18O]   H2[18O]    0     18        18
D       D2O        0     2         2
T       HTO        0     3         3
S       SO4-2      0.0   SO4       31.972
~~~~~~~~~~clipped~~~~~~~~~~~~~~~~~~~~~~~~~~~~~~~~~
```

```
ISOTOPES
H
 -isotope D permil 155.76e-6 # VSMOW (Clark & Fritz 1997)
 -isotope T TU 1e-18 # Solomon & Cook, in Cook &
 Herczeg 2000
 # 1 THO in 10^18 H2O

C
 -isotope [13C] permil 0.0111802 # VPDB, Vienna Pee Dee Belemnite
 # (Chang & Li 1990)
 -isotope [14C] pmc 1.175887709e-12 # Mole fraction of 14C in Percent
 Modern Carbon
```

| | |
|---|---|
| | $x$ can be retrieved with GET($i1$,[, $i2$, ...]) and a set of subscripts can be tested to determine if a value has been stored with EXISTS($i1$[, $i2$, ...]). PUT may be used in RATES, USER_PRINT, or USER_PUNCH BASIC programs to store a value. The value may be retrieved by any of these BASIC programs. The value persists until overwritten using a PUT statement with the same set of subscripts, or until the end of the run. For a KINETICS data block, the BASIC programs for the rate expressions are evaluated in the order in which they are defined in the input file. |
| RXN | Amount of reaction (moles) as defined in -steps in REACTION data block for a batch-reaction calculation, otherwise zero |
| S_S("MgCO3") | Current moles of a solid-solution component |
| SAVE | Last statement of BASIC program that returns the moles of kinetic reactant, counted positive when the solution concentration of the reactant increases |
| SI("Calcite") | Saturation index of a phase, $Log10\ (IAP/K)$ |
| SIM_NO | Simulation number, equals one more than the number of END statements before current simulation |
| SIM_TIME | Time (s) from the beginning of a kinetic batch-reaction or transport calculation |
| SR("Calcite") | Saturation ratio of a phase, (IAP/K) |
| STEP_NO | Step number in batch-reaction calculations, or shift number in ADVECTION and TRANSPORT calculations |
| SUM_GAS("{CO2, O2}","O") | returns Summed moles of an element in gas-formulas listed in {.., ..}.write the chemical formula in {..}, not the name of the gas in PHASES |
| SUM_S_S("CaCdCO3","O") | Summed moles of an element in SOLID_SOLUTIONS. |
| SUM_SPECIES("{OH-, NaOH}","H") | returns Summed moles of an element in SOLUTION, EXCHANGE, and SURFACE_SPECIES listed in {.., .., ..}. |
| SURF("As", "Hfo") | Moles of an element sorbed on a SURFACE. |
| SYS("Na") | Total moles of an element in all phases (SOLUTION, EQUILIBRIUM_PHASES, SURFACE, EXCHANGE, SOLID_SOLUTIONS, and GAS_PHASE) |
| TC | Temperature in Celsius |
| TIME | Time interval for which moles of reaction are calculated in rate programs, automatically set in the time-step algorithm of the numerical |

| | |
|---|---|
| GET(i1[, i2, ...]) | Retrieves the value that is identified by the list of one or more subscripts. Value is zero if PUT has not been used to store a value for the set of subscripts. Values stored in global storage with PUT are accessible by any BASIC program. See description of PUT for more details |
| GET_POR(cell_no) | Porosity in a cell |
| GRAPH_SY -la("H+"), -la("e-") | Plots variables on the secondary y-axis of the graph |
| GRAPH_X tot("Na") | Defines the x-axis of the graph (1 variable) |
| GRAPH_Y tot("Cl"), tot("K") | Plots variables on the y-axis of the graph |
| KIN("CH2O") | Moles of a kinetic reactant |
| LA("HCO3-") | Log10 of activity of an aqueous, exchange, or surface species |
| LK_NAMED("aa_13C") | Log10 of a K value in NAMED_EXPRESSIONS at the current temperature. |
| LK_PHASE("O2(g)") | Log10 of a K value in PHASES at the current temperature. |
| LK_SPECIES("OH-") | Log10 of a K value of a SOLUTION, EXCHANGE, or SURFACE_SPECIES at the current temperature. |
| LM("HCO3-") | Log10 of molality of an aqueous, exchange, or surface species |
| M | Current moles of reactant for which the rate is being calculated (see KINETICS) |
| M0 | Initial moles of reactant for which the rate is being calculated (see KINETICS) |
| MISC1("Ca(x)Sr(1-x) SO4") | Mole fraction of component 2 at the beginning of the miscibility gap, returns 1.0 if there is no miscibility gap (see SOLID_SOLUTIONS) |
| MISC2("Ca(x)Sr(1-x) SO4") | Mole fraction of component 2 at the end of the miscibility gap, returns 1.0 if there is no miscibility gap (see SOLID_SOLUTIONS) |
| MOL("HCO3-") | Molality of an aqueous, exchange, or surface species |
| MU | Ionic strength of the solution (mol) |
| OSMOTIC | Returns the osmotic coefficient if the Pitzer model is used, or 0.0 if the ion-association model is used |
| PARM(i) | Parameter array defined in KINETICS data block |
| PERCENT_ERROR | Percent charge-balance error [100(cations- \|anions\|)/(cations + \|anions\|)] |
| PRINT | Write to output file |
| PUNCH | Write to selected-output file |
| PUT(x, i1[, i2, ...]) | Saves value of $x$ in global storage that is identified by a sequence of one or more subscripts. Value of |

| RESTORE line | Set pointer to DATA statement of *line* for subsequent READ |
|---|---|
| RETURN | Return from subroutine |
| RTRIM("a ") | Trims white space from the end of a string |
| SGN(a) | Sign of *a*, +1 or -1 |
| SIN(a) | Sine function |
| SQR(a) | $a^2$ |
| SQRT(a) | $\sqrt{a}$ |
| STR$(a) | Convert number to a string |
| TAN(a) | Tangent function |
| TRIM("a") | Trims white space from beginning and end of a string |
| VAL(string) | Convert string to number. |
| WEND | indicates the end of a "While" loop |
| WHILE (expression) ... WEND | "While" loop |

**Table 28   Special codes in BASIC of PHREEQC**

| ACT("HCO3-") | activity of an aqueous, exchange, or surface species |
|---|---|
| ALK | alkalinity of solution |
| CALC_VALUE("pCa") | evaluates a definition of calculated values |
| CELL_NO | cell number in TRANSPORT or ADVECTION calculations |
| CHANGE_POR(0.21, cell_no) | modifies the porosity of a cell |
| change_surf ("Hfo", 0.2, "Sorbedhfo", 0, cell_no) | changes the diffusion coefficient of a SURFACE and renames the SURFACE |
| CHARGE_BALANCE | aqueous charge balance in equivalents |
| DESCRIPTION | description of a solution |
| DIST | distance to midpoint of cell in TRANSPORT calculations, cell number in ADVECTION calculations, "-99" in all other calculations |
| EDL("Na", "Hfo") | The moles of an element or water in the diffuse layer, the charge (eq or C/m2) or the potential (V) of a surface |
| EQUI("Calcite") | Moles of a phase in the pure-phase (equilibrium-phase) assemblage |
| EXISTS(i1[, i2, ...]) | Determines if a value has been stored with a PUT statement for the list of one or more subscripts. The function equals 1 if a value has been stored and 0 if no value has been stored. Values are stored in global storage with PUT and are accessible by any BASIC program. See description of PUT for more details. |
| GAS("CO2(g)") | Moles of a gas component in the gas phase |

The BASIC code can be used within the keyword RATES, but also for USER_GRAPH, USER_PRINT and USER-PUNCH and always occurs between the commands
    -start
    -end.
Table 27 presents a list of the standard commands within the BASIC interpreter of PHREEQC, Table 28 the special codes in BASIC of PHREEQC.

**Table 27   List of standard commands within the BASIC interpreter of PHREEQC (Parkhurst & Appelo 1999)**

| | |
|---|---|
| +, -, *, / | Add, subtract, multiply, and divide |
| String1 + String2 | String concatenation |
| a ^ b | Exponentiation |
| <, >, <=, >=, <>, =,AND, OR, XOR, NOT | Relational and Boolean operators |
| ABS(a) | Absolute value |
| ARCTAN(a) | Arctangent function |
| ASC(character) | ASCII value for character |
| CHR$(number) | Convert ASCII value to character |
| COS(a) | Cosine function |
| DIM a(n) | Dimension an array |
| DATA list | List of data |
| EXP(a) | $e^a$ |
| FOR i = n TO m STEP k ........ NEXT I | "For" loop |
| GOTO line | Go to line number |
| GOSUB line | Go to subroutine |
| IF (expr) THEN statement ELSE statement | If, then, else statement (on one line; a '\' may be used to concatenate lines) |
| INSTR("aab", "b") | returns the character position of substring within a string, 0 if not found |
| LEN(string) | Number of characters in *string* |
| LOG(a) | Natural logarithm |
| LOG10(a) | Base 10 logarithm |
| LTRIM(" ab") | trims white space from beginning of a string |
| MID$(string, n) | Extract characters from position *n* to end of *string*. |
| MID$(string, n, m) | Extract *m* characters from *string* starting at position *n*. |
| a MOD b | returns remainder a/b |
| ON expr GOTO line1, line2, ... ON expr GOSUB line1, line2, ... | If the expression's value, rounded to an integer, is *N*, go to the *N*th line number in the list. If *N* is less than one or greater than the number of line numbers listed, execution continues at the next statement after the ON statement |
| READ | Read from DATA statement |
| REM | At beginning of line, line is a remark with no effect on the calculations |

```
 -parms -5.0 0.1 .5 -0.11 # parameter in kinetics equation
parm(1) = log10(A/V) in 1/dm
parm(2) = exponent for (m/m0)
parm(3) = exponent for O2
parm(4) = exponent for H+
RATES
Pyrite
 -start
 5 rem Pyrite weathering rates
 10 if (m <= 0) then goto 200 // m = mole of reactant *
 20 if (si("Pyrite") >= 0) then goto 200 // si = saturation index *
 20 rate = -10.19 + parm(1) \
 21 + parm(3)*lm("O2") \
 22 + parm(4)*lm("H+") \
 23 + parm(2)*log10(m/m0) // parm(i) = parameter*
 // lm= log10 molality *
 30 moles = 10^rate * TIME // time interval defined in steps*
 40 if (moles > m) then moles = m
 50 if (moles >= (mol("O2")/3.5)) then moles = mol("O2")/3.5
 200 save moles
 -end
```

* the '///' included comments cannot appear like this in a PHREEQC-BASIC script because the BASIC interpreter is trying to interpret them. It is only possible to include commentary lines at the beginning of a line by means of REM (remark).

In order to write your own kinetics programs it is necessary to familiarize yourself with the programming language BASIC and particularly with the special BASIC-codes within PHREEQC.

## 2.2.2.3.2.   BASIC within PHREEQC

The BASIC interpreter, which comes along with the Linux operating system (Free Software Foundation, Inc.), is implemented in PHREEQC. It is e.g. used, as already demonstrated, for the integration of kinetic rates to determine converted quantities of substance in mol with respect to a given time. Therefore, a BASIC program for each kinetic reaction has to be ready either in the database (PHREEQC.dat, WATEQ4F.dat, etc.) or in the respective input file. Each programs stands for itself (no global variables) and lines have to be numbered consecutively (e.g. 10, 20, 30,…). The transfer of data between the BASIC programs and PHREEQC is done by using the command GET and PUT as well as the command TIME. The final result of a kinetic calculation is written back to PHREEQC by means of SAVE. Thereby, no rates but quantities of moles are transferred after each reaction. A positive sign indicates that concentrations of the reactant in solution have increased, a negative sign that they decreased.

SELECTED_OUTPUT
-file 4_Calcite.csv
-saturation_indices calcite
end

\* the '//' included comments cannot appear like this in a PHREEQC-BASIC script as the BASIC interpreter is trying to interpret them. It is only possible by means of REM (remark) to include commentary lines at the beginning of a line.

Fig. 45 shows that the calcite equilibrium is attained very rapidly at low $CO_2$ partial pressures (in the example 0.03 Vol-%), but distinctly slower at increased $CO_2$ partial pressures (in the example 1 Vol-%).

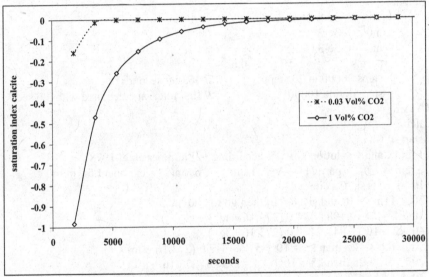

**Fig. 45    Time-dependent calcite dissolution at 0.03 Vol% $CO_2$ (atmospheric pressure) and increased $CO_2$ partial pressure (1 Vol%)**

Further examples can be found as already quoted in chapter 2.1.4.2 for K-feldspar, albite, calcite, pyrite, organic carbon and pyrolusite in the database PHREEQC.dat or WATEQ4F.dat within the keyword RATES. There, all parameters are marked as comments by means of the # sign in the block KINETICS.

In the following, an example for the definition of **pyrite weathering rates** is given:

KINETICS
# example for KINETICS data block for pyrite
      -tol    1e-8               # tolerance for Runge_Kutta
      -m0   5e-4               # initial amount of pyrite in mol
      -m    5e-4

### 2.2.2.3.1.    Defining reaction rates

As reaction rates can be fitted mathematically in very different manners, there is an option (and need) in PHREEQC to declare any mathematical term in the form of a little BASIC program within the keyword RATES as will be shown in the following example of a **time-dependent calcite dissolution** (3_Kinetics-solution-of-calcite.phrq):

```
SOLUTION 1 distilled water
pH 7
temp 10
EQUILIBRIUM_PHASES
CO2(g) -3.5
KINETICS 1
 Calcite
 -tol 1e-8
 -m0 3e-3
 -m 3e-3
 -parms 50 0.6
 -steps 36000 in 20 steps // 36.000 seconds*
 -step_divide 10000 // first interval calculated with 3.6 sec.*
RATES
Calcite
 -start
 1 rem Calcite solution kinetics according to Plummer et. al 1978
 2 rem parm(1) = A/V, 1/dm parm(2) = exponent for m/m0
 10 si_cc = si("Calcite")
 20 if (m <= 0 and si_cc < 0) then go to 200
 30 k1 = 10^(0.198 - 444.0/(273.16 + tc))
 40 k2 = 10^(2.84 - 2177.0/(273.16 + tc))
 50 if tc <= 25 then k3 = 10^(-5.86 - 317.0/(273.16 + tc))
 60 if tc > 25 then k3 = 10^(-1.1 - 1737.0/(273.16 + tc))
 70 t = 1
 80 if m0 > 0 then t = m/m0
 90 if t = 0 then t = 1
 100 moles = parm(1) * 0.1 * (t)^parm(2)
 110 moles = moles * (k1 * act("H+") + k2 * act("CO2") + k3 * act("H2O"))
 120 moles = moles * (1 - 10^(2/3*si_cc))
 130 moles = moles * time //this line is a "must" for each BASIC-program*
 140 if (moles > m) then moles = m
 150 if (moles >= 0) then goto 200
 160 temp = tot("Ca")
 170 mc = tot("C(4)")
 180 if mc < temp then temp = mc
 190 if -moles > temp then moles = -temp
 200 save moles //this line is a "must" for each BASIC-program*
 -end
```

### 2.2.2.3 Introductory examples for kinetics

Advanced modeling includes modeling of kinetically controlled processes (for theory see chapter 1.2). Normally the reaction rate varies with the reaction process and this leads to a set of simple differential equations. The integration of the reaction rates over time can be carried out e.g. with the help of the Runge-Kutta algorithm. The implementation of Fehlberg (1969) within PHREEQC offers the possibility to evaluate the derivatives in partial steps by performing error estimation and comparing it with a user-predetermined tolerance limit (Cash & Karp 1990).

For kinetic modeling in PHREEQC two keywords are necessary: KINETICS n (n = number of SOLUTION, for which the kinetics shall be calculated) and RATES. For both keywords, a "rate name" has to be entered, e.g. calcite when the dissolution of calcite shall be modeled kinetically. The general syntax within the keyword KINETICS is shown in Table 26.

**Table 26   Syntax within the keyword kinetics in PHREEQC**

| KINETICS m-n | [m<n] |
|---|---|
| rate name | *rate name* and its associated rate expression must be defined within a RATES data block, e.g. pyrite, or any aquatic species |
| -formula | chemical formula or the name of a phase |
| -m | current moles of reactant [default = m0] |
| -m0 | initial moles of reactant |
| -parms | a list of numbers may be entered that can be used in a BASIC program within the rate expressions, for example constants, exponents, or half-saturation constants |
| -tol | Tolerance for integration procedure [default = $1 \cdot 10^{-8}$ mol/L], the value of *tolerance* is related to the concentration differences that are considered significant for the elements in the reaction. Smaller concentration differences that are considered as significant require smaller tolerances. |
| -steps | Time steps over which the rate expressions is integrated, n in m steps [default: n = 1] in seconds, e.g. 500 in 3 steps or 100 300 500 |
| -step_divide | If *step_divide* is greater than 1.0, the first time interval of each integration is set to *time* = step/step_divide; if step_divide is less than 1.0, then *step_divide* is the maximum moles of reaction that can be added during a kinetic integration subinterval. |
| runge_kutta | (1,2,3 or 6) designates the preferred number of time subintervals to use when integrating (default 3) |

The general syntax for RATES is "rate name", -start, and -end. A BASIC program is obligatory between -start and -end (see chapter 2.2.2.3.1).

USE solution 1; USE surface 1; EQUILIBRIUM_PHASES 1; Fix_H+ -3.0 NaOH 10; END
USE solution 1; USE surface 1; EQUILIBRIUM_PHASES 1; Fix_H+ -4.0 NaOH 10; END
USE solution 1; USE surface 1; EQUILIBRIUM_PHASES 1; Fix_H+ -5.0 NaOH 10; END
USE solution 1; USE surface 1; EQUILIBRIUM_PHASES 1; Fix_H+ -6.0 NaOH 10; END
USE solution 1; USE surface 1; EQUILIBRIUM_PHASES 1; Fix_H+ -7.0 NaOH 10; END
USE solution 1; USE surface 1; EQUILIBRIUM_PHASES 1; Fix_H+ -8.0 NaOH 10; END
USE solution 1; USE surface 1; EQUILIBRIUM_PHASES 1; Fix_H+ -9.0 NaOH 10; END
USE solution 1; USE surface 1; EQUILIBRIUM_PHASES 1; Fix_H+ -10 NaOH 10; END
USE solution 1; USE surface 1; EQUILIBRIUM_PHASES 1; Fix_H+ -11 NaOH 10; END

USE solution 2; USE surface 1; EQUILIBRIUM_PHASES 1; Fix_H+ -3.0 NaOH 10; END
USE solution 2; USE surface 1; EQUILIBRIUM_PHASES 1; Fix_H+ -4.0 NaOH 10; END
USE solution 2; USE surface 1; EQUILIBRIUM_PHASES 1; Fix_H+ -5.0 NaOH 10; END
USE solution 2; USE surface 1; EQUILIBRIUM_PHASES 1; Fix_H+ -6.0 NaOH 10; END
USE solution 2; USE surface 1; EQUILIBRIUM_PHASES 1; Fix_H+ -7.0 NaOH 10; END
USE solution 2; USE surface 1; EQUILIBRIUM_PHASES 1; Fix_H+ -8.0 NaOH 10; END
USE solution 2; USE surface 1; EQUILIBRIUM_PHASES 1; Fix_H+ -9.0 NaOH 10; END
USE solution 2; USE surface 1; EQUILIBRIUM_PHASES 1; Fix_H+ -10 NaOH 10; END
USE solution 2; USE surface 1; EQUILIBRIUM_PHASES 1; Fix_H+ -11 NaOH 10; END

Fig. 44 shows the amount of arsenic sorbed versus pH. Sorption takes place in particular as protonated bidentate species and to a minor share as the monodentate species. The non-protonated bidentate species has no significant share. Although no definitions were made for the surface complexation of Cl⁻ and Na⁺ in this simplified example the result changes significantly by setting the concentration of Na and Cl e.g. to 100 mmol/L.

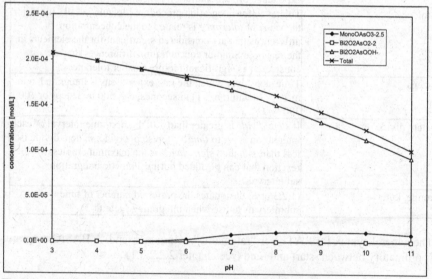

**Fig. 44    Sorption of arsenic on goethite according to CD-MUSIC model**

                          Bi          BiOH-0.5
SURFACE_SPECIES                              # data from Hiemstra & Riemsdijk (1999)
                          MonoOH-0.5 = MonoOH-0.5
                          log_K 0
                          BiOH-0.5 = BiOH-0.5
                          log_k 0
                          MonoOH-0.5 + H+ + AsO4-3 = MonoOAsO3-2.5 + H2O
                          log_k   20.1
                          -cd_music  -1 -6 0 0.25 5
                          # charge contribution of planes 0=-1 1=-6 2=0, CD-value = 0.25·5
                          2BiOH-0.5 + 2 H+ + AsO4-3 = Bi2O2AsO2-2 + 2H2O
                          log_K   27.3  # -0.6
                          -cd_music -2 -4  0 0.5 5
                          # charge contribution of planes 0=-2 1=-4 2=0, CD-value = 0.5·5
                          2BiOH-0.5 + 3H+ + AsO4-3 = Bi2O2AsOOH- + 2H2O
                          log_K   33.9  # -0.6
                          -cd_music -2 -4  0  0.6 5
                          # charge contribution of planes 0=-2 1=-3 2=0 CD-value = 0.6·5
SURFACE 1
                          MonoOH .00055 39 2        # name, sites(moles), area(m2/g), mass(g)
                          -capacitance   1.1   4.5     # F/m2
                          -cd_music
                          #     -donnan                # calculate diffuse layer with Donnan model
                          BiOH  .00055  39 0.5       # name, sites(moles), area m2/g, mass(g)
                          -capacitance   1.1   4.5     # F/m2
                          -cd_music
                          #     -donnan                # calculate diffuse layer with Donnan model

SOLUTION 1; -units  mmol/kgw; pH 8.0; As  0.0000; Na 100. charge; Cl 100.
SOLUTION 2; -units  mmol/kgw; pH 8.0; As  1     ; Na 100. charge; Cl 100.

USE surface none

PHASES
    Fix_H+
    H+ = H+
    log_k  0.0
END

USER_GRAPH
             -headings pH  MonoOAsO3-2.5 Bi2O2AsO2-2  Bi2O2AsOOH- Total
             -chart_title "Arsenic sorption"
             -axis_titles pH mol/L
             -axis_scale x_axis 3.0 11.0 1 0.25
             -axis_scale y_axis 1e-6 3.0e-4 1e-5
             -connect_simulations true
             -start
             10 GRAPH_X -LA("H+")
             20   Total   =   MOL("MonoOAsO3-2.5")   +   MOL("Bi2O2AsO2-2")   +
MOL("Bi2O2AsOOH-")
             30   GRAPH_Y       MOL("MonoOAsO3-2.5"),   MOL("Bi2O2AsO2-2"),
MOL("Bi2O2AsOOH-"), Total
             -end

The proportionality factor in the definition of SURFACE 1 states the moles of this surface site per mole of the phase. This form of defining the surface accounts for the amount of iron hydroxides precipitated (2 mmol) in step 3 of the job. Thus more or less no iron remains in solution and 8.133 μmol/L (81.33%) of uranium are removed due to surface complexation; the composition of surface species is given in Table 25. For more details run the introductory file and check the output.

**Table 25    Results of surface complexation divided into strong and weak binding sites**

| strong site:    $1 \cdot 10^{-5}$ moles 0.005 mol/(mol Fe(OH)$_{3(a)}$) | μmol | weak site:    $4 \cdot 10^{-4}$ moles 0.2 mol/(mol Fe(OH)$_{3(a)}$) | μmol |
|---|---|---|---|
| **Hfo_sOUO2+** | **4.322** | Hfo_wOH | 180.8 |
| Hfo_sOHCa+2 | 4.233 | Hfo_wOH2+ | 133.4 |
| Hfo_sOH | 0.8164 | Hfo_wOHSO4-2 | 55.48 |
| Hfo_sOH2+ | 0.6022 | Hfo_wSO4- | 20.51 |
| | | Hfo_wO- | 5.616 |
| | | **Hfo_wOUO2+** | **3.811** |
| | | Hfo_wOCa+ | 0.3752 |

Because there is no database available so far containing CD-MUSIC parameters three surface complexes are defined in the following examples according to data from Hiemstra and Riemsdijk (1999) for the surface complexation of arsenate on goethite. Based on IR spectrometry and similarities to phosphate they stated a monodentate, a bidentate, and a protonated bidentate species:

$$1 \ FeOH^{-1/2} + 1 \ H^+ + AsO_4^{3-}{}_{(aq)} \rightarrow FeO^pAsO_3{}^q + 1 \ H_2O \qquad \log\_k = 20.1 \quad CD = 0.25$$

$$2 \ FeOH^{-1/2} + 2 \ H^+ + AsO_4^{3-}{}_{(aq)} \rightarrow Fe_2O_2{}^pAsO_2{}^q + 2 \ H_2O \qquad \log\_k = 27.9 \quad CD = 0.50$$

$$2 \ FeOH^{-1/2} + 3 \ H^+ + AsO_4^{3-}{}_{(aq)} \rightarrow Fe_2O_2{}^pAsOOH^q + 2 \ H_2O \quad \log\_k = 27.9 \quad CD = 0.50$$

In the above equations p and q are the charges present on the inner and outer oxygens, respectively. The values can be calculated from the CD values. For details of the calculation see Hiemstra and Riemsdijk (1996, 1999). In the input file  (2c_Sorption_surface_complexation_CD-MUSIC.phrq)  only  these  three surface complexation species are defined; then first a solution without arsenic is applied followed by a solution containing 1 mmol/L arsenic. Each time the pH is fixed on values between 3 and 11. Concentration of Na and Cl was set to 1000 mmol/L. The semicolon is used here as an equivalent for carriage return (new line) in order to make the file as compact as possible. Replacing semicolons by carriage returns the script might be easier to read for beginners.

```
TITLE sorption of arsenate on ironhydroxide with CD-MUSIC approach
KNOBS
-iterations 500
-pe_step_size 2.5

SURFACE_MASTER_SPECIES # according to Hiemstra & Riemsdijk (1999)
 Mono MonoOH-0.5
```

Hfo_sOH = Hfo_sO- + H+
log_k    -8.93                          # -pKa2

Hfo_wOH + H+ = Hfo_wOH2+
log_k    7.29                           # = pKa1

Hfo_wOH = Hfo_wO- + H+
log_k    -8.93                          # = -pKa2

Hfo_sOH + Ca+2 = Hfo_sOHCa+2
log_k    4.97

Hfo_wOH + Ca+2 = Hfo_wOCa+ + H+
log_k -5.85
......

The complete list of surface complexation reaction defined in the selected database, e.g. WATEQ4F.dat or one of the other .dat files, can be viewed by click on the subfolder DATABASE. A simple example is given in the following introductory example (2b_Sorption_surface_complexation_UO2.phrq). The task is to simulate the scavenging of uranium by formation of ironhydroxides when a reduced acid mine water is treated with oxygen and limestone. The script contains three jobs which are separated by an END keyword.

```
DATABASE WATEQ4F.dat
TITLE sorption of uranyl on precipitated ironhydroxides
SOLUTION 1 acid mine water containing 2380 ppb Uranium
 pH 3
 pe 4
 units mmol/kgw
 Fe 2
 S 2.635
 U 10 umol/kgw
END
USE SOLUTION 1
EQUILIBRIUM_PHASES 1 # equilibrate with calcite and oxygen
 Calcite 0
 O2(g) 0.0001
SAVE SOLUTION 1
END
USE SOLUTION 1 # equilibrate Fe(OH)3(a) + perform surface complexation
SURFACE 1
 Hfo_wOH Fe(OH)3(a) equilibrium_phase 0.2 5e4
 # weak site coupled to Fe(OH)3(a), 0.2= proportionality factor, surface (m2/g)

 Hfo_sOH Fe(OH)3(a) equilibrium_phase 0.005
 # strong site coupled to Fe(OH)3(a), 0.005 = proportionality factor
EQUILIBRIUM_PHASES 1
 Fe(OH)3(a) 0 0
END
```

In this case, only the keyword EXCHANGE is used since as mentioned above the definition of EXCHANGE_MASTER_SPECIES and EXCHANGE_SPECIES is included in WATEQ4F.dat. The task of this job is simply to calculate the exchange reaction of a given solution 1 (1 liter) with a certain amount of a clay mineral (volume defined by 1.1 moles total exchange capacity). Be aware that the selectivity coefficients (log_k for exchange species) in the WATEQ4F.dat are just functors and not valid for real aquifer material. Running the input file will show a resulting pH of 9.4 and completely changed composition for solution 1:

| | | | | | |
|---|---|---|---|---|---|
| Na | 69.39 | µmol/L | Cd | $8.396 \cdot 10^{-9}$ | µmol/L |
| Cl | 40.0 | µmol/L | Pb | $3.887 \cdot 10^{-6}$ | µmol/L |
| Ca | $2.016 \cdot 10^{-03}$ | µmol/L | Zn | $5.935 \cdot 10^{-6}$ | µmol/L |

For modeling **surface complexation** PHREEQC offers four models:
- A generalized two-layer model with no explicit calculation of the diffuse-layer composition.
- an electrostatic double layer model with explicit calculation of the diffuse-layer
- a non-electrostatic model
- CD-MUSIC

For a surface complexation approach in PHREEQC three keywords are essential: SURFACE, SURFACE_MASTER_SPECIES, and SURFACE_SPECIES. The definition of a surface master species is comparable to that of an exchange master species and given names are arbitrary as well. A surface consists of one or more binding sites and as many surfaces as necessary can be defined.

As already mentioned some databases installed with the PHREEQC software contain definitions (Table 24) based on a diffuse double-layer model (2pK model) and data for ironhydroxides (Dzombak and Morel, 1990). The surface is named "Hfo" (Hydrous ferric oxide) containing two sites: a strong binding site, Hfo_s, and a weak binding site, Hfo_w. Dzombak and Morel (1990) used 0.2 mol for the weak sites and 0.005 mol for the strong sites per mol Fe, a surface area of $5.33 \cdot 10^4$ m$^2$/mol Fe, and a gram-formula weight of 89 g Hfo/mol Fe.

```
SURFACE_MASTER_SPECIES
 Hfo_s Hfo_sOH # strong binding site Hfo_s
 Hfo_w Hfo_wOH # weak binding site Hfo_w
SURFACE_SPECIES
 Hfo_sOH = Hfo_sOH # strong binding site Hfo_s
 log_k 0.0 # dummy

 Hfo_wOH = Hfo_wOH # weak binding site Hfo_w
 log_k 0.0 # dummy

 Hfo_sOH + H+ = Hfo_sOH2+ # additional surface complexes
 log_k 7.29 # pKa1
```

At least one exchange master species has to be defined in the following manner:

EXCHANGE_MASTER_SPECIES

| | | |
|---|---|---|
| X | X- | # X has one negative load |
| Y | Y-2 | # Y has a twofold negative load |

X and Y are arbitrary names: X (without charge), X- (with charge). Furthermore, the exchange species has to be defined by the keyword EXCHANGE_SPECIES:

EXCHANGE_SPECIES
        X- = X-
        log_k    0                    # dummy log_k
        Na+ + X- = NaX                # define new exchange_species
        log_k 0.0                     # per definition 0.0 for the first cation
        -gamma 4.0        0.075       # define activity coefficient
        Ca+2 + 2X- = CaX2
        log_k 0.5                     # log_k relative to NaX.
        -gamma 5.0        0.165       # define activity coefficient
        ......

Finally, there are several options to define the modeling task by using the keyword EXCHANGE:

EXCHANGE 1-10                         # calculate exchange for cells 1 to 10
        X        1.5                  # moles on the exchanger
        Y        0.2
        -equilibrate 5                # calculate initial equilibrium with solution 5
or
EXCHANGE 11                           # measured exchange composition of cell 11
        CaX2    0.3                   # 0.3 moles Ca
        NaX     0.5                   # 0.5 moles Na→ 2 · 0.3 + 0.5 = 1.1 moles X

For more complex options to define the initial exchange composition we refer to the PHREEQC manual. A very simple example for an exchange calculation is given in the following PHREEQC input file (2a_Sorption_exchange.phrq):

```
DATABASE WATEQ4F.dat # use of WATEQ4F.dat is required !
TITLE Exchange example
SOLUTION 1
units umol/kgw
pH 6
Cd 1
Pb 10
Zn 10
Cl 40
EXCHANGE 1 # calculate exchange for solution 1
CaX2 0.3 # 0.3 moles Ca.
NaX 0.5 # 0.5 moles Na. Sum= 2·0.3 + 0.5 = 1.1 moles X.
END
```

Fig. 43 was generated by calculating the mean value and standard deviation (SD) for all uranium species in the solution and all pH permutations. The plot shows thus the mean concentrations and mean value plus SD respectively mean value minus SD. The file UO2.prj generating the data for this example is enclosed on the CD of the book. It will run only with the example.dat from the book's CD because this is a renamed Wateq4f.dat (containing uranium data) with the necessary modifications as mentioned above.

### 2.2.2.2 Introductory example for sorption

The capability of PHREEQC to deal with sorption will be demonstrated in three examples. The first one is using the cation ion exchange approach, the second one DDLM (diffuse double-layer model), and the third one CD-MUSIC (charge distribution multisite complexation). Both DDLM and CD-MUSIC are surface-complexation models.

If exchange shall be modeled three keywords are needed: EXCHANGE_MASTER_SPECIES, EXCHANGE_SPECIES, and EXCHANGE. In some databases installed with the PHREEQC package "exchange"-data are included (Table 24); however, these data are only examples and have to be replaced by site-specific data. This can be done in the *name*.dat file with any text-editor or in the input file, as this overwrites information from the .dat-file.

**Table 24    Default data for cation exchange and surface complexation with respect to databases installed with PHREEQC**

| | cation exchange | surface complexation (diffuse double-layer model) |
|---|---|---|
| Phreeqc.dat | $Na^+$, $K^+$, $Li^+$, $NH_4^+$,$Ca^{2+}$, $Mg^{2+}$, $Sr^{2+}$, $Ba^{2+}$, $Mn^{2+}$, $Fe^{2+}$, $Cu^{2+}$, $Zn^{2+}$, $Cd^{2+}$, $Pb^{2+}$, $Al^{3+}$ | $H_3BO_3$, $Ba^{2+}$, $CO_3^{2-}$, $Ca^{2+}$, $Cd^{2+}$, $Cu^{2+}$, $F^-$, $Fe^{2+}$, $Mg^{2+}$, $Mn^{2+}$, $PO_4^{3-}$, $Pb^{2+}$, $SO_4^{2-}$, $Sr^{2+}$, $Zn^{2+}$ |
| Wateq4F.dat | $Na^+$, $K^+$, $Li^+$, $NH_4^+$,$Ca^{2+}$, $Mg^{2+}$, $Sr^{2+}$, $Ba^{2+}$, $Mn^{2+}$, $Fe^{2+}$, $Cu^{2+}$, $Zn^{2+}$, $Cd^{2+}$, $Pb^{2+}$, $Al^{3+}$ | $Ag^+$, $H_3AsO_3$, $H_3AsO_4$, $H_3BO_3$, $Ba^{2+}$, $Ca^{2+}$, $Cd^{2+}$, $Cu^{2+}$, $F^-$, $Fe^{2+}$, $Mg^{2+}$, $Mn^{2+}$, $Ni^{2+}$, $PO_4^{3-}$, $Pb^{2+}$, $SO_4^{2-}$, $SeO_3^{2-}$, $SeO_4^{2-}$, $Sr^{2+}$, $UO_2^{2+}$, $Zn^{2+}$ |
| Minteq.dat | - | $H_3AsO_3$, $H_3AsO_4$, $H_3BO_3$, $Ba^{2+}$, $Be^{2+}$, $Ca^{2+}$, $Cd^{2+}$, $Cu^{2+}$, $Ni^{2+}$, $PO_4^{3-}$, $Pb^{2+}$, $SO_4^{2-}$, $Zn^{2+}$ |
| Minteq.V4.dat | - | $Ag^+$, $H_3AsO_3$, $H_3AsO_4$, $H_3BO_3$, $Ba^{2+}$, $Be^{2+}$, $Ca^{2+}$, $Cd^{2+}$, $CN^-$, $Co^{2+}$, $Cr(OH)_2^+$, $CrO_4^{2-}$, $Cu^{2+}$, $Hg(OH)_2$, $Mg^{2+}$, $MoO_4^{2-}$, $Ni^{2+}$, $PO_4^{3-}$, $Pb^{2+}$, $SO_4^{2-}$, $Sb(OH)_6^-$, $SeO_4^{2-}$, $SeO_3^{2-}$, $Sn(OH)_2$, $VO_2^+$, $Zn^{2+}$ |
| LLNL | $Na^+$, $K^+$, $Li^+$, $NH_4^+$,$Ca^{2+}$, $Mg^{2+}$, $Sr^{2+}$, $Ba^{2+}$, $Mn^{2+}$, $Fe^{2+}$, $Cu^{2+}$, $Zn^{2+}$, $Cd^{2+}$, $Pb^{2+}$, $Al^{3+}$ | $Ba^{2+}$, $H_3BO_3$, $Ca^{2+}$, $Cd^{2+}$, $Cu^{2+}$, $F^-$, $Fe^{2+}$, $Mg^{2+}$, $Mn^{2+}$, $PO_4^{3-}$, $Pb^{2+}$, $SO_4^{2-}$, $Sr^{2+}$, $Zn^{2+}$ |

Edit sampling method is used to chose between LHS (Latin Hypercube Sampling) and Monte Carlo Sampling. Finally, LJUNGSKILE offers to calculate species concentrations at the given pH or by changing one parameter (e.g. pH or pe) within a certain range. This is done by checking in the multiple run box and edit the range and the interval length.

LJUNGSKILE can be started from the GUI with "simulation" from the main menu. Output is written in files named species.out respectively PHROUT.number with number running from 1 to the total number of e.g. pH steps. For visualization, the visualization tool LDP20.exe can be used either by Display from the LJUNGSKILE main menu or directly from the folder where LDP20.exe is installed. For high quality plots and plots according to the user´s desires data can be imported to any spreadsheet for further evaluation.

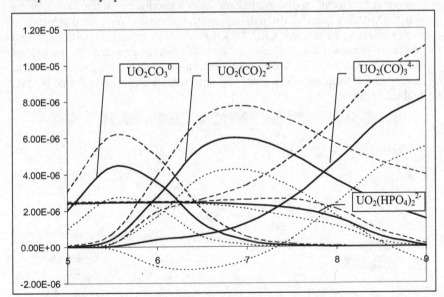

**Fig. 43   Concentration of the four most dominant uranium species as function of pH with mean values (solid lines) and ± standard deviation (dashed lines)**

Alternatively, the database example.dat can be used which is a modified Phreeqc.dat file and is created by the installation routine. Then, the species of interest have to be edited via **Edit project parameters**.

In the column "mean value" the log_k values from the database used have to be entered for the species of interest. The distribution for LHS or Monte Carlo simulation can be defined as "normal" distributed, then the assumed standard deviation of the log_k is entered in the column "SD or max value". Alternatively, one can enter "uniform" in distribution and enter a maximum value of log_k in the column "SD or max value". Alternatively, a solid phase and the partial pressure of carbon dioxide can be entered. LJUNGSKILE will then maintain equilibrium with the mineral entered and the carbon dioxide partial pressure by means of EQUILIBRIUM_PHASES. Additionally, the master species of the solution has to be entered in the template **edit water**. The same template is used to define the pH, pe, and temperature.

A new project is created in LJUNGSKILE via **File/new**. Then a database has to be selected. This can be any valid PHREEQC database, however, two theoretical species must be included which are used by LJUNSKILE to maintain electrical charge balance. These changes have to be made using any text editor.

```
SOLUTION_MASTER_SPECIES
Im Im 0.000000 Im 40.000000
Ip Ip 0.000000 Ip 40.000000

SOLUTION_SPECIES
 Im = Im
 log_k 0.000000
 delta_h 0.000000 kcal
 Ip = Ip
 log_k 0.000000
 delta_h 0.000000 kcal
 Im + e- = Im-
 log_k 30.000000
 delta_h 0.000000 kcal
 Ip = Ip+ +e-
 log_k 30.000000
 delta_h 0.000000 kcal
Ip+ + H2O = IpOH + H+
 log_k -20.00
 delta_h 0.000000 kcal
Im- + H2O = ImH + OH-
 log_k -20.00
 delta_h 0.000000 kcal
```

Fig. 42 shows the change in concentrations of calcium, magnesium, sulfate, and total inorganic carbon (TIC) during the three steps of contact with different minerals.

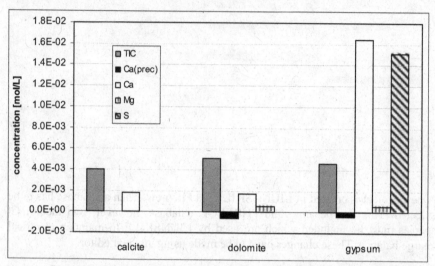

**Fig. 42  Development of water quality of rainwater after subsequent contact with calcite, dolomite, and gypsum assuming 1% $CO_2$ partial pressure of soil gas. Negative values indicate precipitation (of calcite) due to incongruent dissolution of dolomite and gypsum.**

## 2.2.2.1.4.   Example 1d: Modeling uncertainties – LJUNGSKILE

As mentioned before (chapter 2.1.5), results of thermodynamical or kinetic modeling depend significantly on thermodynamic stability constants or reaction rates. PHREEQC does not offer an option to evaluate this aspect except for manually changing parameters within a range from minimum to maximum. However, if more than one parameter is changed the number of necessary permutations is growing rapidly. The probabilistic speciation code LJUNGSKILE (Odegard-Jensen et al 2004) couples PHREEQC with either a Monte Carlo or a Latin Hypercube Sampling (LHS) approach to allow calculation of species diagrams with uncertainties. Species diagrams can be plotted by means of a chart template using LDP20.exe or via export to any scientific chart software. LJUNGSKILE and the viewing tool LDP20 can be downloaded from http://www.geo.tu-freiberg.de/ software/Ljungskile/index.htm. Both programs install automatically and can be started showing the following template:

or gases. To model this, a more detailed look at the syntax is necessary. The syntax of lines following the keyword EQUILIBRIUM_PHASES is *name, SI, moles, option*. As explained before, *name* is the name of the mineral or gas (as defined in the database used), *SI* is the desired saturation index for the minerals. In case of gases, this value is the logarithm of the desired partial pressure in bar (0.01 bar → -2). *Moles* is the amount of moles wich can be dissolved (default 10 mol); by setting moles to 0.0 only precipitation of the mineral is allowed. If only dissolution is required this can be set by adding the statement *diss* as option at the end of the line.

These options will be demonstrated in the following example (1c_Solution-of-calcite-CO2.phrq). If rainwater comes into contact with calcite assuming a certain $CO_2$ partial pressure this can be modeled as shown in the upper part of input file example 2b. The second part after the first END describes what happens if this water then comes into contact with dolomite. By setting Calcite 0.2 0 PHREEQC maintains a SI of 0.2 (slightly oversaturated); the 0 provides that no calcite will be dissolved. Thus, incongruent dissolution of minerals can be modeled very easily in PHREEQC. The third part in the input file provides the dissolution of gypsum; this will also lead to a secondary formation of calcite which is again handled by setting *moles* to zero.

```
Title example 2b dissolution calcite & dolomite
Solution 1 # distilled water ~ rain water
temp 20
pH 6.4

EQUILIBRIUM_PHASES
Calcite 0 # assume contact with calcite
CO2(g) -2 # and a CO2 partial pressure of 1% = 0.01 bar
O2(g) -0.68 # used to equilibrate with O2 of air
SAVE SOLUTION 1
END # end of first job
USE SOLUTION 1
EQUILIBRIUM_PHASES # assume contact with dolomite
Dolomite 0 10 diss # SI=0, 10 moles available, only dissolution!
CO2(g) -2
O2(g) .00001
Calcite 0.2 0 # SI=0.2 (slighty oversaturated), 0 mol --> no
 dissolution
SAVE SOLUTION 2
END

USE SOLUTION 2
EQUILIBRIUM_PHASES # assume contact with gypsum
Gypsum 0
Calcite 0.2 0
END
```

0.010 mol/L = 10 mmol/L; $I_3$ = 40 mmol/L, $f_3$ = 0. 48, $c_3$ = 0.0104 mol/L = 10.4 mmol/L, etc. With three iterative steps a concentration of about **10 mmol/L of gypsum is calculated.**

Modeling

In comparison to this calculation, the dissolution of gypsum in distilled water shall now be modeled by means of PHREEQC The input is very simple as it concerns distilled water and thus, the SOLUTION block contains only pH = 7 and temperature = 20 °C. To enforce equilibrium with gypsum, the keyword EQUILIBRIUM_PHASES and a saturation index of 0 are used.
The input file looks as follows (1b_Solution-of-gypsum.phrq):

```
 TITLE example 2 dissolution of gypsum
 SOLUTION 1
 temp 20
 pH 7.0
 EQUILIBRIUM_PHASES
 gypsum 0
 END
```

The output file contains an additional block "beginning of batch-reaction calculations", and a "phase assemblage" block besides the already known paragraphs solution composition, description of solution, distribution of species, saturation indices. Phase assemblage contains: mineral phase – SI – log IAP – log KT – initial (initial amount of gypsum, 10 mol/kg by default) – final (amount of gypsum, which still exists as solid after dissolution) – delta (amount of dissolved gypsum = final - initial; negative value stands for dissolution, positive values indicate precipitation).

As distilled water (with no constituents) is used, the amount of dissolved gypsum (phase assemblage delta) is equal to the amount of $Ca^{2+}$ and $SO_4^{2-}$ (solution composition molality, respectively distribution of species).

The result of the dissolution of gypsum is $1.532*10^{-2}$ = **15.32 mmol/L**, in comparison to about 10 mmol/L of the preceding calculation. Looking at the species distribution it can be seen that besides the free ions $Ca^{2+}$ and $SO_4^{2-}$ the following complexes have been formed as well: $CaSO_4^0$, $CaOH^+$, $HSO_4^-$ and $CaHSO_4^+$. Due to the formation of the $CaSO_4^0$ complex (**4.949 mmol/L**), the dissolution of gypsum will be clearly increased (see also chapter 1.1.4.1.1). It is a process that had not been considered in the simple manual calculation above.

Already, by means of this first simple example, the complexity of describing the hydrogeochemistry of aquatic systems and the limitations of interpretations without computer-aided modeling can be understood.

## 2.2.2.1.3.   Example 1c equilibrium – solution of calcite with $CO_2$

Besides modeling a simple equilibrium as in the previous example, the keyword EQUILIBRIUM_PHASES also allows to model any disequilibrium with minerals

for dolomite(d); d = dispersedly distributed) due to its inertness. In contrast to this, a rapid precipitation can be expected for calcite with an SI of 0.74. Referring to the iron represented in Fig. 41, a fast precipitation reaction of amorphous iron hydroxide can be anticipated. Thereby, only a moderate super-saturation occurs (SI = +0.18). Pyrite is significantly supersaturated and will likely precipitate with time, after amorphous iron hydroxide, forming finely distributed crystals. Hematite, magnetite, and goethite are generally formed from $Fe(OH)_3(a)$ during conversion reactions and will not precipitate directly. Altogether, it can be observed that the total concentration of iron with Fe = 0.0025 mg/L is very low and thus not sufficient for all precipitation reactions to reach equilibrium.

## 2.2.2.1.2.    Example 1b equilibrium – solution of gypsum

The question "How much gypsum can be dissolved in distilled water?" shall be answered by manual calculation and then by means of PHREEQC for comparison [pK gypsum = 4.602 (at T = 20 °C)].

Calculation
The chemical equation for the dissolution of gypsum is:
$$CaSO_4 \leftrightarrow Ca^{2+} + SO_4^{2-}$$

$$K_{gypsum} = \frac{\{Ca^{2+}\} \cdot \{SO_4^{2-}\}}{\{CaSO_4\}}$$

$K = [Ca^{2+}] * [SO_4^{2-}] = 10^{-4.602}$     (as $[CaSO_4] = 1$)
as $[Ca^{2+}] = [SO_4^{2-}]$    $K = [SO_4^{2-}]^2$    $[SO_4^{2-}] = \textbf{0.005 mol/L = 5 mmol/L}$

This result calculated based on the mass-action law is, however, not a concentration but an activity (chapter 1.1.2). The conversion from activity to concentration is carried out using the activity coefficient (Eq. 10). The ionic strength is calculated according to Eq.12:

$$I = 0.5 \cdot \sum m_i \cdot z_i^2$$

where m is the concentration in mol/L and z the oxidation state of the species i. Since the concentration is unknown, iterative calculation has to be performed with a first approximation that the activity of 5 mmol/L replaces the concentration. The results for $Ca^{2+}$ and $SO_4^{2-}$ are:

$$I = 0.5 \cdot \sum 5 \cdot 2^2 + 5 \cdot 2^2 = 20 \, mmol/L$$

From the graphical correlation between ionic strength and activity coefficient (Fig. 2) an activity coefficient $f_1$ of about 0.55 and a concentration $c_1$ of $a_i/f_i$ = 0.005/0.55 = 0.009 mol/L = 9 mmol/L, respectively is found. If this first approximation for the concentration is now used in the equation for the ionic strength, the following results will be obtained: $I_2$ = 36 mmol/L, $f_2$ = 0.5, $c_2$ =

The ratio N(5)/N(-3) is approximately 3:1. The Fe(3)/Fe(2) ratio is 4:1. It is important to consider that the predominant Fe(2) species are $Fe^{2+}$ and the positively charged complex $FeCl^+$ which are subject to cation exchange. On the other hand, Fe(3) occurs mainly as non-charged complex $Fe(OH)_3^0$ and is thus hardly retained at all. U(6) clearly dominates compared to U(5) and U(4). In contrast to U(4), U(6) is considerably more soluble and thus more mobile. But the predominant U(6) species are the negatively charged complexes $(UO_2(CO_3)_3^{4-}$, $UO_2(CO_3)_2^{2-})$, which are subject to interactions with e.g. iron hydroxides. Mobility may thus be limited. The different ratios of reduced to oxidized species for N, Fe, and U are in accordance with the theoretical oxidation/reduction succession (see also Fig. 21). The oxidation of Fe(2) to Fe(3) already starts at pE values of 0, the oxidation of N(-3) to N(5) only at pE= 6, while the oxidation of uranium is already finished at a pE value of 8.451, which was determined in the seawater sample.

Hints for super- or undersaturation of minerals can be found in the last paragraph of the initial solution calculations entitled "saturation indices". Graphical representation of saturation proportions is often done by means of bar charts, where SI = 0 marks the point of intersection between the x-axis and the y-axis, and the bars of super-saturated phases point upwards and those for under-saturated phases downwards (example Fe-bearing mineral phases Fig. 41).

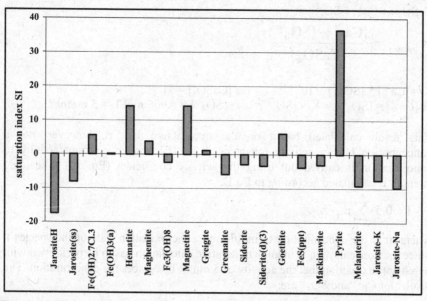

**Fig. 41   EXCEL bar chart to represent all super- and undersaturated iron-bearing mineral phases**

It is important to note that not all mineral phases with an SI > 0 necessarily will precipitate because slow reaction rates and prevailing boundary conditions may lead to the preservation of disequilibria over long periods. Therefore, dolomite will not precipitate from seawater despite its distinctly positive SI of 2.37 (or 1.82

## 2.2.2.1.1.   Example 1a standard output – seawater analysis

By means of the example of the seawater analysis already discussed in chapter 2.2.1.1 it is shown what kind of results can be obtained from the standard output. The corresponding PHREEQC input file can be found on the enclosed CD (PhreeqC_files/0_Introductory-Examples/1a_Seawater-analysis.phrq).

General information is found in the paragraphs "**solution composition**" and "**description of solution**". Solution composition shows that the water is of Na-Cl-type (Cl = 0.55 mol/L, Na = 0.47 mol/L; seawater).

The ionic strength of 0.6594 mol/L found in "description of solution" represents the high total mineralization of the seawater. To verify the accuracy of the analysis, the electrical charge balance and the analytical error are considered (electrical balance (eq) = $7.370 \cdot 10^{-04}$; percent error, $100*(Cat-|An|)/(Cat+|An|)$ = 0.06). Note: In Germany, the equation $100*(Cat-|An|)/[0.5*(Cat+|An|)]$ is often used (Hölting 1996, DVWK 1990). This alternate form of the charge balance equation is also used in WATEQ4F (Ball and Nordstrom, 1991). Thus the error would be 0.12 %. Anyway, the accuracy of the analysis is very good and the analysis can be used for further modeling. If the command "charge" is put behind chloride, as shown in the example in chapter 2.2.1.1, a total charge compensation will be enforced [electrical balance ($1.615 \cdot 10^{-16}$) and analytical error (0.00)]. Under "redox couples" the redox potential for each single redox couple is listed as pE- or $E_H$ value.

Not only the total concentration of each element can be taken from "distribution of species" but also the distribution of species, i.e. the share of free cations, negatively charged, positively charged, and non-charged complexes. With this information it is possible to draw conclusions about oxidative/reductive ratios, mobility, solubility, or even toxicity of elements and species. The cations Na, K, Ca, and Mg mainly exist (87-99 as free cations, only 1-13 % account for metal-sulfate-complexes. Chloride predominates as free ion to nearly 100 %. It hardly reacts with other bonding partners. C(4) occurs predominantly as $HCO_3^-$ ion (70 %), yet reacts to a lower percentage with Mg and Na forming $HCO_3^-$ and $CO_3^{2-}$ complexes. S(6) behaves similar to C(4) forming predominantly $SO_4^{2-}$. N(5) and N(-3) occur predominantly as $NO_3^-$ and to a less amount as $NH_4^+$. The easiest way to picture species distribution is a pie chart. Fig. 40 shows exemplatory the species distribution for C(4) and S(6).

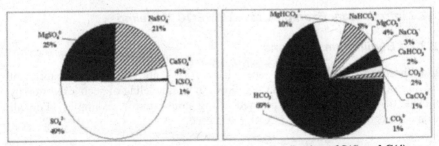

**Fig. 40    EXCEL pie charts to represent the species distribution of S(6) and C(4)**

### 2.2.1.4 Grid

The GRID folder offers to plot data in spreadsheet format. However, a file name ("example.csv") and the desired information has to be defined by using the command SELECTED_OUTPUT in the input file, e.g. the saturation indices of anhydrite and gypsum,

SELECTED_OUTPUT
    -file   example.csv
    -si    anhydrite gypsum

The spreadsheet file has to be opened manually in the folder GRID (does not happen automatically). Files with the extension ".csv" (Microsoft Excel files, delimited by comma) can be directly opened in the GRID folder. If no file name is entered in the command line, "selected.out" will be used as default. This file can be opened in GRID also, but is not displayed automatically (to open "selected.out" the file tye "all files" (*.*) must be chosen). For other graphical representations it is recommended to open the SELECTED_OUTPUT file in a spreadsheet program (e.g. EXCEL) to make further changes and take advantage of graphical options in those programs.

### 2.2.1.5 Chart

Data in the folder GRID can be highlighted and plotted in the CHART template by click on the right mouse button ("Plot in chart"). Values in the first selected column will be considered as x-values and all values in the following columns as y-values. A second possibility is using the keyword USER_GRAPH to define directly in the input file the parameters to be plotted in the CHART diagram (see exercise chapter 3.3.3).

Using the right mouse button, the diagram area can be formatted by "format chart area" (font, background). With "chart options", it is possible to add a second y-axis, a legend, titles, and labels for the x- and y-axis. The axes, the legend, and the graph itself can be formatted by selecting and clicking the right mouse button.

## 2.2.2 Introductory Examples for PHREEQC Modeling

### 2.2.2.1 Equilibrium reactions

Equilibrium reactions (theory see chapter 1.1) are the simplest form of hydrogeochemical modeling. In the following, the modeling of such a reaction by means of PHREEQC is explained using four simple examples. For all calculations the database WATEQ4F.dat is used.

### 2.2.1.3 Output

The modeling can be started either via Calculations/Start or by the icon "calculate". A "PHREEQC for Windows-progress" window opens showing input, output and database file as well as the calculation progress in line 4. In the lower part calculation time and potential errors are displayed. DONE appears when the calculation is performed or terminated. By clicking on DONE, the progress window closes and the output folder opens.

An output file is automatically created with the name of the input file and the additional extension "out". If one explicitly wants to enter a different name, it can be done under Calculations/Files Output-File. Editing in the output file is not possible (only via external text editor, but not recommended).

The output consists of a standard output plus additional results per input. The standard output has the following structure:

- Reading data base (the database including keywords is read)
- Reading input data (repetition of data and keywords from the input file)
- Beginning of initial solution calculation (standard calculations)
  <u>solution composition</u>: element concentration in mol/kg (molality) and mol/L (moles)
  <u>description of solution</u>: pH, pE, activity, charge balance, ionic strength, error of analysis, etc.
  <u>distribution of species</u>: in each first line total concentration of an element in mol/L, followed by the species of that element with concentration c in mol/L, activity a in mol/L, log c, log a, and log Gamma (= log activity coefficient = log (activity/concentration) = log a − log c; see also chapter 1.1.2.4)
  <u>saturation indices</u>: saturation indices with mineral name, SI, log IAP, log KT (SI = log IAP − log KT; see also chapter 1.1.4.1.2), and mineral formula; positive values mean super-saturation, negative values under-saturation with regard to the respective mineral phase.

If redox-sensitive elements (e.g. $NO_3^-$, $NH_4^+$ in the case of the seawater analysis) are declared in the input file, a paragraph "redox couples" will be displayed in the output after "description of solution" that contains all individual redox couples (in the example N(-3)/N(5)) with their respective partial redox potentials as pE, and $E_H$ value in volts.

Following the standard output (beginning of initial solution calculation) the task-specific results are listed, i.e. this is now a modified solution not the initial solution anymore. The structure of the output file is displayed by an index in the window on the right. By double clicking on the tree structure one gets to the beginning of the chosen chapter in the output. Especially when searching long output files, the index is a significant help not to confound results from initial and modeled solutions.

ISOTOPE_RATIOS prints the absolute ratio of minor to major isotope for each minor isotope and the ratio converted to standard measurement units.

NAMED_EXPRESSIONS defines analytical expressions that are functions of temperature for isotopes

CALCULATE_VALUES allows user-defined BASIC statements

### 2.2.1.2 Database

The databases WATEQ4F.dat, MINTEQ.dat, PHREEQC.dat and LLNL.dat are automatically installed with the program PHREEQC and can be chosen from the menu Calculations/File under Database File. Alternatively, the database can be defined for each input file by the keyword DATABASE followed by the file path. This overwrites any database selected by default via the menu Calculations/File. If the keyword DATABASE is used, it must be the first keyword in the input file.

The internal structure of thermodynamic databases has already been explained in detail in chapter 2.1.4.2 by means of the example WATEQ4F.dat. Lines beginning with "#" are only comments, e.g. each first line of reaction blocks under the keyword SOLUTION_SPECIES.

When modeling rare elements, one will often recognize that not all necessary parameters are available in an existing database. Thus, there is theoretically the option to create/add own databases (e.g. as combination of different databases) or to change already existing ones. In chapter 2.1.4.1 and chapter 2.1.5, problems related to database maintenance, verification of database consistency or existence of species, and differences in the conditions under which the solubility constants have been determined, have already been discussed. Using the data browser of PHREEQC allows to view the selected database but not to edit it. If changes have to be made in the database (not recommended for beginners) this can be done with any external text editor, e.g. WORDPAD, and saved as ASCII file.

If elements, species, stability constants, and/or solubility constants that are unavailable in an existing database, are to be used for one job only, it is advisable to define them directly in the input file rather than to change the database itself. As a declaration in an input file always has a higher rank, it overwrites information of a database. Like in the database, the keyword SOLUTION_MASTER_SPECIES has to be used to define the element (e.g. C), the ionic form (e.g. CO3-2), the contribution of the element to alkalinity (e.g. 2.0), the mole mass of the species for the input in mg/L (e.g. 61.0171), and the atomic mass of the element (e.g. 12.0111) (see also Table 21). When entering the keyword SOLUTION_SPECIES, a reaction, the respective solubility constant log k and the enthalpy delta h in kcal/mol or kJ/mol at 25 °C additionally have to be defined (for further operations see also Table 22), e.g.

| | |
|---|---|
| Reaction | CO3-2 = CO3-2 |
| Solubility constant | log k    0.0 |
| Enthalpy | -gamma 5.4    0.0 |

SURFACE_SPECIES is used to define a reaction and log K for each surface species, including surface master species

SURFACE defines the amount and composition of an assemblage of surface binding sites (either explicit by defining the amounts of the surfaces in their neutral form or implicit through equilibrium with a solution); a surface assemblage may have multiple surfaces and each surface may have multiple binding sites

### Advanced features
INVERSE_MODELING simulates the genesis of a given (final) solution from one or a mixture of multiple original solutions including any kind of equilibrium reactions with mineral or gas phases

KINETICS defines time-dependent (kinetic) reactions and specifies reaction parameters for batch-reaction and transport calculation

INCREMENTAL_REACTIONS is used to save CPU time during kinetic batch-reactions

RATES allows to define any mathematical rate expressions for kinetic reactions by means of an integrated programming language (BASIC)

ADVECTION allows one-dimensional piston-flow with any chemical reaction offered by PHREEQC; dispersion and diffusion are not considered

TRANSPORT is used to simulate one-dimensional transport including advection, dispersion, diffusion, and diffusion to adjacent stagnant zones (double-porosity aquifers)

USER_GRAPH plots user-defined results (written in a Basic program) to the tab CHART as the modeling is running

USER_PRINT prints user-defined results (written in a Basic program) to the standard output file as the modeling is running

COPY copies a solution, mineral or gas phase, surface, etc., at the end of the simulation to one or a range of new index number(s)

### Modeling isotopes
ISOTOPES is used to define names, units, and absolute isotope ratio for individual minor isotopes

ISOTOPE_ALPHAS prints calculated isotopic ratios defined with CALCULATE_VALUES

USER_PUNCH prints user-defined results (written in a Basic program) to the SELECTED_OUTPUT file as the modeling is running

PRINT can suppress the standard output or define which parameters are written to the standard output file

KNOBS is used to redefine parameters that cause numerical problems

**Defining data**
PHASES can be used to define chemical reactions between solid and aqueous phases with their thermodynamic constants in the input file; its use is optional and overwrites default definitions in the database

PITZER specifies (equivalent to PHASES for the ion-association theory) thermodynamic constants if ion-interaction is used (Pitzer parameters); it overwrites definitions in the database file

LLNL_AQUEOUS_MODEL_PARAMETER defines parameters for the LLNL aqueous model used in EQ3/6 and Geochemist Workbench, assembled in llnl.dat

SOLID_SOLUTIONS is used to define a non-ideal (2 components) or ideal (>2 components) solid-solution assemblage

SOLUTION_MASTER_SPECIES defines the correspondence between the element and aqueous primary and secondary species (e.g. element: S; primary species: $SO_4^{2-}$); it can be used optional in the input file to define additional or overwrite existing species from the database

SOLUTION_SPECIES defines chemical reactions, thermodynamic constants, and activity coefficients for each species; it can be used optional in the input file to define additional or overwrite existing species from the database

EXCHANGE_MASTER_SPECIES defines correspondence between an exchange site and an exchange species; it can be used optional in the input file to define additional or overwrite existing species from the database

EXCHANGE_SPECIES is used to define a half-reaction and relative log K for each exchange species

EXCHANGE defines the amount and composition of an assemblage of exchangers (either explicit by composition or implicit through equilibrium with a solution)

SURFACE_MASTER_SPECIES defines correspondence between a surface binding site and a surface master species; it can be used optional in the input file to define additional or overwrite existing species from the database

**Modeling isotopes**

| ISOTOPES | NAMED_EXPRESSIONS |
|---|---|
| ISOTOPE_ALPHAS | CALCULATE_VALUES |
| ISOTOPE_RATIOS | |

**Basic keywords**

SOLUTION defines the chemical composition of a water and is obligatory for any PHREEQC input file; without any subkeyword this would be distilled water.

SOLUTION_SPREAD is an alternative input format for SOLUTION that is compatible with the output of many spreadsheet programs such as EXCEL

TITLE is used to include a comment for the simulation; additional comments can be added anywhere in the input data block after a „#" sign

DATABASE can be used to overwrite the selected default database for an individual input file; if used it must be the first keyword in the input file

END defines the end of an input job; it is mandatory to conclude an initial modeling and re-use the modeled solutions in subsequent reactions within the same input job, e.g. it has to appear between the keywords SAVE and USE

EQUILIBRIUM_PHASES is used to equilibrate a solution with either a solid phase or a gaseous phase (in an open system)

MIX can be used to mix one or more solutions in any ratios

GAS_PHASE defines equilibrium with a gas phase in a closed system (in contrast to EQUILIBRIUM_PHASES for open systems)

REACTION defines irreversible reactions which either add or remove specified amounts of elements to or from the aqueous solution

REACTION_TEMPERATURE is used to model a range of different temperatures during a batch reaction; it overwrites any default temperature defined in SOLUTION and can be used as well in transport modeling

SAVE is used to save an interim result of the modeling for later use within the same input job; this can be e.g. the composition of a solution, a gas phase, or a surface

USE is used to recall previously saved interim results (compare SAVE)

SELECTED_OUTPUT saves user-defined parameters in a file that is suitable for processing by spreadsheet programs

when more than one aqueous solution composition has to be defined. Data obtained e.g. from a laboratory spreadsheet format can be copied directly into the PHREEQC input file. SOLUTION_SPREAD is compatible with the format of many spreadsheet programs, such as EXCEL. The column headings are element names, element valence state names or isotope names. One subheading can be used to define speciation (e.g. „as SO4", or „as NO3"), specify element specific units, redox couples, phase names and saturation indices. All succeeding lines are the data values for each solution, with one solution defined in each line.

The extension "phrq" is linked with PHREEQC for Windows, however, when saving PHREEQC input files the extension has to be explicitly added to the file name, it is not added automatically. The input files are basically plain ASCII files that can be read and edited with any editor.

To model equilibrium reactions, kinetics, and reactive transport or to define additional data more keywords besides TITLE, SOLUTION, and END are available. In the following, their meanings are briefly described grouped into basic keywords that find a wide range of application by all users, keywords for defining data and for advanced modeling as well as very special keywords used by advanced users mainly. A complete list of keywords including a detailed description of individual input parameters and syntax is available in the PHREEQC manual (ftp://brrcrftp.cr.usgs.gov/geochem/unix/phreeqc/manual.pdf).

**Basic keywords**

| | |
|---|---|
| SOLUTION | REACTION |
| SOLUTION_SPREAD | REACTION_TEMPERATURE |
| TITLE | SAVE |
| DATABASE | USE |
| END | SELECTED_OUTPUT |
| EQUILIBRIUM_PHASES | USER_PUNCH |
| MIX | PRINT |
| GAS_PHASE | KNOBS |

**Defining data**

| | |
|---|---|
| PHASES | EXCHANGE_MASTER_SPECIES |
| PITZER | EXCHANGE_SPECIES |
| LLNL_AQUEOUS_MODEL_PARA | EXCHANGE |
| METER | SURFACE_MASTER_SPECIES |
| SOLID_SOLUTIONS | SURFACE_SPECIES |
| SOLUTION_MASTER_SPECIES | SURFACE |
| SOLUTION_SPECIES | |

**Advanced features**

| | |
|---|---|
| INVERSE_MODELING | ADVECTION |
| KINETICS | TRANSPORT |
| INCREMENTAL_REACTIONS | USER_GRAPH |
| RATES | USER_PRINT |
| | COPY |

A list of element concentrations follows. Whereas ions like Ca, Mg, etc. that occur only in one redox state are indicated as elements, ions whose concentration is determined in different redox states are denoted individually with their valence in parentheses, as in the example Fe(3) and Fe(2). However, the syntax is defined in the database (*.dat) not in the PHREEQC code. For complexes like $HCO_3^-$, $NO_3^-$, $SO_4^{2-}$, three input options exist:

[ion] ([valence]) [concentration in mg/L] **as** [complex form] *in the example for* $HCO_3$, $NH_4$
[ion] ([valence]) [concentration in mmol/L] **gfw**[molar mass of the complex]
*gfw = gram formular weight, in the example for $NO_3^-$*
[ion] ([valence]) [concentration in mmol/L] **mmol/L** *in the example for $SO_4^{2-}$*

In the latter case, mmol/L defines a unit different from the default unit defined under the subkeyword "units". It is important that the reference (in the example "liter") is the same as that used under the subkeyword "units". Alternatively, ppm could be defined generally under units and ppb for an individual element or mg/kgw (kg water) in general and mol/kgw for an individual element.
Furthermore, the command **"charge"** can be used with any element, the pH or the pE value, but it may **only** appear **once** in the whole input file (as in the example with chloride). The use of "**charge**" enforces a total charge compensation by means of the chosen element or the pH or the pE value, respectively and thus maintains electrical balance. The element with the highest concentrations might be chosen to keep the relative error as small as possible by means of an arbitrary increase or decrease of the concentration for charge compensation. The keyword "charge" may not be used with "Alkalinity".
The pH, pE, or individual elements may be combined with a mineral or gas phase and a saturation index (in the example: **O(0)  1.0  O2(g) -0.7**). It causes a change in concentration of the respective element to obtain equilibrium or a defined disequilibrium in terms of the defined mineral or gas phase. If no saturation index is given along with the phase name, the default SI = 0 (equilibrium) will be used. For gases, the logarithm of the partial pressure is specified in bar (instead of the saturation index for minerals): -0.7 in the example thus means a $O_2$ partial pressure of $10^{-0.7} = 0.2$ bar or 20 Vol-%.
If a redox couple is defined in the same line as an element, beyond the concentration input (in the example: **N(5)/N(-3)** beyond U) the species distribution (of uranium) is not calculated via the standard $E_H$ value, but based on the redox equilibrium of the given redox couple.
The shortcut **STRG+T** opens a list of species defined in the database, **STRG+H** a list of minerals and gases defined in the database. Select the species or phase and press ENTER (no double click!) to transfer the selected species or phase to the position of the cursor in the input file.
Alternatively to the keyword SOLUTION, SOLUTION_SPREAD can be used for the input of solutions. The input is transposed compared to the input for SOLUTION, i.e. the rows of input for SOLUTION become the columns of input for SOLUTION_SPREAD. This tab-limited format is especially convenient to use

The structure of an input file will be explained by means of the example of the following seawater analysis (Fig. 39). The order of parameters and species in example SOLUTION 1 seawater analysis corresponds to a certain logic for instruction purposes. However, in general it does not matter in which order the details are entered in the input file. They only have to appear under the keyword SOLUTION.

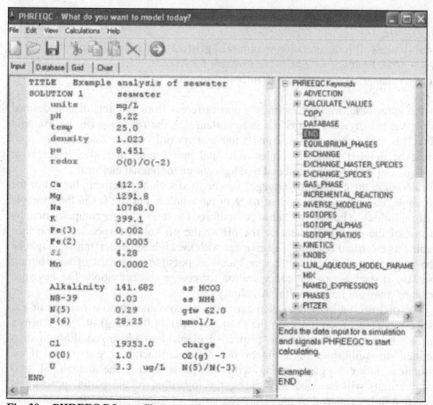

Fig. 39    PHREEQC Input file (example seawater analysis)

To define the units for the input of concentrations the keyword "units" has to be used. Possible units are ppb and ppm or g, mg, and ug (not µg!) per Liter as well as mol, mmol, and umol per Liter or per kg water. Temperature (temp) is denoted in °C. The density (density) can be entered in g/cm³, with a default of 0.9998. That information is especially important for highly mineralized waters, like e.g. seawater. To insert the measured Eн value a conversion to the pE value is necessary (see chapter 1.1.5.2.2, Eq. 65). If no pE value is given, pE is assumed to be 4 by default. A redox couple (redox) can be defined to calculate the pE value that will be used to model the species distribution of redox-sensitive elements if no pE is given.

### 2.2.1.1 Input

The template Input consists of three windows (Fig. 39). The left, initially blank window is the active area to write the input file - a chemical analysis to be modeled together with the commands to perform the particular modeling task - by means of a simple text editor. PHREEQC keywords and PHREEQC BASIC statements are listed in the upper right window (window can be (in)activated under menu View/Keywords). A mouse click on the "+" symbol displays the list of keywords and subkeywords. The utilization of the BASIC commands is explained in chapter 2.2.2.3.2. The lower right window which can be (in)activated under menu View/Hints contains explanations for individual keywords from the keyword list above.

A simple input consists of the three keywords TITLE, SOLUTION and END. However, a simple job will also run using the keyword SOLUTION only. END is only required to separate multistage tasks. Anything written in the line beyond TITLE is for documentation purposes only. Keywords can generally be inserted to the left windows from the list on the right hand side by double clicking on the respective commands. For the keyword index three options can be chosen under Edit/Preference/Input in the main menu:

- Insert code templates from keywords index, e.g. for SOLUTION
  SOLUTION 1-10
  pH 6.05
  pe 14.8
  -units mg/L
  Na 1 mmol/L
  Cl 37 charge
  C(4) 0.6 as HCO3

- Insert comments with templates (default setting upon initial installation), e.g. for SOLUTION
  SOLUTION 1-10 # a number or a range of numbers. Default: 1.
  pH 6.05 # Default: 7.
  pe 14.8 # Default: 4.
  -units mg/L # Default: mmol/kgw
  Na 1 mmol/L # Chemical symbol from the 1st column in
      SOLUTION_MASTER_SPECIES, concentration,
      concentration is adapted to charge balance
  Cl 37 charge # concentration is adapted to charge balance
  C(4) 0.6 as HCO3 # Concentration is in mg of HCO3 = 0.6/0.61 =
      0.98 mmol/L

- Insert templates as comments, e.g. for SOLUTION
  #SOLUTION

The examples and explanations might be helpful for a beginner to understand the required syntax. For more advanced users, however, replacing the exemplatory values gets tiresome and too many comments quickly render the input file confusing. Those users might wish to de-select all three options and will by double click on the keyword list only get the keyword as in previous versions of PHREEQC. A more helpful option might be to use the Hints window (menu View/Hints) in the lower right corner.

Both GUI's have the capability to start the PHREEQC program and to display the output file. Fig. 38 and Fig. 39 display how both appear for the user.

**Fig. 38   Screenshot of PHREEQCI with the working spreadsheet to enter data for a solution**

PHREEQCI has the advantage for novice user to offer icons for certain keywords (e.g.  for a solution) and to assist the user in terms of working spreadsheets and creating the input file from these spreadsheets. On the other hand, PHREEQC for Windows offers plotting results without transfering the data to external software (Excel, Origin etc.). So PHREEQCI might be better suited for very beginners while PHREEQC for Windows is the better choice for intermediate and advanced users. Readers may as well install both GUI's working with both versions parallel. Although PHREEQC for Windows is utilizing the input file extension .phrq and PHREEQCI the input file extension .pqi they can be used vice versa.

In this textbook we refer mainly to PHREEQC for Windows and its graphical capabilities. Therefore we will describe in the following briefly how to navigate through PHREEQC for Windows. After starting the program by click on PHREEQC.exe, a window with four templates opens: INPUT (chapter 2.2.1.1), DATABASE (chapter 2.2.1.2), GRID (chapter 2.2.1.4), and CHART (chapter 2.2.1.5). The template OUTPUT appears only after an input file has been run through PHREEQC and is thus available for displaying.

- the geochemical database
- the parser reading the input file and deriving a series of eqations from it
- the solver for a series of resulting nonlinear functions (Newton-Raphson)
- the output file containing the results
- and optional graphical or tabular presentations of results

PHREEQC is the core of the geochemical model containing the parser and the solver. The parser extracts species information from the input file and links it based on the equations in the database in nonlinear reaction equations. These species equations are then substituted by mole- and charge-balance equations. The goal is to reach equilibrium, where all functions relevant to a specific equilibrium calculation are equal to zero. The Newton-Raphson approach is used to find the zeros of the functions by which each function is differentiated with respect to each master unknown to form the Jacobian matrix. A set of linear equations is formed from the Jacobian matrix that can be solved to approximate iteratively a solution to the nonlinear equations.

The input files must be written in certain syntax and two graphical user interfaces (GUI) are available to support the writing of the input file:

- PHREEQC for Windows
- PHREEQCI

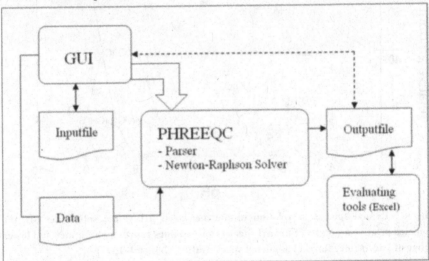

**Fig. 37 Schematic chart of geochemical modeling with PHREEQC. GUI's can be either PHREEQC for Windows or PHREEQCI. Installing one the GUI's will automatically install PHREEQC and several databases**

Both GUI's are public domain and can be downloaded via http://wwwbrr.cr.usgs.gov /projects/GWC_coupled/ phreeqc/ and it is highly recommended to download as well the manual (ftp://brrcrftp.cr.usgs.gov/geochem/unix/phreeqc/manual.pdf; 2.2 MB).

aqueous species were determined analytically, their concentrations can be compared to modeled values from total element concentrations to estimate the reliability of the modeling.

It is also important to indicate the range of the error of each species for calculated species distributions. The pH value is a significant parameter to be measured. In practice, it can be measured with an accuracy of $\pm 0.1$ pH units. Particularly with respect to reactions in which several protons occur, this uncertainty may have a significant impact on the result (Fig. 36). Sensitivity analyses can be performed by simply entering the anticipated error in the analytical data (such as a $\pm 0.1$ pH change) and propagating this change through a speciation and saturation index calculation. This type of error propagation can demonstrate the effect of errors from analytical data on geochemical calculations. The program code LJUNGSKILE offers the possibility to include uncertainty analysis in PHREEQC (see section 2.2.2.1.4 for an example).

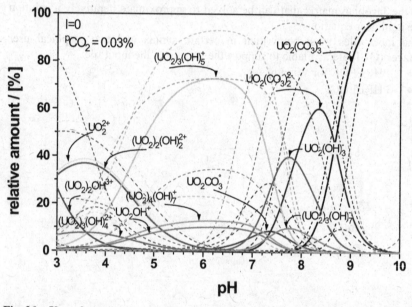

**Fig. 36**  **Uranyl species in relation to the measured pH value; solid lines are the modeled relative amounts of uranyl species, dashed lines represent an upper and lower range of uncertainty for each modeled species (after Meinrath 1997)**

## 2.2 Use of PHREEQC

### 2.2.1 The structure of PHREEQC and its graphical user interfaces

A geochemical model consists of several components:

- the input file describing the problem to be solved

has never been changed in the above cited thermodynamic databases (Zhu & Merkel 2001).

**Table 23   Dissociation constants for U (6) hydroxo species (*** = no data available)**

| Species | log K NEA (1992) | log K IAEA (1992) |
|---|---|---|
| $UO_2OH^+$ | -5.2 | -5.76 |
| $UO_2(OH)_2^0$ | < -10.3 | -13 |
| $(UO_2)_2(OH)_2^{2+}$ | -5.62 | -5.54 |
| $(UO_2)_3(OH)_5^+$ | -15.55 | -15.44 |
| $(UO_2)_3(OH)_2^+$ | -11.9 | *** |
| $(UO_2)_2(OH)_3^+$ | -2.7 | -4.06 |
| $(UO_2)_4(OH)_7^+$ | -21.9 | *** |
| $UO_2(OH)_3^-$ | -19.2 | *** |
| $(UO_2)_3(OH)_7^-$ | -31 | *** |
| $UO_2(OH)_4^{2-}$ | -33 | *** |

Furthermore, it is of great importance that solubility-products and complexation constants taken from the literature are clearly attached to the appropriate reaction equation. The example of the definition of the mineral rutherfordine ($UO_2CO_3$) in PHREEQC (Fig. 29) and EQ 3/6 (Fig. 30) shows that different reaction equations can be used for the same mineral. Whereas PHREEQC uses the chemical equation $UO_2CO_3 = UO_2^{2+} + CO_3^{2-}$, EQ 3/6 applies the equation $UO_2CO_3 + H^+ = HCO_3^- + UO_2^{2+}$. Because of the different reaction equations, the solubility-product will not be identical.

Additionally, thermodynamic data are established by laboratory tests under defined boundary conditions (temperature, ionic strength) that can be transferred to natural, geogenic conditions only to a limited extent. Uranium thermodynamic databases were e.g. mainly derived from nuclear research dealing with relatively high uranium concentrations of up to 0.1 mol/L in matrices with a total mineralization of up to 1 mol/L whereas concentrations in natural aquatic systems are normally in the nmol/L for uranium and mmol/L for total mineralisation.

In the laboratory, often relatively high ionic strengths (0.1 or 1 molar solution) have to be used, e.g. when working under extreme pH conditions. To refer complexation constants or solubility-products back to an ionic strength of zero, the same procedures as for the calculation of the activities from measured concentrations can be applied (e.g. extended DEBYE-HÜCKEL limiting-law equation). However, because the validity of the ion-association theory ends with 1 molar solutions, such experiments are in a range that is no longer valid with the ion-association theory. If solubility-products and complexation constants are extracted from literature, data will be gathered that has been obtained under different experimental boundary conditions, and processed by different calculation procedures considering the extrapolation of constants to an ionic strength of zero. Sometimes these data are not even recalculated to an ionic strength of zero at all.

Progress toward an internally consistent and reliable thermodynamic database for geochemical calculations is a tedious, slow, and poorly supported enterprise. For some applications, a smaller but consistent subset of data is sufficient. If

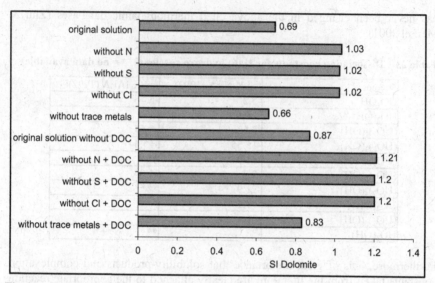

**Fig. 35** **Dolomite saturation index of complete and incomplete water analyses (calculated with PHREEQC after data by Merkel 1992)**

However, the most common sources of divergent results are both the approach used for the calculation of the activity coefficient (chapter 1.1.2.6) and the thermodynamic databases (chapter 2.1.4). The thermodynamic databases provide the respective program with the fundamental geochemical information for individual species. Different databases use - sometimes significantly - differing data with different solubility-products, different species, minerals and reaction equations. Nordstrom et al (1979, 1990), Nordstrom & Munoz (1994), Nordstrom (1996, 2004) discuss this inconsistency of thermodynamic databases in detail. For some species for which stability constants have been published not even the existence of the respective species has been proved beyond doubt, as can been shown in the following example.

Two surveys regarding uranium species in the year 1992 (Grenthe et al. 1992 [NEA 92] and Fuger et al. 1992 [IAEA 92]) came up with quite different interpretations regarding some hexavalent uranium-hydroxo-species. These differences have considerable influence on the species distribution of a measured total uranium concentration at neutral and basic pH values (Table 23).

Even greater differences exist for the mineral barium arsenate $Ba_3(AsO_4)_2$. While this mineral is not contained in PHREEQC.dat and LLNL.dat, it is listed in MINTEQ.dat as well as in WATEQ4F.dat with such a low solubility-product, that this mineral may react as arsenic-limiting phase during thermodynamic modeling. However, it is not $Ba_3(AsO_4)_2$ but $BaHAsSO_4·H_2O$ that might be a limiting mineral phase under certain conditions (Planer-Friedrich et al. 2001). The quoted low solubility-product for $Ba_3(AsO_4)_2$ is based on a misinterpretation of the precipitating mineral (Chukhlantsev 1956). However, even though this misinterpretation has been clarified already in 1985 (Robins 1985), the constant

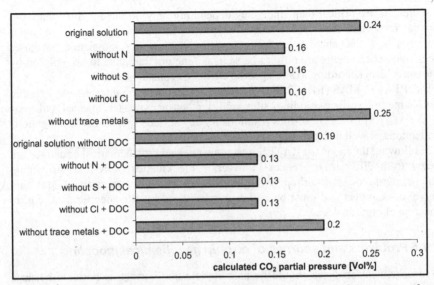

**Fig. 33** CO$_2$ **equilibrium partial pressure of complete and incomplete water analyses (calculated with PHREEQC after data by Merkel 1992)**

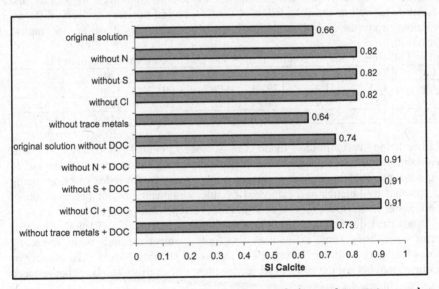

**Fig. 34** Calcite saturation index of complete and incomplete water analyses (calculated with PHREEQC after data by Merkel 1992)

coefficients are critical data since they depend not only on the aqueous phase but on the respective solid phase with the specific features of its inner and outer surfaces (see also chapter 1.1.4.2). Therefore, within thermodynamic databases selectivity coefficients are only to be seen as functors that have to be replaced by measured data according to site-specific exchange constants.

SURFACE_MASTER_SPECIES defines analogously the interrelation between the name of surface binding sites and the surface master species, whereas SURFACE_SPECIES describes reactions for any surface species sorted by cations and anions as well as by strongly and weakly bound partners.

Following the keyword RATES, reactions rates and mathematical equations are listed from different references to describe the kinetics of K-feldspar, albite, calcite, pyrite, organic carbon, and pyrolusite reactions. The predefined rates only serve as examples and must be replaced or adjusted by site-specific data, e.g. in the case of organic decay.

## 2.1.5 Problems and sources of error in geochemical modeling

Hydrochemical analyses should be as complete and correct as possible because they are the basic prerequisite of a reliable hydrogeochemical model. Errors in the initial hydrochemical analyses propagate through all simulations to the final result. Fig. 33 to Fig. 35 show the calculation of saturation indices for calcite and dolomite as well as the calculation of the $CO_2$ partial pressure omitting different variable from the fowollowing analysis to simulate input of an incomplete analysis:

pH = 7.4, temp. = 8.1°C, conductivity = 418 μS/cm, concentrations in mg/L

| $Ca^{2+}$ | 74.85 | $Cl^-$ | 2.18 | $Fe^{2+}$ | 0.042 | $Mn^{2+}$ | 0.014 |
|---|---|---|---|---|---|---|---|
| $Mg^{2+}$ | 13.1 | $HCO_3^-$ | 295.0 | $Pb^{2+}$ | 0.0028 | $Zn^{2+}$ | 0.379 |
| $Na^+$ | 1.88 | $SO_4^{2-}$ | 2.89 | $Cd^{2+}$ | 0.0026 | $SiO_2$ | 0.026 |
| $K^+$ | 2.92 | $NO_3^-$ | 3.87 | $Cu^{2+}$ | 0.030 | DOC | 8.8255 |

Generalizing assumptions made in hydrogeochemical modeling programs complicate the transferability to natural systems, e.g. assuming thermodynamic equilibrium. This assumption is often not true especially for redox reactions being dominated by kinetics and catalyzed by microorganisms, or for precipitation of certain minerals. Both processes can maintain disequilibria over a long time.

Numerical dispersion or oscillation effects can occur as accidental source of error when using finite differences and finite element methods while modeling mass transport. Utilizing the criteria of numerical stability (Grid-Peclet number or Courant number) or the random walk procedure, these errors can be either reduced or even eliminated.

For all reactions added manually to existing databases, a master species - if not yet existent - has to be defined using the keyword SOLUTION_MASTER_SPECIES.

For the species in solution (SOLUTION_SPECIES, Table 22), listed in the top row with current number, solubility constant log k and enthalpy delta h are given in kcal/mol or kJ/mol at a temperature of 25 °C. Following the sub-keyword "gamma", parameters for the calculation of the activity coefficient $\gamma$ according to the WATEQ-DEBYE-HÜCKEL ion-association theory (compare to chapter 1.1.2.6.1) are given. With the sub-keyword "analytical", coefficients $A_1$ to $A_5$ are defined to calculate the temperature dependency of the solubility-product.

**Table 22   Example of definition of species in solution (SOLUTION_SPECIES) from WATEQ4F.dat**

| CO3-2 primary master species |
| --- |
|    CO3-2 = CO3-2 |
|    log_k    0.0 |
|    -gamma  5.4   0.0 |
| CaCO3                  78 |
|    Ca+2 + CO3-2 = CaCO3 |
|    log_k    3.224 |
|    delta_h   3.545 kcal |
|    -analytical -1228.732   -0.299444   35512.75   485.818   0.0 |
| S2-2                 502 |
|    HS- = S2-2 + H+ |
|    log_k    -14.528 |
|    delta_h   11.4kcal |
|    -no_check |
|    -mole_balance  S(-2)2 |
|    -gamma  6.5   0.0 |

"No check" indicates that the reaction equation is not checked for charge and elemental balance (by default all reactions are checked). If "no check" is used, "mole balance" is required to define the stoichiometry of the species, e.g. for polysulfide species (see Table 22, $S_2^{2-}$ contains 2 S atoms, but only one will be used for the combination of HS⁻).

Definitions of reactions with solid or gaseous phases (PHASES) are done accordingly to those of dissolved species. When looking up equilibrium constants in a database it is important to look under the correct keywords. The equilibrium constant of the reaction $CaCO_3 = Ca^{2+} + CO_3^{2-}$ describing the dissolution of the mineral calcite (log K = -8.48, under the keyword PHASES) is totally different from the equilibrium constant of the reaction $Ca^{2+} + CO_3^{2-} = CaCO_3^0$ describing the formation of the aquatic complex $CaCO_3^0$ (log K = 3.224, under the keyword SOLUTION_SPECIES) even though the reactions may look alike at first glance.

EXCHANGE_MASTER_SPECIES defines the interrelation between the name of an exchanger and its master species. Based on this, EXCHANGE SPECIES describes a half-reaction and requires a selectivity coefficient for each exchanger species. In contrast to stability constants or dissociation constants, these selectivity

logical blocks by keywords. Each logical block has a different syntax for reading and interpreting data. In PHREEQC, there are the following blocks:

- master species in solution (Table 21) (SOLUTION_MASTER_SPECIES)
- species in solution (Table 22) (SOLUTION_SPECIES)
- phases: solid phases and gas phases (PHASES)
- exchange of master species (EXCHANGE_MASTER_SPECIES)
- exchange of species (EXCHANGE_SPECIES)
- surface master species (SURFACE_MASTER_SPECIES)
- surface species (strong and week binding species, sorted by cations and anions) (SURFACE_SPECIES)
- reaction rates (RATES)
- END

**Table 21 Example for the definition of master species in solution (SOLUTION_MASTER_SPECIES) from the PHREEQC database WATEQ4F.dat**

| Element | Master species | Alkalinity | mole mass in g/mol | atomic mass of elements |
|---------|----------------|------------|--------------------|-----------------------|
| C | CO3-2 | 2.0 | 61.0173 | 12.0111 |
| H | H+ | -1.0 | 1.008 | 1.008 |
| Fe(+2) | Fe+2 | 0.0 | 55.847 | |
| Fe(+3) | Fe+3 | -2.0 | 55.847 | |
| N | NO3- | 0.0 | 14.0067 | 14.0067 |
| N(-3) | NH4+ | 0.0 | 14.0067 | |
| N(0) | N2 | 0.0 | 14.0067 | |
| N(+3) | NO2- | 0.0 | 14.0067 | |
| N(+5) | NO3- | 0.0 | 14.0067 | |
| P | PO4-3 | 2.0 | 30.9738 | 30.9738 |
| S(-2) | H2S | 0.0 | 32.064 | |
| S | SO4-2 | 0.0 | 96.0616 | 32.064 |
| Si | H4SiO4 | 0.0 | 60.0843 | 28.0843 |

The contribution of each master species to the alkalinity in Table 21 is calculated according to the predominant species at a pH of 4.5. For example, the predominant species for $Fe^{3+}$ at pH 4.5 is $Fe(OH)_2^+$ with two $OH^-$-ions that are able to bind two $H^+$-ions. Therefore a factor of -2 results for the alkalinity. For inorganic C with the dominant species $H_2CO_3$ and two $H^+$-ions the factor will be +2.

Column 4 in Table 21 specifies in which way the input in mg/L has to be done. In this example, C has to be defined as carbonate, however, nitrate, nitrite, ammonia each defined as elementary nitrogen, P as elementary phosphorous, S as sulfate and Si as $SiO_2$. If, for example, P is defined as phosphate in mg/L, all subsequent calculations would be wrong. A thorough study of the respective databases is thus absolutely necessary for each input. These problems can be avoided by entering all concentrations in mol/L.

| Database | NEA | PHREEQC | WATEQ4F[1] | HATCHES | NAGRA/PSI TDB | MINTEQ[2] | LLNL[3] |
|---|---|---|---|---|---|---|---|
| Ga |  |  |  |  |  |  | + |
| Gd |  |  |  |  |  |  | + |
| H | + | + | + | + | + | + | + |
| He |  |  |  |  |  |  | + |
| Hf |  |  |  |  |  |  | + |
| Hg | + |  |  |  |  | + | + |
| Ho |  |  |  |  |  |  | + |
| I | + |  | + | + | + | + | + |
| In |  |  |  |  |  |  | + |
| K | + | + | + | + | + | + | + |
| Kr |  |  |  |  |  |  | + |
| La |  |  |  |  |  |  | + |
| Li | + | + | + | + | + | + | + |
| Lu |  |  |  |  |  |  | + |
| Mg | + | + | + | + | + | + | + |
| Mn |  | + | + | + | + | + | + |
| Mo |  |  | + | + |  |  | + |

| Database | NEA | PHREEQC | WATEQ4F[1] | HATCHES | NAGRA/PSI TDB | MINTEQ[2] | LLNL[3] |
|---|---|---|---|---|---|---|---|
| Sm |  |  |  |  |  |  | + |
| Sn | + |  | + | + | + |  | + |
| Sr | + | + | + | + | + | + | + |
| Tb |  |  |  |  |  |  | + |
| Tc |  |  | + | + |  |  | + |
| Th |  |  | + | + |  |  | + |
| Ti |  |  |  |  |  |  | + |
| Tl |  |  |  |  |  | + | + |
| Tm |  |  |  |  |  |  | + |
| Tn |  |  |  |  | + |  |  |
| U | + |  | + | + | + | + | + |
| V |  |  |  |  |  | + | + |
| W |  |  |  |  |  |  | + |
| Xe |  |  |  |  |  |  | + |
| Y |  |  |  |  |  |  | + |
| Yb |  |  |  |  |  |  | + |
| Zn | + | + | + |  |  | + | + |
| Zr |  |  | + | + |  |  | + |

[1] additionally considered in WATEQ4F.dat: fulvate and humate
[2] additionally considered in MINTEQ.dat: 2-, 3-, 4-methylpyridine, acetate, benzoate, butanoate, citrate, cyanate, cyanide, diethylamine, dimethylamine, EDTA, ethylene, ethylenediamine, formate, glutamate, glycine, hexylamine, isobutyrate, isophthalate, isopropylamine, isovalerate, methylamine, n-butylamine, n-propylamine, NTA, para-acetate, phthalate, propanoate, salicylate, tartrate, tributylphosphate, trimethylamine, trimethylpyridine, valerate
additionally considered in MINTEQ v4.dat: Co, Mo, acetate, benzoate, butylamine, butyrate, citrate, cyanide, diethylamine, dimethylamine, dom_a, dom_b, dom_c, edta, ethylenediamine, formate, 4-picoline, glutamate, glycine, hexylamine, isobutyrate, isophthalate, isopropylamine, isovalerate, methylamine, nta, phenylacetate, phthalate, propionate, propylamine, salicylate, tartarate, 3-picoline, trimethylamine, 2-picoline
[3] additionally considered in LLNL.dat: acetate, ethylene, orthophthalate

### 2.1.4.2 Structure of thermodynamic databases

A thermodynamic geochemical database is divided into several blocks with different variables. If it is defined as relational database, several tables (relations) with different variables are necessary. However, many programs (among them PHREEQC and EQ 3/6) read the data from a plain ASCII file that is separated in

database format but in a form which is needed for the specific program. To use thermodynamic data, e.g. in PHREEQC, they have to be converted into the respective format using a transfer program.

With the help of appropriate filters it is also possible to create a partial database out of the standard database. Especially when a huge number of analyses have to be calculated - as with a coupled modeling (transport plus reaction) - CPU-time can be saved with a reduced database. However, it must be verified that the partial database yields comparable results to the original database.

**Table 20    Thermodynamic databases with elements considered**

| Database / Last update | NEA 1999 | PHREEQC 2003 | WATEQ4F[1] 2005 | HATCHES 1999 | NAGRA/PSI TDB 2002 | MINTEQ[2] 2005 | LLNL[3] 2005 |
|---|---|---|---|---|---|---|---|
| Ag | + | | + | | | + | + |
| Al | + | + | + | + | + | + | + |
| Am | + | | | + | + | | + |
| Ar | | | | | | | + |
| As | + | | + | + | + | + | + |
| Au | | | | | | | + |
| B | + | + | + | + | + | + | + |
| Ba | + | + | + | + | + | + | + |
| Be | | | | | | + | + |
| Br | + | + | + | + | + | + | + |
| C | + | + | + | + | + | + | + |
| Ca | + | + | + | + | + | + | + |
| Cd | + | + | + | | | + | + |
| Ce | | | | | | | + |
| Cl | + | + | + | + | + | + | + |
| Cm | | | | | | | |
| Co | | | | | | | + |
| Cr | | | | | | + | + |
| Cs | + | | + | | + | | + |
| Cu | + | + | + | | | + | + |
| Dy | | | | | | | + |
| Er | | | | | | | + |
| Eu | | | | | + | | + |
| F | + | + | + | + | + | + | + |
| Fe | + | + | + | + | + | + | + |

| Database / Last update | NEA 1999 | PHREEQC 2003 | WATEQ4F[1] 2005 | HATCHES 1999 | NAGRA/PSI TDB 2002 | MINTEQ[2] 2003 | LLNL[3] 2005 |
|---|---|---|---|---|---|---|---|
| N | + | + | + | + | + | + | + |
| Na | + | + | + | + | + | + | + |
| Nb | | | + | | | | |
| Nd | | | | | | | + |
| Ne | | | | | | | + |
| Ni | | + | + | + | + | + | + |
| Np | | | + | + | | | + |
| O | + | + | + | + | + | + | + |
| P | + | + | + | + | + | + | + |
| Pa | | | | | | | |
| Pb | + | + | + | | | + | + |
| Pd | | | + | + | | | + |
| Pm | | | | | | | + |
| Pr | | | | | | | + |
| Pu | | | + | + | | | + |
| Ra | | | | | | + | + |
| Rb | + | | + | | | + | + |
| Re | | | | | | | + |
| Rn | | | | | | | + |
| Ru | | | | | | | + |
| S | + | + | + | + | + | + | + |
| Sb | | | | | | + | + |
| Sc | | | | | | | + |
| Se | + | | + | + | + | + | + |
| Si | + | + | + | + | + | + | + |

textbook for the modeling the exercises in chapter 3. The utilization of PHREEQC is explained in greater detail in chapter 2.2.

```
EQ3NR input file name= co3aqui.3i
 Description= "Uranium Carbonate solution"
 Version level= 7.2

 endit.
 Tempc= 2.50000E+01
 rho= 1.00000E+00 tdspkg= 0.00000E+00
tdspl= 0.00000E+00
 fep= 0.00000E+00 uredox=
 tolbt= 0.00000E+00 toldl= 0.00000E+00 tol-
sat= 0.00000E+00
 itermx= 0
* 1 2 3 4 5 6 7 8 9 10
 iopt1-10= 0 0 0 0 0 0 0 0 0 0
 iopg1-10= 0 0 0 0 0 0 0 0 0 0
 iopr1-10= 0 0 0 0 0 0 0 0 0 0
 iopr11-20= 0 0 0 0 0 0 0 0 0 0
 iodb1-10= 0 0 0 0 0 0 0 0 0 0
 uebal= H+
 nxmod= 0
 data file master species= Na+
 switch with species=
 jflag= 0 csp= 1.00000E-03
 data file master species= UO2++
 switch with species=
 jflag= 19 csp= 0.
 Mineral= UO2CO3
 data file master species= HCO3-
 switch with species=
 jflag= 21 csp= -3.481
 gas= CO2(g)
 data file master species= SO4--
 switch with species=
 jflag= 0 csp= 1.00000E-10
 data file master species= Cl-
 switch with species=
```

**Fig. 32    Example for an EQ 3/6 input file (dissolution of the mineral rutherfordine as a function of the CO₂ partial pressure)**

## 2.1.4 Thermodynamic databases

### 2.1.4.1 General

Thermodynamic databases are the primary source of information of all geochemical modeling programs. Basically, it is possible to create individual thermodynamic databases with almost any program. However, it is a considerable effort and requires great care. Normally one accesses already existing databases.

Table 20 shows a variety of thermodynamic data collections and the elements considered. The thermodynamic data are usually not available in a current

```
 UO2CO3
 date last revised = 02-jul-1993
 keys = solid
 VOPrTr = 0.000 cm**3/mol (source =
* mwt = 330.03690 g/mol
 3 chemical elements =
 1.0000 C 5.0000 O 1.0000 U
 4 species in data0 reaction
 -1.0000 UO2CO3 -1.0000 H+
 1.0000 HCO3- 1.0000 UO2++

* log k grid (0-25-60-100/150-200-250-300 C) =
 -3.8431 -4.1434 -4.4954 -4.7855
 -5.0616 -5.2771 500.0000 500.0000
* Extrapolation algorithm: constant enthalpy approxi-
mation
```

**Fig. 30   Excerpt from the NEA database for EQ 3/6; definition of the mineral rutherfordine (elements which exist in a similar form in the PHREEQC database are boldly marked; the different log_k values are due to different reaction equations (also compare to chapter 2.1.5))**

Similarly, an input file looks much more simple in PHREEQC than in EQ 3/6 as shown in Fig. 31 and Fig. 32 for the dissolution of the mineral rutherfordine in water with 1 mmol/L sodium-chloride and low sulfate concentrations (0.0001 mmol/L) under oxidizing conditions (pE = 14) at 25 °C and a $CO_2$ partial pressure of 0.033 kPa (atmospheric conditions).

```
TITLE solution Rutherfordine as function of CO2 partial pressure

SOLUTION 1 water with 1 mmol/L Na and Cl
units mmol/kgw
temp 25
pH 7
pe 14
Na 1
S(6) 1E-7
Cl 1

EQUILIBRIUM_PHASES 1
CO2(g) -3.481
Rutherfordine 0

END
```

**Fig. 31   Example for a PHREEQC input file (dissolution of the mineral rutherfordine as a function of the $CO_2$ partial pressure)**

Since there are no more advanced options in EQ3/6 compared to the latest version of PHREEQC, the simplicity of input and thermodynamic constant definition strongly votes for the use of PHREEQC which is furthermore public domain including the graphical user interface. PHREEQC will also be used in the present

Furthermore, it is possible to shorten the data output user-defined and to export it in a spreadsheet compatible data format. A BASIC interpreter program is implemented for programming user-specific questions concerning kinetics and output formats. The BASIC interpreter also supports direct graphic output in connection with the user interface "PHREEQC for Windows". Several revised versions were made available since 1999 and updates are still ongoing.

Two features that a user might still miss in the latest PHREEQC Version 2.14.3 (with the Windows Interface 2.14.02, release November, 17, 2007) are:

- consideration of uncertainties for thermodynamic constants
- inverse modeling for parameter fitting, such as e.g. pK values

As an add-on to PHREEQC, the program LJUNGSKILE (Odegaard-Jensen et al. 2004, http://www.geo.tu-freiberg.de/software/Ljungskile/index.htm) is introduced in section 2.2.2.1.4 to consider uncertainties in model input parameters. Independent programs like FITEQL4 (Herbelin and Westall 1999) or Protofit (Turner and Fein 2006) can be used if questions of parameter fit have to be adressed. Another program which is also based on PhreeqC and overcomes PHREEQC's limitations of one-dimensional steady-state flow with simple boundary conditions only, is PHAST (see section 2.2.2.5.3 for an example).

### 2.1.3.2 EQ 3/6

EQ 3/6 consists of two programs: EQ 3 is a pure speciation code whose results are processed for further questions within EQ 6. In the early 1980s and 1990s, EQ3/6 was the leading geochemical software code since it already contained features like solid-solution minerals, surface complexation, kinetically controlled reactions, ion-association and ion-interaction (Pitzer) and an extended temperature range from 0 to 300°C which were widely missing in other programs including PHREEQC. However during the last couple of years there was no further substantial development within EQ3/6 while all the above mentioned features were successively covered by the most recent versions of PHREEQC.

A major disadvantage today is that EQ 3/6 remained written in FORTRAN and that there is no graphical user interface. All EQ 3/6 input files and thermodynamic constants have to be written in FORTRAN format which makes handling prone to errors. Errors in the format (placement within a row) can easily lead to fatal errors. Thermodynamic data and input definition for PHREEQC is much easier since reaction equations are written in the syntax of chemical formulas. A comparison of Fig. 29 and Fig. 30 shows how complicated the definition of the same mineral phase (rutherfordine, $UO_2CO_3$) is in EQ 3/6 compared to PHREEQC.

```
Rutherfordine 606
UO2CO3 = UO2+2 + CO3-2
log_k -14.450
delta_h -1.440 kcal
```

**Fig. 29    Definition of the mineral rutherfordine in PHREECQ (WATEQ4F.dat)**

- calculation of element concentrations, molalities, activities of aquatic species, pH, pE, saturation index, mole transfer as function of reversible/irreversible reactions

In 1988, a version of PHREEQE was written including PITZER equations for ionic strengths greater 1 mol/L thus applicable for brines or highly concentrated electrolytic solutions (PHRQPITZ, Plummer et al. 1988). PHREEQM (Appelo & Postma 1994) included all options of PHREEQE and additionally a one-dimensional transport module taking into account dispersion and diffusion. PHRKIN was an add-on module to PHREEQE to model kinetically controlled reactions.

In 1995 PHREEQC (Parkhurst 1995) was completely rewritten using the C programming language. This version removed nearly all limits regarding number of elements, aquatic species, solutions, phases, exchangers and surface complexes by abandoning FORTRAN formats in the input files. Additionally, the equation solver was revised (more robust now) and several other options were added. With the 1995 version to the present, the following options have been possible:

- to enter the measured concentration of an element in different master species in the input data (e.g. N as $NO_3$, $NO_2$ and $NH_4$)
- to define the redox potential either by the measured $E_H$ value (as pE value) or via a redox couple [e.g. As(III)/As(V) or U(IV)/U(VI)]
- to model surface-controlled reactions such as surface complexation and ion exchange by integrated double-layer models (Dzombak & Morel 1990) and a non-electrostatic model (Davis & Kent 1990)
- to model reactions with multicomponent gas phases as closed or open systems
- to administer the amounts of minerals in the solid phase and to determine automatically thermodynamically stable mineral associations
- to calculate the amount of water and the pE value in the aquatic phase during reaction and transport calculations using hydrogen-oxygen-mole equilibria and thus to model the water consumption or water production correctly
- to model convective mass transport with a one-dimensional transport module
- to model the composition of a given water by inverse modeling based on one, or several initial waters and chemical changes that occur along a flowpath

The most recent version, PHREEQC in the version 2 (Parkhurst & Appelo 1999), additionally allows for the following simulations:

- the formation of ideal and non-ideal solid solution minerals
- kinetic reactions with user-defined conversion rate
- dispersion and/or diffusion in 1D transport and adding immobile cells as option to the mobile cells in a 1D column
- change the number of exchanger places with dissolution or precipitation of reactants
- Inclusion of isotope balances in inverse modeling

As successor of SOLGASMIX (Besmann 1977), CHEMSAGE is mainly used for technical issues, e.g. development of alloys, ceramics, semiconductors, and superconductors, material processing, and investigation of material behavior.

Dynamic reactions like processes in blast furnaces, roasting processes, or the solidification of liquid alloys can be simulated using the REACTOR MODEL MODULE. Raw material and energy are input parameters with which reactions in the gaseous and condensed phases are simulated under different boundary conditions as well as with different fluxes of material in different parts of the reactor.

According to the distributor, it is also possible to address geochemical problems, environmental pollution in soil, air, and water, and impact of toxic, non-toxic and radioactive waste disposals with the implementation of several modules from the program SUPCRT 92 (Johnson et al. 1992).

However, only few applications in aquatic systems were found in literature. A reason for the rare use in the areas of hydrogeology and environmental science may also be the commercial marketing of both the program and the accompanying databases.

### 2.1.3 Programs based on equilibrium constants

Computer codes used commonly by geo-scientists and environmental engineers are based on equilibrium constants. Frequently used programs are WATEQ4F, MINTEQA2, EQ 3/6, and PHREEQC. Data processing is very convenient in WATEQ4F using standard Excel files, however, limited to calculations of analytical error, speciation and saturation index (http://water.usgs.gov/software/wateq4f.html). Using MINTEQA2, it is additionally possible to calculate the distribution of dissolved and adsorbed species (on solid phases) (http://www.scisoftware.com/products/minteqa2_overview/minteqa2_overview.html). The application spectrum of PHREEQC and EQ 3/6 is far greater. Therefore, these two programs are described in more detail. While PHREEQC is public domain software (http://wwwbrr.cr.usgs.gov/projects/GWC_coupled/phreeqc/), EQ 3/6 has to be purchased at the Lawrence Livermore National Laboratories (https://ipo.llnl.gov/technology/software/softwaretitles/eq36.php).

### 2.1.3.1 PHREEQC

The program PHREEQC dates back to 1980 (Parkhurst et al. 1980), at that time written in FORTRAN and named PHREEQE. The option of the program comprised:
- mixing of waters
- modeling equilibrium between solid and aqueous phase by dissolution-precipitation reactions
- modeling effects of changes in temperature

**Table 18  Example for the calculation of an equilibrium constant using the standard-free energy.**

| Species | G [K·J/mol] |
|---------|-------------|
| Calcite | -1130.61 |
| $Ca^{2+}$ | -553.54 |
| $CO_3^{2-}$ | -527.90 |

$$-G = G_{Calcite}-G_{Ca}-G_{CO3}$$
$$-G = -1130.61-(553.54)-(-527.90)$$
$$-G = -49.17$$
$$\log K_{Calcite} = -49.17/5.707 = -8.6157$$

for comparison log K from the experiments (Plummer & Busenberg 1982)
$$\log K_{Calcite} = -8.48 \pm 0.02$$

If the solubility constant for a certain reaction is not explicitly given in a database, but the solubility constants of partial reactions are known, the solubility constant of the total reaction can be calculated from the solubility constants of the partial reactions (see Table 19).

**Table 19  Example for the calculation of the equilibrium constant of a reaction using the equilibrium constants of partial reactions**

| no equilibrium constant available for the following reaction: $CaCO_3 + CO_2 + H_2O = Ca^{2+} + 2HCO_3^-$ | |
|---|---|
| $CaCO_3 = Ca^{2+} + CO_3^{2-}$ | logK = -8.48 |
| $CO_2 + H_2O = H_2CO_3$ | logK = -1.47 |
| $H_2CO_3 = H^+ + HCO_3^-$ | log K = -6.35 |
| $H^+ + CO_3^{2-} = HCO_3^-$ | logK = +10.33 |
| sum of single reactions: $CaCO_3 + CO_2 + H_2O + H_2CO_3 + H^+ + CO_3^{2-}$ $= Ca^{2+} + CO_3^{2-} + H_2CO_3 + H^+ + HCO_3^- + HCO_3^-$ equals: $CaCO_3 + CO_2 + H_2O = Ca^{2+} + 2HCO_3^-$ | |
| Sum of logKs = -8.48 + (-1.47) + (-6.35) + 10.33 = **-5.97** (calculated log K for total reaction) | |

Using programs where the source code is not available, as e.g. CHEMSAGE, offers no means for individual and independent control. Such programs are not advisable for scientific work and risk assessment studies (e.g. high radioactive waste repositories).

## 2.1.2 Programs based on minimizing free energy

CHEMSAGE (ESM (Engineering and Materials Science) Software, http://www.esm-software.com/chemsage/) is a program family based on the minimization of the Gibbs' energy and distributed commercially.

**Fig. 28   Overview on hydro-geochemical modeling programs in chronological order**

Table 18 gives an example for the calculation of an equilibrium constant from the free energy. Due to the relatively big error for the determination of the free energy, it is not advisable to perform such conversions unless unavoidable. Direct experimental determination of equilibrium constants is often more reliable.

# 2 Hydrogeochemical Modeling Programs

## 2.1 General

A selection of computer programs available is listed in Fig. 28 in chronological order. The first generation of geochemical computer programs was developed and published in the beginnings of the 1970's. New programs appeared at the end of the 1970's with improved features. From the early 1980's on it became possible to install these programs on personal computers while mainframes had been the computer platforms until then.

The most frequently used models are MINTEQA2 (Allison et al. 1991), WATEQ4F (Ball & Nordstrom 1991), PHREEQC (PHREEQE) (Parkhurst & Appelo 1999, Parkhurst 1995 & Parkhurst et al. 1980) and EQ 3/6 (Wolery 1992a and 1992b).

### 2.1.1 Geochemical algorithms

The most common approach used by geochemical modeling codes to describe the water-gas-rock-interaction in aquatic systems is the ion-association theory outlined briefly in chapter 1.1.2.6.1. However, reliable results can only be expected up to ionic strengths between 0.5 and 1 mol/L. If the ionic strength exceeds this limit, the ion-interaction theory (e.g. PITZER equations, chapter 1.1.2.6.2) may solve the problem and computer codes have to be based on this theory. The species distribution can be calculated from thermodynamic databases using two different approaches (chapter 2.1.4):

- Determination of the thermodynamically most stable state by minimization of the free energies of reaction (lowest energy state) (e.g. CHEMSAGE) (chapter 2.1.2)
- Solving the non-linear set of equations resulting from equilibrium constants and mass balances in the system (e.g. PHREEQC, EQ 3/6, WATEQ4F, MINTEQA2 etc.) (chapter 2.1.3)

Both processes presuppose the establishment of chemical equilibrium and mass balance. Being in equilibrium, the relation between the equilibrium constant K and the free energy is defined as (see also chapter 1.1.2.2):

$$G_0 = -R \cdot T \cdot \ln K \qquad \text{Eq.(106.)}$$

or for T = 25 °C: $G_0 = -5.707 \cdot \log K$ 　　　　　　　　　　　Eq.(107.)

aquifer thickness in particular. If, for instance in a conservative tracer model the contaminant concentration decreases by 50 percent along a certain distance through dispersion, it follows that, using a 1D model of reactive mass transport, half of the water within the column has to be substituted by uncontaminated groundwater.

**Table 17    Selection of computer codes for reactive transport modeling**

| Name | Dimen-sions | GUI | Comments |
|---|---|---|---|
| PHREEQC | 1D | PHREEQC for Windows PHREEQCI | stationary flow only, dual domain mass transfer |
| EQ6 | 1D | No | stationary flow only |
| TREAC | 2D | Yes, integrated | flowpath coupled with PHREEQC |
| PHAST | 2D/3D | GoPHAST WPHAST | modified version of HST3D (restricted to constant fluid density and constant temperature) coupled with PHREEQC |
| MINTRAN | 2D | No | finite element transport module (PLUME2D), coupled with MINTEQA2 |
| Crunch | 2D(3D) | No | density driven flow, Monod-Type-Reactions, EQ3/6-data |
| TOUGH-REACT | 2D/3D | PetraSim | chemically reactive non-isothermal flows of multiphase fluids in porous and fractured media (geothermal systems, $CO_2$ sequestration, nuclear repositories) |

Software like SEAM3D, a modified version of MT3DMS which is based on Modflow, can handle a set of constituents, however, only by means of the $K_d$ concept. Therefore real world problems can not be modeled by this approach and it is not a reactive transport code.

An extremely simplified application of the described approach is already implemented in the PHREEQC program. Reactive mass transport can be modeled for the one-dimensional case at constant flow rates considering diffusion and dispersion.

Taking into consideration a high possible number of chemical reactions for the reactive mass transport, like what is done for coupled models, the computing times mainly result from the calculations within the thermodynamic code. The 2D or 3D models easily lead to unreasonably long computing times. Since information on the chemical heterogeneity of an aquifer is frequently lacking, the calculation of a 1D model is generally preferable.

However, there is a severe disadvantage with one-dimensional models: they do not take into account the dilution due to the transversal dispersion. Consequently a mass m, that is not susceptible to any chemical reaction, occurs "blurred" at a point x downstream from $x_0$ (the location of m input) due to longitudinal dispersion. The dispersion leads to a smaller maximum concentration, however, and the mass integral equals the mass added at $x_0$. Thus, the impulse of mass remains constant along any simulated one-dimensional distance.

In reality, however, transversal dispersion $D_t$ causes mass exchange in y and z direction leading to dilution. This dilution is a function of $D_t$ and the flow velocity v. If $D_t$ and v are constant within the flow field, than the resulting dilution can be described by a linear function or a constant factor, respectively. The value for this factor can be determined using a conservative 3D model taking into account the

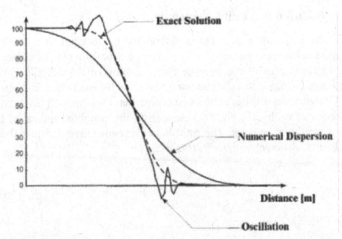

**Fig. 27   Numeric dispersion and oscillation effects for the numeric solution of the transport equation (after Kovarik, 2000)**

### 1.3.3.4.2.   Coupled methods

In physics, the random walk method has already been in use for decades to understand and model diffusion processes. Prickett et al. (1981) developed a simple model for groundwater transport to calculate the migration of contamination. An essential advantage of the methods of random walk and particle tracking is that they are free of numeric dispersion and oszillations (Abbot 1966).

For the method of characteristics (MOC), the convective term is dealt with separately from the dipersive transport term by establishing a separate coordinate system along the convection vector for solving the dispersion problem. In most modeling programs, the convection is approximated with discrete particles. A certain number of particles with defined concentrations is used and moved along the velocity field (Konikoff and Bredehoeft, 1978).

Particularly sophisticated models deal with reactive mass transport, including both the accurate description of the convective and dispersive transport of species, as well as the modeling of interactions of species in water, with solid and gaseous phases (precipitation, dissolution, ion exchange, sorption).

Coupled reactive transport modeling does the flow modeling separately as a first step. After that a modified method of characteristics (MMOC) is carried out based on the calculated flow field. The particles present a complete water analysis or a discrete water volume with certain chemical properties. These particles or water volumes are then moved for every single time step. Using a hydrochemical modeling code (e.g. PHREEQC, MINTEQA2), the interactions of the particles with their environment (i.e. rock, gaseous phases), and with each other are calculated. The results of this thermodynamic modeling are subsequently transferred back to the particles before these are "moved" one time step further. Some examples for such models are given in Table 17.

## 1.3.3.4.1. Finite-difference/finite-element method

For the finite difference method the area is discretized by rectangular cells. The distance of neighboring nodes can differ. The nodes are usually set in the center of gravity of each cell and present the average concentration of the cell. The mass transport is simulated by modeling the chemical reactions for each node in discrete time intervals. Convective, diffusive, and dispersive mass transport is calculated along the four sides of each cell, e.g. by considering the weighted means of the concentrations of neighboring cells. The ratio between convective and dispersive mass flow is called Grid-Peclet number $P_e$ (Eq. 103).

$$P_e = \frac{|v| \cdot L}{D}$$

Eq. (103.)

with    D= dispersivity
L= cell length

and $|v| = \sqrt{v_x^2 + v_y^2 + v_z^2}$

Eq. (104.)

Both the spatial discretisation and the choice of the type of differences (e.g. uplift differences, central differences) have a strong influence on the result. This fuzziness caused by the application of different methods is summarized as "numeric dispersion".

Numeric dispersion can be eliminated largely by a high-resolution discretisation. The Grid-Peclet number helps for the definition of the cell size. Pinder and Gray (1977) recommend the $P_e$ to be $\leq 2$. The high resolution discretisation, however, leads to extremely long computing times. Additionally, the stability of the numeric finite-differences method is influenced by the discretisation of time. The Courant number (Eq. 105) is a criterion, so that the transport of a particle is calculated within at least one time interval per cell.

$$Co = \left| v \frac{dt}{L} \right| < 1$$

Eq. (105.)

Methods applying reverse differences in time are called implicit. Generally these implicit methods, as e.g. the Crank-Nicholson method, show high numerical stability. On the other side, there are explicit methods, and the methods of iterative solution algorithms. Besides the strong attenuation (numeric dispersion) there is another problem with the finite differences method, and that is the oscillation.

With the finite-elements method the discretisation is more flexible, although, as with the finite-differences method, numeric dispersion and oscillation effects can occur (Fig. 27).

instance the method of characteristics (MOC), have the advantage of not being prone to numerical dispersion (see 1.3.3.4.1).

**Table 16    Shape factors for the first order diffusive exchange between mobile and immobile water (Parkhurst & Appelo, 1999)**

| Shape of stagnant region | Dimensions (x,y,z) or 2 r,z | First-order equivalent $f_{s\to1}$ | Comments |
|---|---|---|---|
| Sphere | 2a | 0.21 | 2a = diameter |
| Plane sheet | 2a, ∞, ∞ | 0.533 | 2a = thickness |
| Rectangular prism | 2a, 2a, ∞ | 0.312 | Rectangle |
| | 2a,2a,16a | 0.298 | |
| | 2a,2a,8a | 0.285 | |
| | 2a,2a,6a | 0.277 | |
| | 2a,2a,4a | 0.261 | |
| | 2a,2a,3a | 0.246 | |
| | 2a,2a,2a | 0.22 | Cube |
| | 2a,2a,4a/3 | 0.187 | |
| | 2a,2a,a | 0.162 | |
| | 2a,2a,2a/3 | 0.126 | |
| | 2a,2a,2a/4 | 0.103 | |
| | 2a,2a,2a/6 | 0.0748 | |
| | 2a,2a,2a/8 | 0.0586 | |
| Solid cylinder | 2a, ∞ | 0.302 | 2a = diameter |
| | 2a,16a | 0.298 | |
| | 2a,8a | 0.277 | |
| | 2a,6a | 0.27 | |
| | 2a,4a | 0.255 | |
| | 2a,3a | 0.241 | |
| | 2a,2a | 0.216 | |
| | 2a,4a/3 | 0.185 | |
| | 2a,a | 0.161 | |
| | 2a,2a/3 | 0.126 | |
| | 2a,2a/4 | 0.103 | |
| | 2a,2a/6 | 0.0747 | |
| | 2a,2a/8 | 0.0585 | |
| Pipe wall (surrounds the mobile pore) | 2$r_i$,2$r_0$, | | 2 $r_i$ = pore diameter |
| | 2a,4a | 0.657 | 2 $r_0$ = outer diameter of pipe |
| | 2a,10a | 0.838 | wall thickness ($r_0$ - $r_i$) = a (Eq. 102) |
| | 2a,20a | 0.976 | |
| | 2a,40a | 1.11 | |
| | 2a,100a | 1.28 | |
| | 2a,200a | 1.4 | |
| | 2a,400a | 1.51 | |

$$c_{im} = \beta \cdot f \cdot c_{m0} + (1 - \beta \cdot f)c_{im0}$$

$$\text{with } \beta = \frac{R_m \theta_m}{R_m \theta_m + R_{im} \theta_{im}}$$   Eq. (98.)

$$f = 1 - \exp(\frac{\alpha t}{\beta \theta_{im} R_{im}})$$

with $c_{m0}$ and $c_{im0}$ being the initial concentrations, and $\theta_m$ and $\theta_{im}$ the saturated porosities of the mobile and immobile zones respectively. $R_m$ is the retardation factor of the mobile zone. From these the mixing factor $mixf_{im}$ can be defined, which is a constant for a time t.

$$mixf_{in} = \beta \cdot f$$   Eq. (99.)

If this factor is implemented into Eq.98, the result is:

$$c_{im} = mixf_{im} \cdot c_{m0} + (1 - mixf_{im})c_{im0}$$   Eq. (100.)

Analogously, it follows for the mobile concentration:

$$c_m = (1 - mixf_m)c_{m0} + mixf_m \cdot C_{im0}$$   Eq. (101.)

The exchange factor $\alpha$ is, according to van Genuchten (1985), dependent on the geometry of the stagnant zone. For a sphere, the relation is:

$$\alpha = \frac{D_e \theta_{im}}{(af_{s \to 1})^2}$$   Eq. (102.)

with   $D_e$ = diffusion coefficient in the sphere (m$^2$/s)
   a   = radius of the sphere (m)
   $f_{s1}$ = shape factor (Table 16)

Alternatively, the problem can be solved numerically by applying a finite differences grid on the stagnant zone and determining the diffusive exchange iteratively (Parkhurst and Appelo, 1999; Appelo and Postma, 1994).

### 1.3.3.4 Numerical methods of transport modeling

The numerical methods for solving the transport equation can be subdivided into two groups:
- Solution of the transport equation including the chemical reactions (one equation system for each species to be solved)
- Coupled methods (transport model coupled with hydrogeochemical code)

For coupled models solving the transport equation can be done by means of the finite-difference method (and finite volumes) and of the finite-elements method. Algorithms based on the principle of particle tracking (or random walk), as for

$K_d$ value allows a transformation into a retardation factor that is introduced as a correction term into the general mass transport equation (chapter 1.1.4.2.3).

As already explained in chapter 1.1.4.2.3, the $K_d$ concept must be rejected in most cases, because of its oversimplification and its low suitability for application to natural systems. For example, modeling degradation processes only the degrading substance is considered. This concept might be suitable for radioactive decay, yet if it comes to decomposition of organic matter, it is crucial to consider decomposition products (metabolites) that form and play an important role in transport themselves.

For the saturated and the unsaturated zone, the general mass transport equation can be extended as follows, describing exchange processes with the sediment as well as interactions with the gas phase, and within the aqueous phase.

$$\frac{1}{\partial t}\partial\left(C_i+\left(S_i\frac{d}{n}\right)+\frac{G_i}{n}\right)=D_l\frac{\partial^2 C_i}{\partial z^2}+D\frac{\partial^2 C_i}{\partial z^2}-v\frac{C_i}{\partial z} \qquad \text{Eq. (96.)}$$

with      $v$ = pore velocity [m/s]
          $C_i$ = concentration of the species i [mol/L]
          $S_i$ =concentration of the species i on/ in the solid phase [mol/g]
          $n$ = porosity
          $d$ = density [g/L]
          $G_i$ = concentration of the species i in the gas phase [mol/L]
          $D_l$ = longitudinal dispersion coefficient [m²/s]
          $D$ = diffusion coefficient [m²/s]
          $z$ = spatial coordinate [m]
          $t$ = time [s]

## 1.3.3.3.1.    Exchange within double-porosity aquifers

Diffusive exchange between mobile and immobile water can be expressed mathematically as a mixing process between two zones: One zone containing stagnant water is coupled to a "mobile" zone, where water flows. The diffusive exchange can be described by first order kinetics.

$$\frac{\partial M_{im}}{\partial t}=\theta_{im}\cdot R_{im}\frac{\partial c_{im}}{\partial t}=\alpha\left(c_m-c_{im}\right) \qquad \text{Eq. (97.)}$$

The index "m" stands for mobile and "im" for immobile. $M_{im}$ is the number of moles of a species in the immobile zone and $R_{im}$ the retardation factor of the immobile zone, $c_m$ and $c_{im}$ are the concentrations in mol/kg in the mobile and immobile zone respectively. The symbol $\alpha$ stands for an exchange factor (1/s). The retardation factor $R = 1+ (dq/dc)$ is determined by chemical reactions. The integrated form of Eq. 97 is:

## 1.3.3.2 Idealized transport conditions

Within an aquifer, transport including simple chemical reactions can be described by the following equation in a one-dimensional form:

$$\frac{\partial C_i}{\partial t} = D_l \frac{\partial^2 C_i}{\partial z^2} + D_t \frac{\partial^2 C_i}{\partial z^2} + D \frac{\partial^2 C_i}{\partial z^2} - v \frac{C_i}{\partial z} + C_{ss}$$

Eq. (95.)

$$\underbrace{\qquad\qquad}_{\text{dispersion}} \qquad \underbrace{\qquad}_{\text{diffusion}} \quad \underbrace{\qquad}_{\text{advection}} \quad \underbrace{\qquad}_{\text{sources/sinks}}$$

with
$C_i$ = concentration for the species i dissolved in water [mol/L]
$t$ = time [s]
$D_l$ = longitudinal dispersion coefficient [$m^2$/s]
$D_t$ = transversal dispersion coefficient [$m^2$/s]
$D$ = diffusion coefficient [$m^2$/s]
$z$ = spatial coordinate [m]
$v$ = flow velocity [m/s]
$C_{ss}$ = concentration of the species (source or sink)

Simplified analytical solutions for the transport equation can be derived by analogy from basic equations of heat conduction and diffusion (e.g. Lau et al. (1959), Sauty (1980), Kinzelbach (1983), and Kinzelbach (1987)).

## 1.3.3.3 Real transport conditions

Convection, diffusion, and dispersion can only describe part of the processes occurring during transport. Only the transport of species that do not react at all with the solid, liquid, or gaseous phase (ideal tracers) can be described adequately by the simplified transport equation (Eq. 95). Tritium as well as chloride and bromide can be called ideal tracers in that sense. Their transport can be modeled by the general transport equation as long as no double-porosity aquifers are modeled. Almost all other species in water somehow react with other species or a solid phase. These reactions can be subdivided into the following groups, some of which have already been considered in the previous part of the book.

- Reactions between aqueous and gaseous phase (chapter 1.1.3)
- Dissolution and precipitation (chapter 1.1.4.1)
- Sorption and desorption of dissolved species on solid phases (chapter 1.1.4.2)
- Anion and cation exchange (chapter 1.1.4.2.2)
- Formation of colloids
- Sorption on colloids
- Homogeneous reactions within the aqueous phase (chapter 1.1.5)

All chemical reactions comprise at least two species. For models of transport processes in groundwater or in the unsaturated zone reactions are frequently simplified by a basic sorption or desorption concept. Hereby, only one species is considered and its increase or decrease is calculated using a $K_s$ or $K_d$ value. The

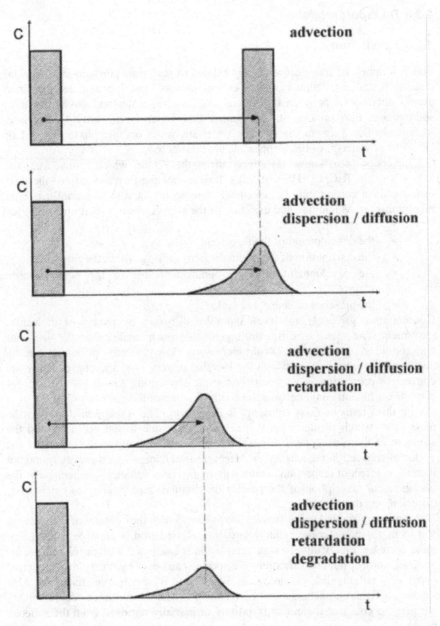

**Fig. 26   Convection, dispersion/diffusion, retardation and degradation of a species (single peak input) versus time along a flow path**

### 1.3.3 Transport models

### 1.3.3.1 Definition

The description of transport is closely related to the terms convection, diffusion, dispersion, and retardation as well as decomposition. First, it is assumed that there are no interactions between the species dissolved in water and the surrounding solid phase. Furthermore, it is assumed that water is the only fluid phase. Multiphase flow, e.g. in the systems water-air, water-organic phase (e.g. oil or DNAPL) or water-gas-organic phase, is not considered here.

Convection (also known as advection) is the vector, which results from the DARCY or the RICHARDS equations. It describes the flow velocity or the flow distance for a certain time t. In general, convection has the major influence on mass transport. Magnitude and direction of the convective transport are controlled by:

- the development of the flow field
- the distribution of the hydraulic permeability within the flow field
- the development of the groundwater table or the potentiometric surface
- the presence of sources or sinks

Concentration gradients are leveled out by diffusion by means of molecular movement. The vector of diffusion is generally much smaller than the vector of convection in groundwater. With increasing flow velocity diffusion can be neglected. In sediments, in which the $k_f$ value is very low, and consequently the convective proportion is very small or even converging towards zero (e.g. for clay), the diffusion could become the controlling factor for mass transport.

The third term in mass transport is dispersion. The dispersion describes the mass flow, which results from velocity variations due to the geometry and the structure of the rock system. From this definition it follows that the smaller the vector of convection the smaller the effect of dispersion. The other way round, an increasing effect of dispersion occurs with higher flow velocity. Consequently, the mathematical description of the species distribution is an overlap of convection, diffusion, and dispersion.

All phenomena that cause species not to spread with the velocity of the water in soil or in groundwater are called retardation. Retardation is possible without any mass decrease. Frequently, though, retardation is combined with degradation. This "degradation" of the concentration of a species can occur by means of radioactive decay of a radionuclide or biological degradation of an organic substance. Also sorption and cation exchange can be included in this definition of "degradation", because the considered element is entirely or partially removed from the aqueous phase.

Fig. 26 shows a simplified illustration of the described phenomena for the one-dimensional case.

## 1.3 Reactive mass transport

### 1.3.1 Introduction

In the previous chapters chemical interactions were described without considering transportation processes in aqueous systems. Models for reactive mass transport combine the chemical interactions with convective and dispersive transport, so that they can model the spatial distribution coupled to the chemical behavior. Requirement for every transport model is a flow model as accurate as possible.

### 1.3.2 Flow models

Flow models show potential or velocity fields resulting from flow in the saturated or unsaturated zone. Together with further boundary conditions, such as pore volume, dispersivity, etc., these potential fields adequately describe the flow regime in order to calculate the transport behavior (Table 15).

**Table 15**   **Description of homogenous, laminar transport processes of a mass c in the saturated and unsaturated zone (without dispersion and diffusion)**

|  | saturated zone | unsaturated zone/soil |
|---|---|---|
| driving force | hydraulic head (gravitational and pressure head) | matrix head (gravitational and capillary head) |
| model equation | DARCY $$\frac{\partial c}{\partial t} = K \frac{\partial h}{\partial l} \cdot \frac{c}{\partial z}$$ | RICHARDS $$\frac{\partial c}{\partial t} = \left( K(P_k) \frac{\partial P_m}{\partial z'} \right) \cdot \frac{c}{\partial z}$$ |
| permeability K | constant | function of matrix head $P_m$ |

Under certain conditions groundwater flow in the saturated zone is more complex than described in Table 15. This is true in particular in the domain of a freshwater/saltwater-interface where the density of water has to be taken into account (density driven flow) and in case of geothermal groundwater systems where permeability (viscosity) and density of groundwater are not constant because of varying temperatures. Based on the concept of the intrinsic permeability ($K_i$) even more complex systems such as multiphase flow can be described.

$$K_i = K \cdot \frac{\eta}{d \cdot g}$$
Eq. (94.)

with:   $K_i$ = intrinsic permeability (independent of fluid properties)
        K = permeability [m/s]
        n = viscosity [kg/m/s]
        d = density [kg/m$^3$]
        g = gravity [m/s$^2$]

can be done for nitrate as limiting substance: $k_1 = 5 \cdot 10^{-4}/a$ for 3 mM $NO_3$ and $k_1 = 1 \cdot 10^{-4}/a$ for 3 µM $NO_3$, which results in $r_{max} = 1.67 \cdot 10^{-11}/s$ and $K_m = 155$ µM. The corresponding Monod equation is as follows:

$$R_C = 6 \cdot s_C \cdot \left( \frac{s_C}{s_{C_0}} \right) \left\{ \frac{1.57 \cdot 10^{-9} m_{O_2}}{2.94 \cdot 10^{-4} + m_{O_2}} + \frac{1.67 \cdot 10^{-11} m_{NO_3^-}}{1.55 \cdot 10^{-4} + m_{NO_3^-}} \right\} \qquad \text{Eq. (87.)}$$

where the factor 6 results when the concentration $s_C$ is converted from mol/kg soil to mol/kg pore water. Plummer et al. (1978) found the following rates for the carbonate dissolution and precipitation:

$$r_{Calcite} = K_1 \cdot \{H^+\} + K_2 \{CO_2\} + K_3 \{H_2O\} - K_4 \{Ca^{2+}\} \{HCO_3^-\} \qquad \text{Eq. (88.)}$$

The constants $k_1$, $k_2$ and $k_3$ depend on the temperature and describe the forward reaction:

$$k_1 = 10^{(0.198 - 444.0 / T_K)} \qquad \text{Eq. (89.)}$$

$$k_2 = 10^{(2.84 - 2177.0 / T_K)} \qquad \text{Eq. (90.)}$$

if temperature $\leq 25°C$

$$k_3 = 10^{(-5.86 - 317.0 / T_K)} \qquad \text{Eq. (91.)}$$

if temperature $> 25°C$

$$k_3 = 10^{(-1.1 - 1737.0 / T_K)} \qquad \text{Eq. (92.)}$$

$K_4$ describes the reverse reaction and can be replaced by the term

$$1 - \left( \frac{IAP}{K_{calcit}} \right)^{\frac{2}{3}} \qquad \text{Eq. (93.)}$$

where IAP is the ion-activity product and $K_{calcite}$ is the calcite solubility-product.

The general kinetic reaction rate of minerals is:

$$R_K = r_K \cdot \left(\frac{A_0}{V}\right) \cdot \left(\frac{m_k}{m_{0k}}\right)^n$$

Eq. (82.)

with    $r_k$   = specific reaction rate ($mol/m^2/s$)
        $A_0$   = initial surface of the mineral ($m^2$)
        $V$     = mass of solution (kg water)
        $m_{0k}$ = initial mineral mass (mol)
        $m_k$   = mass of the mineral (mol) at a time t

$(m_k/m_{0k})^n$ is a factor, which takes into account the change in $A_0/V$ during the dissolution. For an even dissolution from surfaces and cubes n is 2/3. Frequently not all parameters are available, so that simple approaches are useful like:

$$R_K = k_K \cdot (1 - SR)^\sigma$$

Eq. (83.)

In Eq. 83 $k_K$ is an empirical constant and SR is the saturation rate (ion-activity product/solubility-product). Frequently the exponent $\sigma$ equals 1. The advantage of this simple equation is that it is valid both for supersaturation and undersaturation. With saturation $R_K$ becomes zero. $R_K$ can also be expressed by the saturation index [log (SR)] (Appelo et al. 1984):

$$R_K = k_K \cdot \sigma \cdot SI$$

Eq. (84.)

Another example is the Monod equation, which contains a concentration-dependent term:

$$R_k = r_{max} \left(\frac{C}{k_m + C}\right)$$

Eq. (85.)

with    $r_{max}$ = maximum reaction rate
        $k_m$     = concentration, at which the rate is 50% of the maximum rate

The Monod rate is widely used to simulate the degradation of organic matter (van Cappellen & Wang 1996). It can be derived from the general equation for first order kinetics:

$$\frac{ds_C}{dt} = -k_1 s_C$$

Eq. (86.)

with:   $s_C$ = organic carbon content [mol/kg soil]
        $k_1$ = decay constant for first order kinetic reactions [1/s]

If for instance the degradation of organic carbon in an aquifer is considered, a first order degradation parameters ($k_1 = 0.025/a$ for 0.3 mM $O_2$ and $k_1 = 5 \cdot 10^{-4}/a$ for 3 μM $O_2$) can be described by the coefficients $r_{max} = 1.57 \cdot 10^{-9}/s$ and $K_m = 294$ μM in the Monod equation, oxygen being the limiting substance. A similar estimation

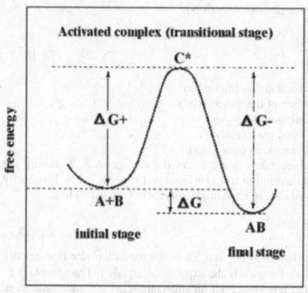

**Fig. 25** Scheme of the free energies ΔG and formation of an activated complex C* as a transitional state of the reaction A+B = AB (after Langmuir 1997)

**Table 14** Activation energy of some chemical processes (after Langmuir 1997)

| Reaction or process | range of typical $E_a$-values [kcal/mol] |
|---|---|
| Physical adsorption | 2-6 |
| Diffusion in solution | <5 |
| Reactions in cells and organisms | 5-20 |
| Mineral solution and precipitation | 8-36 |
| Mineral solution via surface-controlled reaction | 10-20 |
| Ion exchange | >20 |
| Isotope exchange in solution | 18 to 48 |
| Solid phase diffusion in minerals at low temperatures | 20 to 120 |

### 1.2.4 Empirical approaches for kinetically controlled reactions

A kinetically controlled reaction can be described by the equation:

$$\frac{m_i}{d_t} = c_{ik} \cdot k_k$$

Eq. (81.)

with $m_i/dt$ = converted mass (mol) per time (s)

$c_{ik}$ = concentration of the species i

$k_k$ = reaction rate (mol/kg/s)

### 1.2.2.2 Parallel reactions

For reactions that run independently of each other (parallel reactions) and result in the same product, the reaction with the fastest reaction rate determines the kinetics of the whole process.

$$A + B \xleftrightarrow{k_1} C + D$$

Eq. (77.)

$$A \xleftrightarrow{k_2} C + E$$

Eq. (78.)

$$A + F + G \xleftrightarrow{k_3} C + H$$

Eq. (79.)

With $k_1 > k_2 > k_3$ the reaction of Eq. 77 dominates at first. Another reaction can become predominant, when boundary conditions change during the reaction, as e.g. pH increase during calcite dissolution.

### 1.2.3 Controlling factors on the reaction rate

The reaction rate mainly depends on the concentration of reactants and products. According to the collision theory, frequent collisions and rapid conversions occur at high concentrations. Yet, not all collisions cause conversions. A certain relative position of the molecules to each other is required as well as overcoming a specific threshold energy. Besides the concentration, pH, light, temperature, organics, presence of catalysts, and surface-active trace substances can have a significant influence on reaction rates.

The empirical Arrhenius equation describes the dependency of the reaction rate on the temperature

$$\ln k = \ln A - \frac{E_a}{R} \cdot \frac{1}{T}$$

Eq. (80.)

with      k = velocity constant
          A = empirical constant
          R = general gas constant (8.315 J/K mol)
          T = temperature
          $E_a$ = activation energy

The activation energy is the energy required for initiating a reaction. According to transition state theory, an unstable activated complex forms, which has a fairly high potential energy from the kinetic energy of the reactants and decays within a short period of time. Its energy is converted into the binding energy respectively the kinetic energy of the product (Fig. 25). Table 14 shows typical values for the activation energy of some chemical processes.

**Table 13  Calculation of reaction rate, time law, and half-life of a reaction depending on its order**

| | chemical reactions | reaction rate time law | half-life time |
|---|---|---|---|
| 0.order reaction | | $v = -K_k$ <br> $(A) = -K_k \cdot t + (A_0)$ | $t_{1/2} = \dfrac{(A_0)}{2 \cdot K_k}$ <br><br> dependent on concentration |
| 1.order reaction | $A \rightarrow B$ <br> $A \rightarrow B + C$ | $\dfrac{d(A)}{dt} = -K_k \cdot (A)$ <br><br> $(A) = (A_0) \cdot e^{-K_k \cdot t}$ | $t_{1/2} = \dfrac{1}{K_k} \cdot \ln 2$ <br><br> independent on concentration |
| 2.order reaction | $A + A \rightarrow C + D$ <br> $A + B \rightarrow C + D$ | $\dfrac{d(A)}{dt} = -K_k \cdot (A) \cdot (B)$ <br><br> $\dfrac{d(A)}{dt} = -K_k \cdot (A)^2$ <br><br> $\dfrac{1}{(A)} = -K_k \cdot t + \dfrac{1}{A_0}$ | $t_{1/2} = \dfrac{1}{(A_0) \cdot K_k}$ <br><br> dependent on concentration |
| 3.order reaction | $A + B + C \rightarrow D$ | $\dfrac{d(A)}{dt} = -K_k \cdot (A) \cdot (B) \cdot (C)$ | |

## 1.2.2.1 Subsequent reactions

Frequently chemical processes do not occur in one reaction but as a series of reactions.

$$A + B \xrightarrow{\ k_1\ } C \qquad A + B \xleftarrow{\ -k_i\ } C$$

$$C \xrightarrow{\ k_2\ } D \qquad C \xleftarrow{\ -k_2\ } D$$

<div align="right">Eq. (75.)</div>

The equilibrium constant $k_{12}$ is derived from the principle of microscopic reversibility, i.e. in equilibrium every forward and reverse reaction has the same reaction rate.

$$K_{12} = \frac{\{D\}}{\{A\} \cdot \{B\}} = \frac{k_1 \cdot k_2}{(-k_1) \cdot (-k_2)}$$

<div align="right">Eq. (76.)</div>

For subsequent reactions the total reaction rate depends on the reaction with the lowest reaction rate.

For the weathering of trace minerals from the solid matrix, the dissolution occurs selectively on spots where the mineral is exposed to the surface. These mineral surfaces are usually not smooth, but show dislocations (screw, jump, step dislocations) and point defects (vacant sites, interstitial sites) (Fig. 24 left). Dissolved ions are immediately transported from the surface into solution, so that no gradient can develop. Since the total concentrations of trace minerals in the solution are low, no equilibrium can be reached. In the following this dissolution of trace minerals is called surface-controlled.

### 1.2.2 Calculation of the reaction rate

The reaction rate can be determined by inverse geochemical modeling as increase of the products or decrease of the reactants along a flow path over time. In most cases the forward reaction $(A + B \rightarrow C)$ and the simultaneously proceeding reverse reaction $(C \rightarrow A + B)$ have different reaction rates. The total kinetics is the sum of both.

$$v^+ = k^+ \prod_i (X_i)^{n_i}$$

Eq. (72.)

$$v^- = k^- \prod_i (X_i)^{n_i}$$

Eq. (73.)

$$K_{eq} = \frac{k^+}{k^-} = \prod_i (X_i)_{eq}^{n_i}$$

Eq. (74.)

with:        $v^+$ = rate of the forward reaction
             $k^+$ = rate constant of the forward reaction
             $v^-$ = rate of the reverse reaction
             $k^-$ = rate constant of the reverse reaction
             $X$ = reactant or product
             $n$ = stoichiometric coefficient
             $K_{eq}$ = equilibrium constant

Table 13 shows the calculation of the reaction rate, the time law, and the half-life depending on the reaction's order. The order results from the sum of the exponents of the concentrations. The number does not necessarily have to be an integer. The half-life states in which time half of the reactants is converted into the products. Reaction rate constants k are $10^{12}$ to $10^{-11}$ L/s for first order reactions and $10^{10}$ to $10^{-11}$ L/(mol*s) for second order reactions.

For ion exchange the reaction rate depends on the type of binding and exchange. Those processes are the fastest where the exchange only occurs at the edges of mineral grains, as e.g. with kaolinite. Incorporation of ions in mineral layers is much slower, e.g. into montmorillonite or vermiculite, or the intrusion into basal layers, as for illite. Dissolution and precipitation processes sometimes take only hours, but could also need several thousands of years. Redox reactions have long half-lifes in the range of years, especially when catalysts are lacking.

### 1.2.1.2 Kinetics of mineral dissolution

For interactions between solid and liquid phases, two cases have to be distinguished: weathering of rock-forming minerals and the weathering of trace minerals.

For the weathering of rock-forming minerals, the solution kinetics is determined by the solubility-product and transport in the vicinity of the solid-water-interface. If the dissolution rate of a mineral is higher than the diffusive transport from the solid-water interface, saturation of the boundary layer and an exponential decrease with increasing distance from the boundary layer results. In the following text this kind of solution is referred to as solubility-product controlled. If the dissolution rate of the mineral is lower than diffusive transport, no saturation is attained. This process is called diffusion-controlled solution (Fig. 24 right).

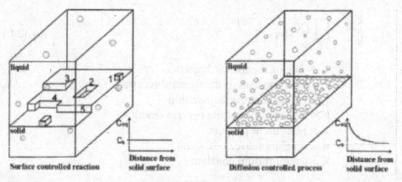

**Fig. 24   Comparison between surface-controlled reactions (left; 1= interstitial sites, 2= vacant sites, 3= screw dislocation, 4= jump dislocation, 5=step dislocation) and diffusion-controlled processes (right)**

In an experiment solubility-product controlled and diffusion-controlled solution can be distinguished by the fact that for diffusion-controlled solution an increase in mixing leads to an increase in the reaction rate. Since this assumption is necessarily true the other way round, it is easier to calculate if the reaction proceeds faster or slower than the molecular diffusion. If it is faster, the reaction is controlled by the solubility-product; if it is slower, it is diffusion-controlled.

## 1.2 Kinetics

For all reactions described in the previous chapter thermodynamic equilibrium, as the most stable time-independent state of a closed system, was assumed. Thermodynamic equations are incapable of describing to what extent or in which time this equilibrium is reached. Thus, slow reversible, irreversible or heterogeneous reactions actually require the consideration of kinetics, i.e. of the rate at which a reaction occurs or the equilibrium is attained.

### 1.2.1 Kinetics of various chemical processes

#### 1.2.1.1 Half-life

Fig. 23 shows the residence times $t_R$ of waters in the hydrosphere and the half-life $t_{1/2}$ of various reactions. If $t_{1/2} \ll t_R$ then it can be assumed that the system is roughly in equilibrium and thermodynamic models can be used. If, on the other hand, $t_R \ll t_{1/2}$ kinetic models must be applied.

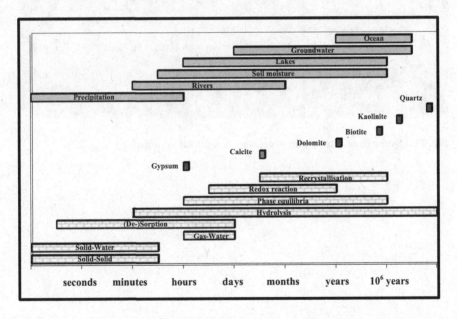

**Fig. 23    Schematic comparison between the residence times $t_R$ of waters in the hydrosphere, the dissolution of various minerals in unsaturated solutions at pH 5 and the half-life $t_{1/2}$ of chemical processes (data after Langmuir 1997, Drever 1997)**

Acid-base reactions and complexation processes especially those with low stability constants occur within micro- to milliseconds. Unspecific sorption with the formation of a disordered surface film is also a fast reaction, while the kinetics of specific sorption and mineral crystallization generally are considerably slower.

$SO_4^{2-}$ to $H_2S(aq)$. The occurrence of organically bound carbon in the groundwater or in the aquifer is required for those reductions. Fig. 21 shows some microbially catalysed redox reaction dependent on $pE/E_H$ conditions.

Fig. 22 schematically shows the most significant hydrogeochemical processes in aqueous systems, and at the water-solid interface.

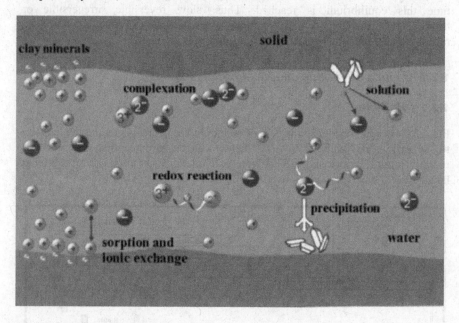

**Fig. 22    Synopsis of interaction processess in aqueous systems**

oxidizing conditions usually prevail, too. Thus low redox potentials in such aquifers can indicate anthropogenic contamination.

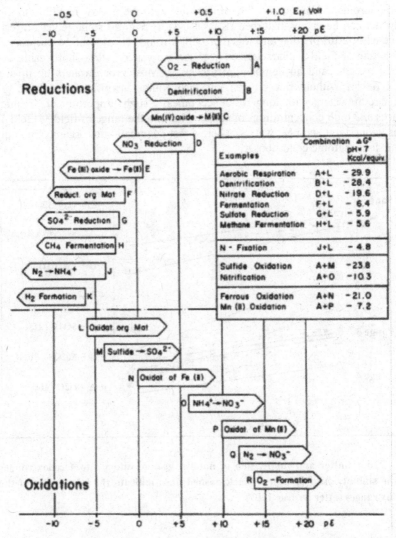

**Fig. 21   Microbially catalyzed redox reactions dependent on pE/$E_H$ conditions (after Stumm and Morgan 1996)**

With increasing depth, even under natural geogenic conditions, oxygen contents and consequently the redox potential in groundwater decreases. Micro-organism, which use the oxygen for their metabolism are the reason for that. If the oxygen, dissolved in water, is consumed, they can gain oxygen, respectively energy form the reduction of $NO_3^-$ to $N_2$ (via $NO_2^-$ and $N_2O(g)$), $Fe^{3+}$ to $Fe^{2+}$ or

## 1.1.5.2.4.    Redox buffer

Analogous to acid-base-buffers, there are also buffers in the redox system, which can level strong variations of the pE value. Yet, the redox equilibrium in groundwater can be easily disturbed (Käss 1984). In Fig. 20 some redox buffers are depicted in a pE/pH diagram together with a rough division of groundwaters into four ranges. Field 1 characterizes near-surface water with a short residence time, free oxygen, and no degradation processes. Most groundwaters lie in the range of field 2 without free oxygen, but also without significant reduction of sulfate. Groundwaters with long residence times, a high proportion of organic substances and high concentrations of sulfide plot into the range of field 3. Field 4 contains young mud and peat waters, where a fast degradation of organic material occurs under anaerobic conditions.

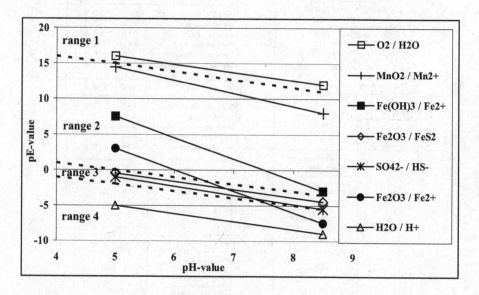

**Fig. 20    Redox buffer and subdivision of natural groundwaters into 4 redox ranges within the stability field of water; black dashed lines indicate the boundaries of the four redox ranges (after Drever 1997)**

## 1.1.5.2.5.    Significance of redox reactions

Oxidation and reduction processes play a major role both in the saturated zone as well as in the unsaturated zone. Within the unsaturated zone there is generally sufficient oxygen from the gas phase to guarantee high redox potentials (500 to 800 mV) in the water. Despite of that, reducing or partly reducing conditions might occur in small cavities (micro-milieus). In aquifers close to the surface

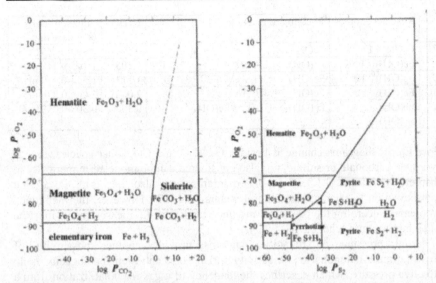

Fig. 18    Left: Fugacity diagram of some iron compounds as a function of $P(O_2)$ and $P(CO_2)$ at 25°C (modified after Garrels u. Christ 1965), Right: Fugacity diagram of some iron and sulfide compounds as a function of $P(O_2)$ and $P(S_2)$ at 25°C (modified after Garrels u. Christ 1965)

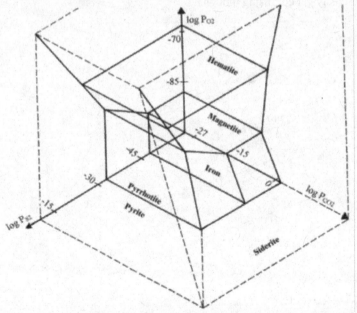

Fig. 19    3-D illustration of a fugacity diagram of some iron compounds as a function of $P(O_2)$, $P(CO_2)$ and $P(S_2)$ at 25°C and a total pressure of 1 atm or higher (modified after Garrels and Christ 1965)

| No | Reaction couples | Equation of reaction | $E_0$ (V) | Equation for boundary line |
|----|------------------|----------------------|-----------|----------------------------|
| 7 | $FeOH^{2+}/Fe^{2+}$ | $FeOH^{2+} + H^+ + e^- = Fe^{2+} + H_2O$ | 0.899 | 0.899-0.0591 pH |
| 8 | $Fe(OH)_2^+/Fe^{2+}$ | $Fe(OH)_2^+ + 2H^+ + e^- = Fe^{2+} + 2H_2O$ | 1.105 | 1.105-0.118 pH |
| 9 | $Fe(OH)_3^0/Fe^{2+}$ | $Fe(OH)_3^0 + 3H^+ + e^- = Fe^{2+} + 3H_2O$ | 1.513 | 1.513-0.177 pH |
| 10 | $Fe(OH)_4^-/Fe^{2+}$ | $Fe(OH)_4^- + 4H^+ + e^- = Fe^{2+} + 4H_2O$ | 2.048 | 2.048-0.236 pH |
| 11 | $Fe(OH)_4^-/Fe(OH)_3^0$ | $Fe(OH)_4^- + H^+ + e^- = Fe(OH)_3^0 + H_2O$ | 0.308 | 0.308-0.0591 pH |

How $E_H$-pH-diagrams change if besides $O_2$, $H_2O$ and $CO_2$ other species, as e.g. hydrogen carbonate or sulfate, are also considered can be modeled numerically in chapter 3.1.3.1and 3.1.3.2. $E_H$-pH diagrams can also be used as a first approximation to characterize natural waters (Fig. 17). However, the mentioned problems concerning the precision and uncertainties of $E_H$ measurements must be taken into account (chapter 1.1.5.2.1).

Partial pressure or fugacity diagrams provide another possibility of presentation. Analogous to the activity for the concentration the fugacity is an effective pressure, which describes the tendency of a gas for volatilization from a phase (Latin fugere = flee). Under low-pressure conditions, the fugacity equals the partial pressure. In fugacity diagrams the species distribution species is displayed as dependent on the partial pressure of e.g. $O_2$, $CO_2$ or $S_2$ (Fig. 18). Furthermore there is the possibility to show the species distribution in 3-D models (Fig. 19). Such illustrations easily get confusing though.

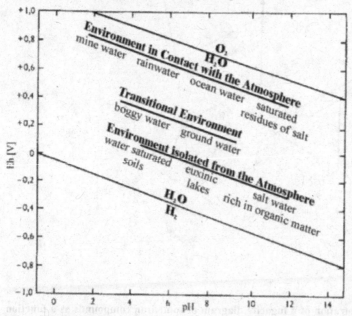

Fig. 17  Classification of natural waters under various $E_H$/pH conditions (modified after Wedepohl 1978)

hydrogen with a partial pressure of $P(H_2) = 10^{-42.6} \cdot 10^5$ Pa. The other way round hydrogen saturated (completely reduced) water is in equilibrium with oxygen of a partial pressure $P(O_2) = 10^{-85.2} \cdot 10^5$ Pa.

$$4\,e^- + 4\,H_2O = 2\,H_2(g) + 4\,OH^-$$

$$\underline{4\,OH^- \qquad\quad = O_2(g)\ + 2\,H_2O + 4\,e^-}$$

$$2\,H_2O \qquad\quad = 2\,H_2(g) + O_2(g)$$

$$K = \frac{\{pH_2\}^2 \cdot \{pO_2\}}{\{H_2O\}^2} = 10^{-85.2} \qquad\qquad\qquad \text{Eq.(71.)}$$

The diagram's vertical boundaries (Fig. 16, number 1-5) are reactions that describe a dissolution in water (hydrolysis) independent of the $E_H$ value. The boundaries of the respective predominance fields are calculated via the equilibrium constants for the conversion of the species at each side of the boundary line into each other.

| No. | Reaction couples | Reaction equation | -log K = pH |
|-----|------------------|-------------------|-------------|
| 1 | $Fe^{3+}/\,FeOH^{2+}$ | $Fe^{3+} + H_2O = FeOH^{2+} + H^+$ | 2.19 |
| 2 | $FeOH^{2+}/\,Fe(OH)_2^+$ | $FeOH^{2+} + H_2O = Fe(OH)_2^+ + H^+$ | 3.48 |
| 3 | $Fe(OH)_2^+/\,Fe(OH)_3^0$ | $Fe(OH)_2^+ + H_2O = Fe(OH)_3^0 + H_2O$ | 6.89 |
| 4 | $Fe(OH)_3^0/\,Fe(OH)_4^-$ | $Fe(OH)_3^0 + H_2O = Fe(OH)_4^- + H^+$ | 9.04 |
| 5 | $Fe^{2+}/\,Fe(OH)_3^-$ | $Fe^{2+} + 3H_2O = Fe(OH)_3^- + 3H^+$ | 9.08 |

The conversion of $Fe^{3+}$ into $Fe^{2+}$ (Fig. 16, number 6), is a pure redox reaction, independent of the pH-value (horizontal boundary). It is calculated after Eq. 58:

$$E_H = E^\circ - \frac{0.0591}{n} \cdot \log \frac{\{red\}}{\{ox\}}$$

For the calculation of the boundary line the activity of both species is equal, i.e. $\{red\} = \{ox\}$. Thus the argument of the logarithm is 1 and the logarithm is 0, i.e. $E_H = E_0$.

| No. | Reaction couples | Reaction equation | $E_0$ (V) | $E_H = E_0$ |
|-----|------------------|-------------------|-----------|-------------|
| 6 | $Fe^{3+}/Fe^{2+}$ | $Fe^{3+} + e^- = Fe^{2+}$ | 0.770 | 0.770 |

The diagonal boundaries display species transformations, which depend on pH and $E_H$. After Eq. 59

$$E_H = E^\circ - 2.303 \cdot \frac{m \cdot R \cdot T}{n \cdot F} \cdot pH - 2.303 \cdot \frac{R \cdot T}{n \cdot F} \cdot \log \frac{\{red\}}{\{ox\}}$$

the calculation of the boundary line ($\{ox\} = \{red\}$) follows:

$$E_H = E^\circ - \frac{0.0591 \cdot m}{n} \cdot pH$$

with m= number of protons used or formed in the reaction

### 1.1.5.2.3. Presentation in predominance diagrams

The presentation of the predominant species for each redox system is called stability (or better) predominance diagram (also called $E_H$-pH or pE-pH diagrams). Predominance diagrams are extremely dependent on which elements in which concentrations and at which ionic strength are considered. Usually only the species dissolved in water are depicted (Fig. 16 left). However, if the concentration or activity falls below certain user-defined limits, often the (predominant) precipitating mineral phase is outlined instead (Fig. 16 right). The lines bordering individual predominance ranges show the pE/pH conditions, under which the activities of two neighboring species equal each other.

How such a $E_H$-pH diagram can be determined analytically is explained below using the example of the Fe-$O_2$-$H_2O$ diagram shown in Fig. 16 left. In each $E_H$-pH diagram the occurrence of the aqueous species is limited by the stability field of water. Above this field $H_2O$ converts to elementary oxygen, below this field to elementary hydrogen (also see Fig. 17).

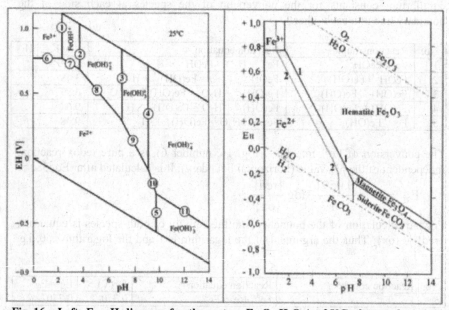

**Fig. 16** Left: $E_H$-pH diagram for the system Fe-$O_2$-$H_2O$ (at 25°C, the numbers 1-11 correspond to the reaction equations described in the text for the calculation of the stability fields, modified after Langmuir 1997) Right: $E_H$-pH diagram for the system Fe-$O_2$-$H_2O$-$CO_2$ (at 25°C, $P(CO_2) = 10^{-2}$ atm), for fields where the total activity is $< 10^{-6}$ (1) resp. $< 10^{-4}$ (2) mol/L the predominant, precipitating mineral phase is outlined (modified after Garrels and Christ 1965).

According to Eq. 71 each oxygen concentration is (analytically) assigned to a certain hydrogen content. This means that oxygen saturated (i.e. completely oxidized) water with the partial pressure of $P(O_2) = 1 \cdot 10^5$ Pa is in equilibrium with

$$- n \cdot \log\{e^-\} = \log K - \log \frac{\{red\}}{\{ox\}}$$

<div align="right">Eq.(61.)</div>

$$- \log\{e^-\} = \frac{1}{n}\log K - \frac{1}{n}\log\frac{\{red\}}{\{ox\}}$$

<div align="right">Eq.(62.)</div>

$$pE = \frac{1}{n}\log K - \frac{1}{n}\log\frac{\{red\}}{\{ox\}}$$

<div align="right">Eq.(63.)</div>

The conversion from pE to the measured redox potential $E_H$ follows from:

$$pE = -\log\{e^-\} = \frac{F}{2.303 \cdot R \cdot T} \cdot E_H$$

<div align="right">Eq.(64.)</div>

F, R, and T=25°C inserted, the following simplified form results [$E_H$ in V]:

$$pE \approx 16.9 \cdot E_H$$

<div align="right">Eq.(65.)</div>

For the system $H_2/H^+$ the following is applicable:

$$E_H = E^\circ\left(\frac{H^+}{H_2}\right) + \frac{R \cdot T}{n \cdot F} \cdot \ln\frac{\{H^+\}^2}{\{H_2\}}$$

<div align="right">Eq.(66.)</div>

$$E_H = 0 + \frac{R \cdot T}{n \cdot F} \cdot \ln\{H^+\}^2 - \frac{R \cdot T}{n \cdot F} \cdot \ln\{H_2\}$$

<div align="right">Eq.(67.)</div>

$$E_H = 0 + \frac{2.303 \cdot R \cdot T}{2 \cdot F} \cdot 2 \cdot \log\{H^+\} - \frac{2.303 \cdot R \cdot T}{2 \cdot F} \cdot \log\{H_2\}$$

<div align="right">Eq.(68.)</div>

$$E_H = 0 - \frac{2.303 \cdot R \cdot T}{F} \cdot pH - \frac{2.303 \cdot R \cdot T}{2 \cdot F} \cdot \log\{H_2\}$$

<div align="right">Eq.(69.)</div>

Inserting standard values for R and F, as well as T =25°C and P($H_2$) = $1 \cdot 10^5$ Pa, it follows:

$$E_H = -0.0591 \cdot pH$$

<div align="right">Eq.(70.)</div>

An increase or decrease of one pH unit causes a decrease or increase, respectively, of the Nernst voltage by 59.1 mV.

The equation for the calculation of redox potentials (Eq. 53) derives from the equation of the Gibbs free energy (compare also Eq. 6).

$$G = G^0 - R \cdot T \cdot \ln \frac{\{red\}}{\{ox\}}$$

Eq.(54.)

$$E_H = - \frac{G}{n \cdot F}$$

Eq.(55.)

$$-\frac{G}{n \cdot F} = -\frac{G^0}{n \cdot F} - \frac{R \cdot T}{n \cdot F} \cdot \ln \frac{\{red\}}{\{ox\}}$$

Eq.(56.)

$$E_H = E^0 - \frac{R \cdot T}{n \cdot F} \cdot \ln \frac{\{red\}}{\{ox\}}$$

Eq.(57.)

Eq. 53 is obtained from Eq. 57 by inversion of numerator and denominator within the argument of the logarithm. That leads to the minus sign in front of the logarithm.

For standard conditions of 25°C and inserting standard values for the gas constant and the Faraday constant, a simplified form ensues:

$$E_H = E^0 - \frac{0.0591}{n} \cdot \log \frac{\{red\}}{\{ox\}}$$

Eq.(58.)

Dealing with pH-dependent redox reactions, as e.g. the oxidation of $Cl^-$ to $Cl_2$ by permanganate at pH 3, the number of protons used and formed must be considered.

$$E_H = E^0 - 2.303 \cdot \frac{m \cdot R \cdot T}{n \cdot F} \cdot pH - 2.30 \cdot \frac{R \cdot T}{n \cdot F} \cdot \log \frac{\{red\}}{\{ox\}}$$

Eq.(59.)

The factor 2.303 results from the conversion of the natural logarithm to the common logarithm. Since redox potentials cannot be used directly in thermodynamic programs (unit: volt!), the pE value was introduced for mathematical convenience. Analogous to the pH value the pE value is the negative common logarithm of the electron activity. Thus, it is calculated using a hypothetic activity, respectively concentration of electrons, which is actually not present in water. For the calculation of the pE value Eq. 51 is used and the following equation is obtained for the equilibrium constant K:

$$\log K = \log \frac{\{red\}}{\{ox\}\{\bar{e}\}^n} = \log \frac{\{red\}}{\{ox\}} + \log \frac{1}{\{e^-\}^n} = \log \frac{\{red\}}{\{ox\}} - n \cdot \log\{\bar{e}\}$$

Eq.(60.)

| Cs | Ba | Lu | Hf | Ta | W | Re | Os | Ir | Pt | Au | Hg | Tl | Pb | Bi | Po | At | Rn |
|----|----|----|----|----|----|----|----|----|----|----|----|----|----|----|----|----|----|
| +1 | +4 | +3 | +4 | +5 | +6 | +7 | +8 | +4 | +6 | +3 | +2 | +3 | +4 | +5 | +6 | +5 |    |
| 0  | +2 | 0  | 0  | 0  | +5 | +6 | +6 | +3 | +4 | +1 | +1 | +1 | +2 | +3 | +4 | +1 |    |
|    | 0  |    |    |    | +4 | +4 | +3 | 0  | +2 | 0  | 0  | 0  | 0  | 0  | +2 | 0  |    |
|    | -2 |    |    |    | 0  | +3 | +2 |    | 0  |    |    |    | -2 | -3 | 0  | -1 |    |
|    |    |    |    |    |    | 0  | 0  |    |    |    |    |    |    |    | -2 |    |    |
|    |    |    |    |    |    | -1 |    |    |    |    |    |    |    |    |    |    |    |

| Fr | Ra |
|----|----|
| +1 | +2 |

### Lanthanides and actinides

| La | Ce | Pr | Nd | Pm | Sm | Eu | Gd | Tb | Dy | Ho | Er | Tm | Yb |
|----|----|----|----|----|----|----|----|----|----|----|----|----|----|
| +3 | +4 | +4 | +4 | +3 | +3 | +3 | +3 | +4 | +4 | +3 | +3 | +3 | +3 |
| 0  | +3 | +3 | +3 | 0  | +2 | +2 | 0  | +3 | +3 | 0  | 0  | +2 | +2 |
|    | 0  | 0  | +2 |    | 0  | 0  |    | 0  | +2 |    |    | 0  | 0  |
|    |    |    | 0  |    |    |    |    |    | 0  |    |    |    |    |

| Ac | Th | Pa | U  | Np | Pu | Am | Cm | Bk | Cf | Es | Fm | Md | No |
|----|----|----|----|----|----|----|----|----|----|----|----|----|----|
| +3 | +4 | +5 | +6 | +7 | +7 | +6 | +4 | +4 | +3 | +3 | +3 | +3 | +3 |
| 0  | 0  | +4 | +5 | +6 | +6 | +5 | +3 | +3 | +2 | +2 | +2 | +2 | +2 |
|    | -3 | 0  | +4 | +5 | +5 | +4 | 0  | 0  | 0  | 0  | 0  | 0  | 0  |
|    | -4 |    | +3 | +4 | +4 | +3 |    |    |    |    |    |    |    |
|    |    |    | +2 | +3 | +3 | 0  |    |    |    |    |    |    |    |
|    |    |    | 0  | 0  | 0  |    |    |    |    |    |    |    |    |

Table 11 shows some redox-sensitive elements in the periodic system of the elements, Table 12 depicts standard potentials for some important redox pairs in aqueous systems.

**Table 12   Standard potentials and $E_H$ in volts for some important redox couples in aqeous systems at 25°C (modified after Langmuir 1997)**

| Reaction | E° Volt | $E_H$ Volt / pH 7.0 | assumptions |
|----------|---------|---------------------|-------------|
| $4H^+ + O_{2(g)} + 4e^- = 2\ H_2O$ | 1.23 | 0.816 | $P_{O2}=0.2$ bar |
| $NO_3^- + 6\ H^+ + 5e^- = 0.5\ N_{2(g)} + 3\ H_2O$ | 1.24 | 0.713 | $10^{-3}$ mol N, $P_{N2}=0.8$ bar |
| $MnO_2 + 4\ H^+ + 2\ e^- = Mn^{2+} + 2\ H_2O$ | 1.23 | 0.544 | $10^{-4.72}$ mol Mn |
| $NO_3^- + 2\ H^+ + 2e^- = NO_2^- + H_2O$ | 0.845 | 0.431 | $NO_3^-=NO_2^-$ |
| $NO_2^- + 8\ H^+ + 6\ e^- = NH_4^+ + 2\ H_2O$ | 0.892 | 0.340 | $NO_3^-=NH_4^+$ |
| $Fe(OH)_3 + 3\ H^+ + e^- = Fe^{2+} + 3\ H_2O$ | 0.975 | 0.014 | $10^{-4.75}$ mol Fe |
| $Fe^{2+} + 2\ SO_4^{2-} + 16\ H^+ + 14\ e^- = FeS_2 + 8\ H_2O$ | 0.362 | -0.156 | $10^{-4.75}$ mol Fe, $10^{-3}$ mol S |
| $SO_4^{2-} + 10\ H^+ + 8e^- = H_2S_{(aq)} + 4\ H_2O$ | 0.301 | -0.217 | $SO_4^{2-}=H_2S$ |
| $HCO_3^- + 9\ H^+ + 8\ e^- = CH_{4(aq)} + 3\ H_2O$ | 0.206 | -0.260 | $HCO_3^-=CH_4$ |
| $H^+ + e^- = 0.5\ H_{2(g)}$ | 0.0 | -0.414 | $P_{H2}=1.0$ bar |
| $HCO_3^- + 5\ H^+ + 4\ e^- = CH_2O\ (DOM) + 2\ H_2O$ | 0.036 | -0.482 | $HCO_3^-=CH_2O$ |

Eq. 53 describes the calculation of individual redox potentials, unlike the measured redox potential, which may be a mixed potential of various redox reactions not in equilibrium.

When citing redox potential values it is important to provide the corresponding redox reaction equation since reversing the equation causes a change in the sign.

**Table 11 Redox-sensitive elements in the PSE and their potential oxidation states in natural aqueous systems (after Emsley 1992, Merkel and Sperling 1996, 1998)**

| | | | | | | | | | | | | | | | | | |
|---|---|---|---|---|---|---|---|---|---|---|---|---|---|---|---|---|---|
| H +1 0 -1 | | | | | | | | | | | | | | | | | He |
| Li +1 0 | Be +2 0 | | | | | | | | | | | B +3 0 | C +4 +2 0 -2 -4 | N +5 +4 +3 +2 +1 0 -1 -2 -3 | O 0 -1 -2 | F -1 0 | Ne |
| Na +1 0 | Mg +2 +1 0 | | | | | | | | | | | Al +3 0 | Si +4 +2 0 -4 | P +5 +3 0 -2 -3 | S +6 +5 +4 +3 +2 0 -2 | Cl +7 +5 +3 +1 0 -1 | Ar |
| K +1 0 | Ca +2 0 -2 | Sc +3 0 | Ti +4 +3 +2 0 | V +5 +4 +3 +2 0 | Cr +6 +5 +4 +3 +2 +1 0 | Mn +7 +6 +5 +4 +3 +2 +1 0 | Fe +6 +4 +3 +2 0 | Co +6 +5 +4 +3 +2 +1 0 -1 | Ni +6 +4 +2 0 | Cu +3 +2 +1 0 | Zn +2 0 | Ga +3 +2 0 | Ge +4 +2 0 | As +5 +3 0 -3 | Se +6 +4 0 -2 | Br +7 +5 +1 0 -1 | Kr |
| Rb +1 0 | Sr +2 0 -2 | Y +3 0 | Zr +4 0 | Nb +5 +3 0 | Mo +6 +5 +4 +3 +2 0 | Tc +7 +6 +5 +4 0 | Ru +8 +7 +6 +4 +3 +2 0 | Rh +3 0 | Pd +4 +2 0 | Ag +3 +2 +1 0 | Cd +2 0 | In +3 +1 0 | Sn +4 +2 0 -4 | Sb +5 +4 +3 0 -3 | Te +6 +4 0 -1 -2 | I +7 +5 +1 0 -1 | Xe |

hydrogen electrode with $P(H_2) = 100$ kPa, pH = 0, temperature = 25°C and a potential of

$$E^\circ\left(\frac{H^+}{H_2}\right) = 0\,mV \qquad\qquad\qquad Eq.(52.)$$

In the aqueous solution, the potential is measured as an integral over all existing redox species (mixed potential).

Since the use of the standard hydrogen electrode in the field would be very tedious and dangerous, other reference electrodes are used. Those reference electrodes have a defined Eigenpotential, $E_B$, which is added to the determined value $E_M$, to obtain the solution potential, or $E_H$, with reference to the standard hydrogen electrode. Mostly Ag/AgCl or mercury chloride ($Hg_2Cl_2$)/ platinum electrodes are used as reference electrodes. The advantage of Ag/AgCl electrodes is the fast response rate, whereas the mercurial chloride/platinum-electrode has a slower response rate but yields higher precision. Faster response times and higher sensitivities can be achieved with microelectrodes where currents are smaller and relative diffusion current per surface area is enhanced.

In practice, the measurement of the redox potential is, independent of the reference electrode, highly problematic. Contamination and memory effects are a common problem with all types of electrodes. Furthermore, many natural waters are likely not to be in thermodynamical redox equilibrium and redox species are present in concentrations too low to give an electrode response (Nordstrom and Munoz 1994). Therefore redox measurements should be aborted after 1 hour if no steady state is reached. The result obtained from the measurement in that case is, that the water is in thermodynamic disequilibrium with regard to its redox species. For thermodynamic modeling this means that species distribution can not be derived from total element concentrations via the measured redox potential. If redox-sensitive elements are decisive for the model, each redox pair has to be determined individually by analytical speciation methods.

### 1.1.5.2.2.   Calculation of the redox potential

The equilibrium redox potential can be calculated from the following Nernst equation:

$$E_h = E^\circ + \frac{R\cdot T}{n\cdot F}\ln\frac{\{ox\}}{\{red\}} \qquad\qquad Eq.(53.)$$

$E^\circ$ = standard redox potential of a system where the activities of the oxidized
  species equal the activities of the reduced species
R = ideal gas constant (8.3144 J/K mol)
T = absolute temperature (K)
n  = number of transferred electrons ($e^-$)
F = Faraday constant (96484 C/mol = J/V mol)
{ox} = activity of the oxidized species
{red} = activity of the reduced species

chelating agents based on the periodic table of elements is problematic. Such generalizations do not appear practical, because the tendency of elements to form complexes critically depends on the corresponding ligand, as Table 10 shows for some examples. And last, but not least, the concentration of the ligand in the solution (main or trace element) is of crucial importance.

**Table 10  Complexation constants (logK) for hydroxide, carbonate, and sulfate complexes (data from WATEQ4F and (*)LLNL data base); Me = metal cations, n = oxidation state of the cations (n = 1, 2, 3)**

| Element | Hydroxo complex $Me^n + H_2O = MeOH^{n-1} + H^+$ | Carbonate complex $Me^n + CO_3^{2-} = MeCO_3^{n-2}$ | Sulfate complex $Me^n + SO_4^{2-} = MeSO_4^{n-2}$ |
|---|---|---|---|
| $Na^+$ | -14.79(*) | 1.27 | 0.7 |
| $K^+$ | -14.46(*) | no data available | 0.85 |
| $Ca^{2+}$ | -12.78 | 3.224 | 2.3 |
| $Mg^{2+}$ | -11.44 | 2.98 | 2.37 |
| $Mn^{2+}$ | -10.59 | 4.9 | 2.25 |
| $Ni^{2+}$ | -9.86 | 6.87 | 2.29 |
| $Fe^{2+}$ | -9.5 | 4.38 | 2.25 |
| $Zn^{2+}$ | -8.96 | 5.3 | 2.37 |
| $Cu^{2+}$ | -8.0 | 6.73 | 2.31 |
| $Fe^{3+}$ | -2.19 | no data available | 4.04 |

### 1.1.5.2 Redox processes

Together with acid-base reactions, where a proton transfer occurs (pH-dependent dissolution/ precipitation, sorption, complexation) redox reactions play an important role for all interactions in aqueous systems. Redox reactions consist of two partial reactions, oxidation and reduction, and can be characterized by oxygen or electron transfer. Many redox reactions in natural aqueous systems can actually not be described by thermodynamic equilibrium equations, since they have slow kinetics. If a redox reaction is considered as a transfer of electrons, the following general reaction can be derived:

$$\{oxidized\ species\} + n \cdot \{e^-\} = \{reduced\ species\} \qquad \text{Eq.(51.)}$$

with n = number of electrons, $e^-$.

### 1.1.5.2.1.  Measurement of the redox potential

Inserting an inert but highly conductive metal electrode into an aqueous solution allows electrons to transfer both from the electrode to the solution and vice versa. A potential difference (voltage) builds up, which can be determined in a current-less measurement. Per definition, this potential is measured relative to the standard

Beside these inorganic ligands there are also organic ligands like humic or fulvic acids, which occur naturally in almost all waters, but also NTA and EDTA, which enter the hydrosphere as phosphate substitutes in detergents (Bernhardt et al. 1984) and can mobilize metals.

The complex binding can be electrostatic, covalent, or a combination of both. Electrostatically bound complexes, where the metal atom and the ligand are separated by one or more hydrogen molecules, are called outer-sphere complexes. They are less stable and are formed when hard cations come into contact with hard ligands (Table 9).

The Pearson concept of "hard" and "soft" acids and bases considers the number of electrons in the outer shell. Elements with a saturated outer shell and low tendency for polarization (noble gas configuration) are called "hard" acids, while elements with only partially filled outer shell, low electronegativity, and high tendency for polarization are "soft" acids.

Inner-sphere complexes, with covalent bounds between a metal atom and a ligand, form from soft metal atoms and soft ligands or soft metal atoms and hard ligands or hard metal atoms and soft ligands and are much more stable.

**Table 9      Classification of metal ions into A and B- type and after the Pearson concept into hard and soft acids with preferred ligands (after Stumm and Morgan 1996)**

| Metal cations type A ("hard spheres") | Transition metal cations | Metal cations type B ("soft spheres") |
|---|---|---|
| $H^+$, $Li^+$, $Na^+$, $K^+$, $Be^{2+}$, $Mg^{2+}$, $Ca^{2+}$, $Sr^{2+}$, $Al^{3+}$, $Sc^{3+}$, $La^{3+}$, $Si^{4+}$, $Ti^{4+}$, $Zr^{4+}$, $Th^{4+}$ | $V^{2+}$, $Cr^{2+}$, $Mn^{2+}$, $Fe^{2+}$, $Co^{2+}$, $Ni^{2+}$, $Cu^{2+}$, $Ti^{3+}$, $V^{3+}$, $Cr^{3+}$, $Mn^{3+}$, $Fe^{3+}$, $Co^{3+}$ | $Cu^+$, $Ag^+$, $Au^+$, $Tl^+$, $Ga^+$, $Zn^{2+}$, $Cd^{2+}$, $Hg^{2+}$, $Pb^{2+}$, $Sn^{2+}$, $Tl^{3+}$, $Au^{3+}$, $In^{3+}$, $Bi^{3+}$ |
| according to Pearson concept | | |
| hard acids | Transition range | soft acids |
| all metal cations type A plus $Cr^{3+}$, $Mn^{3+}$, $Fe^{3+}$, $Co^{3+}$, $UO^{2+}$, $VO^{2+}$ | all divalent transition metal cations plus $Zn^{2+}$, $Pb^{2+}$, $Bi^{3+}$ | all metal cations type B except for $Zn^{2+}$, $Pb^{2+}$, $Bi^{3+}$ |
| preference for ligand atom | | |
| N >> P, O >> S, F >> Cl | | P >> N, S >> O, Cl >> F |

Chelates are complexes with ligands that form more than one bond with the positively charged metal ion (multidentate ligands). Such complexes show an especially high stability. Complexes with more than one metal atom are called multi- or polynuclear complexes.

By means of complexation, a metal can occur in normally unknown or rare oxidation states. For instance, $Co^{3+}$, being a strong oxidizing agent, is normally not stable in aqueous solutions, but it is stable as $Co(NH_3)_6^{3+}$. Furthermore, complexation can prevent disproportionation, as in the case of $Cu^+$ e.g., which converts into $Cu^{2+}$ and Cu(s) in an aqueous solution, although it is stable as $Cu(NH_3)_2^+$.

Deducting general statements about the stability of different complexes e.g. from the ionic strength or dividing compounds into generally well and poor

Charge distribution multi-site complexation model (CD-MUSIC)

An advanced version of a triple layer model is the charge distribution multi-site complexation model (Hiemstra and Van Riemsdijk 1996, 1999). The assignment of the three layers is the same, only the nomenclature is different; the numbers 0, 1, 2 are assigned to the o-, the β-, and the d plane, respectively. The clear advantage of the CD-MUSIC model is that it takes into account the chemical composition of the crystal surface which can be investigated, e.g. by in-situ infrared-spectroscopy, EXAFS (extended x-ray absorption fine structure) investigations, or TEM (Transmission Electron Microscopy). Thus, the relevant parameters are not free fitting parameters as in the three models described above (DDLM, CCM, TLM) but are constrained by measured physical or chemical data. Cation and anion sorption are treated in the same way based on Pauling's concepts of charge distribution of ions. Furthermore, the CD-MUSIC model can take into account competitive sorption of two or more ligands. However, CD-MUSIC can not be applied to amorphous solids.

## 1.1.5 Interactions in the liquid phase

### 1.1.5.1 Complexation

Complexation has a significant influence on dissolution and precipitation of minerals as already described in chapter 1.1.4.1.3. In contrast to the dissolution of minerals, complexation is a homogeneous reaction. It can be described by the mass-action law. The complexation constant, K, gives information about the complex stability. Large complex constants indicate a strong tendency for complexation, or high complex stability.

Positively charged, zero-charged, and negatively charged complexes can be distinguished. Contaminants for instance have an especially high mobility if they occur as zero-charged complexes, since they undergo almost no exchange processes, whereas (positively or negatively) charged complexes show interactions with other ions and solid surfaces.

A complex can be defined as a coordination compound of a positively charged part with a negatively charged part, the ligand. The positively charged part is usually a metal ion or hydrogen, but may also be another positively charged complex. Ligands are molecules, which have at least one free pair of electrons (bases). This ligand can either be free anions like $F^-$, $Cl^-$, $Br^-$, $I^-$ or negatively charged complexes as $OH^-$, $HCO_3^-$, $CO_3^{2-}$, $SO_4^{2-}$, $NO_3^-$, and $PO_4^{3-}$.

From the periodic table of elements the following elements can be possible ligands:

| Group | 4 | 5 | 6 | 7 |
|-------|---|---|---|---|
|       | C | N | O | F |
|       |   | P | S | Cl |
|       |   | As | Se | Br |
|       |   |   | Te | I |

## Diffuse Double-Layer Model (DDLM)
This model is based on the Gouy-Chapman theory (diffuse double-layer theory). The theory states that in the area of the boundary layer between solid and aqueous phase, independently of the surface charge, increased concentrations of cations and anions within a diffuse layer exists because of electrostatic forces. In contrast to the constant-capacitance model, the electrical potential does not change up to a certain distance from the phase boundaries and is not immediately declining in a linear manner (Fig. 15 left). Diffusion counteracts these forces, leading to dilution with increasing distance from the boundary. This relation can be described physically by the Poisson-Boltzmann equation.

## Constant-Capacitance Model (CCM)
The constant-capacitance model assumes that the double layer on the solid-liquid phase boundary can be regarded as a parallel-plate capacitor (Fig. 15 middle).

## Triple-Layer Model (TLM)
While CCM and DDLM assume that all ions are at one plane, the triple layer includes different planes, in which the surface complexes are bound. In the original version of Davis et al. (1987) the protons and hydroxide ions are bound at the layer (o-plane) close to the phase boundary, whereas inner-sphere complexes are bound in a $\beta$-plane somewhat dislodged. Both planes are assumed as constant-capacity layers. The range outside the $\beta$-plane containing the outer-sphere complexes is modeled as a diffuse layer (Fig. 15 right).

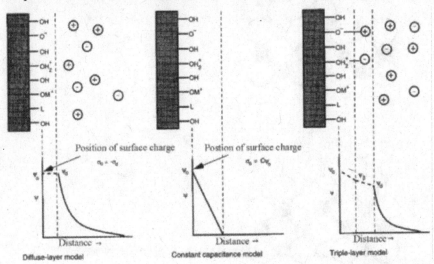

**Fig. 15   Idealized distribution of the electrical potential in the vicinity of hydrated oxide surfaces after (from left to right) the diffuse-layer model, the constant-capacitance model and the triple-layer model (after Drever 1997).**

Similar to complexes in solution, surface complexes can be distinguished in inner-spherical complexes (e.g. phosphate, fluoride, copper), where the ion is directly bound to the surface, and outer-spherical (e.g. sodium, chloride) complexes where the ion is covered by a hydration sleeve with electrostatic binding. The inner-sphere complex is much stronger and independent of electrostatic forces, i.e. a cation can also be sorbed on a positively charged surface (Drever 1997).

On this basis, four models will be discussed, which enable a calculation of the electrical potential, namely the constant-capacitance, the diffuse-double-layer, the triple-layer and the charge distribution multi-site complexation model.

Original Surface-Metals with
Incomplete Coordination

Coordination Sphere-Completed
by Water Molecules

Proton Reorganisation for Forming
of Surface-Hydroxyl-Groups

● Metal Ion      ○ Oxygen

Fig. 14   The process of surface complexation (after Drever 1997)

Using the Freundlich isotherm, a retardation factor can be calculated as with the linear Henry isotherm. Advantageous in comparison to the linear model is that an upper limit for sorption capacity is defined.

Langmuir isotherm
The Langmuir isotherm was developed to describe sorbents with a limited number of sorption sites on their surface:

$$C^* = \frac{a \cdot b \cdot C}{1 + a \cdot C}$$
Eq.(48.)

with    a = sorption constant
        b = maximum sorbable mass of the substance (mg/kg)

$$Rf = 1 + \frac{Bd}{q} \cdot \left[ \frac{a \cdot b}{(1 + a \cdot C)^2} \right]$$
Eq.(49.)

From the scientific point of view, however, all approaches in the sense of the $K_d$ concept (Henry, Freundlich or Langmuir isotherm) are unsatisfactory, since the complex exchange processes including surface reactions can not be described by empirical fitting parameters. Boundary conditions like pH value, redox potential, ionic strength, or competition of individual sorbents in solution for the same binding sites are not considered.
Thus, even though the $K_d$ concept is frequently applied, often because no parameters for deterministic or mechanistic approaches are available, results from laboratory and field experiments are seldom transferable to real systems. The $K_d$ concept could only provide a suitable prognosis model if no changes in boundary conditions are to be expected.

Mechanistic models for surface complexation
Surface complexation is a theory to describe the phenomenon of sorption. At the surface of iron, aluminum, silica, and manganese hydroxides as well as humic substances, there are cations that are not completely surrounded by oxygen ions in contrast to the cations in the interior of the crystal lattice. Because of their valence electrons they may bind water molecules. After sorption, the protons of these water molecules rearrange such that every surface oxygen atom binds only one proton. The second proton binds to oxygen atoms in the crystal lattice (Fig. 14). Thus, a layer of functional groups is formed containing O, S, or N on the surface of the mineral (double layer).
After Stumm and Morgan (1996) the reaction can be described as follows:

$$\{GH\} + Me^{z+} \leftrightarrow \{GMe^{z-1}\} + H^+$$
Eq.(50.)

Here, GH is a functional group as $(R\text{-}COOH)_n$ or $(=AlOH)_n$. The capability of functional groups to form complexes strongly depends on the acid-base behavior and, hence, on pH changes in an aquatic system.

on surface complexation for the determination of electric potentials, e.g. constant-capacitance, diffuse-double layer, triple layer, and charge distribution multi-site complexation (CD-MUSIC) model.

## Empirical models - sorption isotherms

Sorption isotherms are the depiction of sorption-interactions using simple empirical equations. Initially, the measurements were done at constant temperature, that is why the term "isotherm" was introduced.

### Linear-regression isotherm (Henry isotherm)

The most simple form of a sorption isotherm is the linear-regression equation.

$$C^* = K_d \cdot C$$

Eq.(44.)

with   $C^*$ = mass of substance sorbed at a mineral (mg/kg)
   $K_d$ = distribution coefficient
   $C$ = concentration of the substance in water (mg/L)

Linear-sorption terms have the advantage of simplicity and they can be converted into a retardation factor Rf, so that the general transport equation can be easily expanded by applying the correction term:

$$Rf = 1 + \frac{Bd}{q} \cdot \frac{C^*}{C} = 1 + \frac{Bd}{q} \cdot K_d$$

Eq.(45.)

with   $Bd$ = bulk density
   $q$ = water content

A severe disadvantage is that the relation is linear, so that there is no upper limit to the sorption.

### Freundlich isotherms

Using the Freundlich isotherm, an exponential relation between sorbed and dissolved molecules can be described:

$$C^* = K_d \cdot C^n$$

Eq.(46.)

$$Rf = 1 + \frac{Bd}{q} \cdot n \cdot K_d \cdot C^{n-1}$$

Eq.(47.)

A further empirical constant n is introduced, which is usually less than 1. The Freundlich isotherm is based on a model of a multi-lamellar coating of the solid surface assuming *a priori* that all sites with the largest binding energy (of electrostatic forces) are occupied (steep section of the curve). Only when significantly increasing the concentration of analyte in solution, sorption will also occur at additional sites with lower binding energy (flattening of the curve).